W9-CLS-791

Installations by Architects

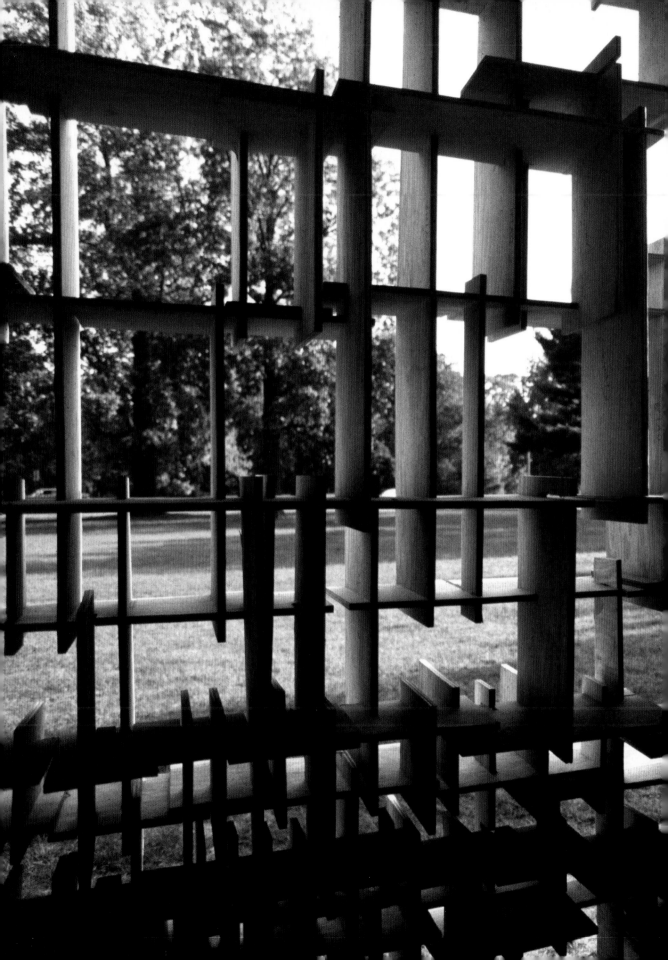

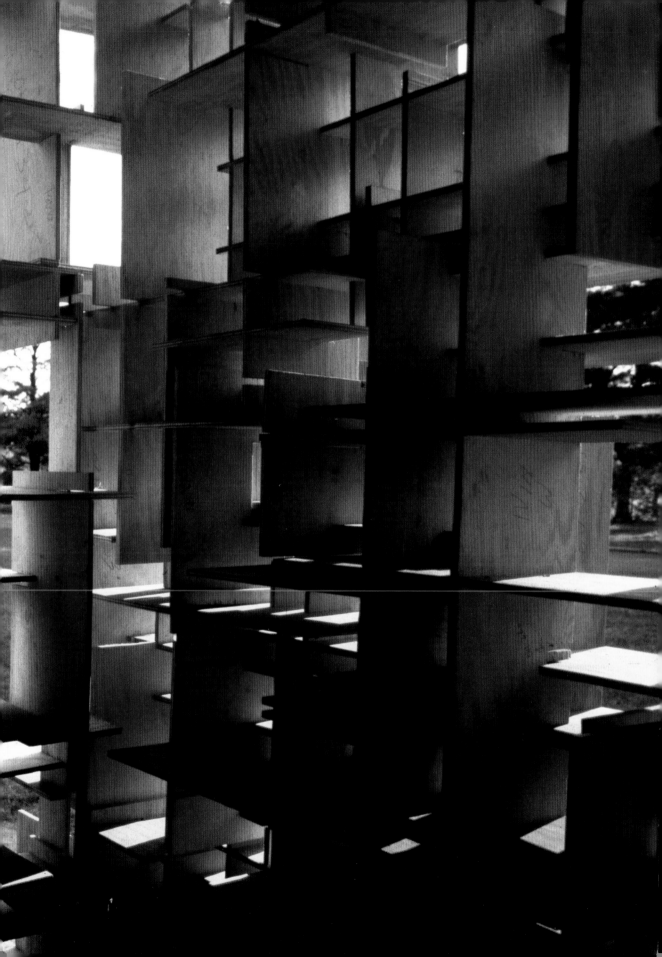

# Installations
## — by —
# Architects

## Experiments in Building and Design

**Sarah Bonnemaison and**
**Ronit Eisenbach**

Princeton Architectural Press | New York

# Contents

*To Christine Macy and Daniel, Jonah, and Adam Chazan,*
*the members of our respective families, who have provided us*
*with support and encouragement all along.*

# Acknowledgments

This book is the result of a collaborative effort far greater than the sum of its two authors, Sarah Bonnemaison and Ronit Eisenbach. In 2001 we began the project in a flurry of optimism and excitement. And here we are, seven years later, reflecting on the long path from initial conversation to completed work.

We started by collecting articles about installations by architects that had been published in design journals worldwide. Eisenbach led this initial research effort by developing a database, which grew to include 563 entries documenting over 400 projects by 200 architects from 15 countries. To find unpublished projects, we chaired a call for papers at the Association of Collegiate Schools of Architecture in New Orleans in 2004. This session led to a theme issue for the *Journal of Architectural Education* in May 2006.

Grouping the works thematically, we developed the structure of *Installations by Architects* and selected a short list of projects to illustrate each theme. Interviews with architects followed as we developed the major ideas we wished to explore through each project. The manuscript for the introduction was a collaborative effort; the chapters "Tectonics," "Body," and "Nature" were written by Sarah Bonnemaison; and "Memory," "Public Space," and the conclusion by Ronit Eisenbach.

We are grateful to the many architects who took the time out of their busy schedules to recall with us, on the telephone or in face-to-face interviews, projects from their early years in practice and to reflect on the value of their installation work. We especially appreciate the thoughtful reflections of Christine Macy, who helped us to develop the structure and sharpen the ideas included in the first four chapters of the book. Thanks also to Nat Chard, Richard Etlin, Dan Hoffman, Guido Francescato, Mark Robbins, Garth Rockcastle, Thomas Schumacher, and Diane Thompson for their insight and advice.

For assistance in the research and development phases, we would like to thank Jessica Braun, Brenda Margolis, Ryan Sullivan, and Shannon Young. We are grateful for the assistance of Anita Regan and Mike Fischer in obtaining images and copyright permissions.

The research phase of this project was facilitated by financial support from the Graham Foundation for Advanced Studies in the Fine Arts, Dalhousie University, and the University of Maryland. Research leave for Ronit Eisenbach was supported by the University of Maryland General Research Board.

We would like to thank Clare Jacobson for her early support of the project; our editor, Linda Lee; and Princeton Architectural Press for bringing it to fruition.

# Introduction

Over the last few decades a rich and increasingly diverse practice has emerged in the art world that invites the public to touch, enter, and experience the work, whether it is in a gallery, on city streets, or in the landscape. Influenced by early site-specific sculptures, happenings, and conceptual and performance art, these temporary works have become known as *installations*.

An installation is a three-dimensional work of art that is site-specific. In this sense it is very much art that aspires to be architecture. So what happens if an architect creates an installation? How is the work different from one made by an artist? The answer lies not in the work itself, perhaps, but in what it offers to the field of architecture.

For architects, installations are a way to explore architectural ideas without the limitations imposed by clients. An installation differs from a conventional architectural design in several ways: it is temporary, that is, its demise is planned from the outset; its function turns away from utility in favor of criticism and reflection; and it foregrounds the content. Architect and critic Mark Robbins puts it succinctly: "In some way, an installation is a distillation of the experiences of architecture."[1]

Like paper projects and competitions, installations allow architects to comment on and critique the status quo, and to imagine new forms, methods, and ideas in architecture. And as ephemeral constructions, they also offer precious freedom to experiment. Allan Wexler, an architect and an artist, says that installations allowed him to be experimental: "Things could happen quite quickly, and I could physically build them myself, they were inexpensive, they were small, I could then take a risk because it wasn't a huge endeavor, it wasn't a high cost. These could be self-motivated, I didn't need the client in order to get me started on a project. They were very nice, convenient devices to explore architecture in a reduced fashion."[2]

Constructed in a wide range of locations, installations reach diverse audiences and often generate conversations about the built environment. In the words of art historian Julie Reiss, "There is always a reciprocal relationship of some kind between the viewer and the work, the work and the space, and the space and the viewer."[3] The viewer's presence is an integral part of the installation, and Reiss believes it may be the most important aspect of this kind of work.

Installations have become a popular vehicle for teaching and research in university architecture programs. Early architectural research laboratories, such as Frei Otto's Institute for Lightweight Structures in Stuttgart and György Kepes's Center for Advanced Visual Studies at MIT, brought technological innovation into design research. Pioneers like Otto Piene, Friedrich St. Florian, and Eda Schaur produced very creative work in these environments. This type of research continues in such diverse institutes as the MIT Media Lab, the Center for Information Technology and Architecture at the Royal Danish Academy in Copenhagen, and Bartlett Faculty of the Built Environment in London.

Design faculty use installations as a mode of exploration in studios, seminars, and classes on construction and theory.[4] The pioneer in this respect was the Bauhaus, with its strong integration of craft, performing arts, and architecture; and, more recently, Cranbrook Academy of Art under the direction of Dan Hoffman, where architecture was taught through building objects and site-specific works.[5] Other programs, like those at Dalhousie University, offer courses and special summer programs dedicated to architectural installations.[6] Such courses ask students to connect ideas to objects, and to use their design and construction skills

top
Invited by György Kepes to be a
fellow at MIT's Center for Advanced
Visual Studies, Freidrich St. Florian
experimented with laser beams
and mirrors as a way to sketch out
volumes with light. Freidrich St.
Florian, *Imaginary Space*, Moderna
Museet, Stockholm, Sweden, 1969

middle
Students in a graduate seminar were
asked to design an installation with
critical content. This group took on
the custom of locking up Halifax's
Public Gardens at night and in winter.
In response, they decided to take the
park to the citizens. Asher DeGroot,
Dave Gallaugher, Kevin James, Jacob
JeBailey, *Walking the Park*, Halifax,
Nova Scotia, Canada, 2006

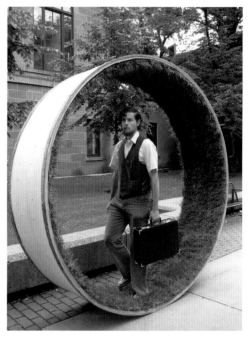

bottom
Ninety-nine garments collected from
students were hung around the piers
of a bridge under which homeless
people lived. Sacrificing privacy for
individual warmth, the residents
took the clothes piece by piece,
gradually altering the character of
the installation. Sara McDuffee and
Jessica Schulte, *99 Pieces of Clothes*,
Detroit, Michigan, USA, 2002

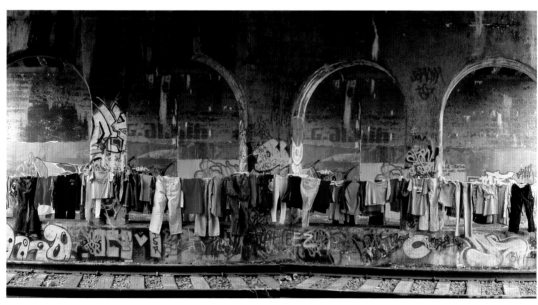

**top left**

*Dunescape* was a rolling landscape
of cabanas, locker rooms, and wading
pools much appreciated by museum
visitors in the heat of summer. This
installation became an important
reference for subsequent designs by
the office. SHoP, *Dunescape*, P.S.1
Contemporary Art Center, Queens,
New York, USA, 2000

**bottom left**

The 12,000-square-foot (1,200
square meters) environment, was
built of cut cedar ribs positioned
at shifting angles to create a
continuously undulating surface.
SHoP, *Dunescape*, interior view

**bottom right**

Working with wood and plaster,
Kurt Schwitters gradually trans-
formed his apartment to create an
environment that shared affinities
with the Dada and Constructivist
movements. Today, many historians
consider *Merzbau* to be the first
installation. Kurt Schwitters, *Merzbau*,
Hanover, Germany, 1923–43

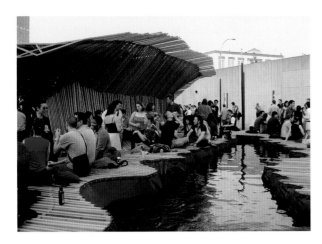

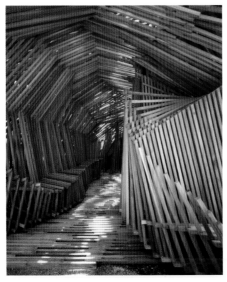

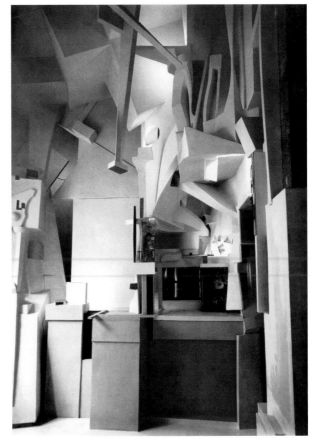

to actively and cleverly engage the public in a dialogue about issues they believe are important. Students must also take responsibility for the construction process and learn how to manage their time and materials. Once the piece is built, they experience firsthand the loose fit between intentions and interpretation. Ultimately, they acquire skills in social action and critical thinking, which they carry with them into their professional lives.

Installation design is integral to the practices of an increasing number of architectural firms. Like competition design, it presents an opportunity to explore ideas that can later be incorporated into built work. Christopher Sharples of SHoP, for example, suggests that the research ideas that have carried his office from one set of projects to the next originate in *Dunescape* (2000), an installation created for P.S.1 Contemporary Art Center in New York. The repetitive use of a standardized lumber module—a response to the fast construction process—and detailing strategies inspired by industrial design have both evolved into SHoP's subsequent design projects. For other firms, creating installations is a way to shift the focus from the built work to the design process. The London-based firm muf architecture/art has integrated installations and the events associated with them into its practice as a form of research and as a way to engage the community and provoke conversation with future users—in the designers' words, to "establish ambition."[7]

**Historical touchstones**

The term *installation* appeared in the fine-arts lexicon relatively recently. In the 1950s, artists such as Allan Kaprow described their room-size multimedia works as *environments.* Phrases such as *project art* and *temporary art* joined the term *environment* in the 1970s.[8] When this type of work became a major movement in the 1990s, there was a shift in terminology to the word *installation.*[9]

As we look at the history of installation practice, a number of projects stand out because of the powerful and imaginative ways in which they commented on the built environment. Early on, *Merzbau* by artist Kurt Schwitters carries a great artistic force. The project began in 1923, when Schwitters started to transform his apartment in Hanover, Germany, using a combination of collage, interior design, and sculpture built with rectilinear wood and plaster forms. This process went on for twenty years and eventually took over most of his home, filling rooms with grottos, caves, and pillars, and even spilling out onto the balcony. *Merzbau* was a walk-through environment that shared affinities with the playfulness of Dada and with the formal explorations of the Constructivists. Art historian Mark Rosenthal argues that the architectural elements of *Merzbau* illustrated an important aspect of installation art as it would subsequently develop: "[In this] overall environment with little or no escape route, the enchantment draws heavily on theatrical roots, the suspension of disbelief being chief among these. One witnesses an extreme vision of reality or may have the sense of being inside the artist's mind; indeed, a simulacrum of a consciousness is created."[10]

In Austria, architect and artist Walter Pichler created "wearables" that were three-dimensional expressions of individual perception in the age of communication technology. For example, in 1967, he presented the *Tragbares Wohnzimmer* (Wearable Living Room), a symbolically charged apparatus that extended the body by means of a television set. Together with Hans Hollein, he argued that architecture should be freed from the constraints of construction, and sculpture from the limits of abstraction. Pichler, often referred as a "practitioner of personal obsessions" created a commentary that is far from private in its search for archetypes. He built shelters to evoke the eternal, then organized art events to take place in and around them.

top left

Searching for archetypal forms, Walter Pichler drew and built chapel-like structures to shelter his figurative sculptures and create theatrical environments for performance art. Walter Pichler, *Houses for the Steles*, 1987, drawing

bottom left

*Resurrection City* was not a sit-in but a "live-in" that took place by the reflecting pool on the Mall in Washington, D.C. Tunney Lee, John Wiebenson, James Goodell, and Kenneth Jadin, *Resurrection City*, Washington, D.C., USA, 1968

top right

An architectural protuberance on a classical facade, *Oasis* was an "emergency exit leading people to another realm." Haus-Rucker-Co, *Oasis No. 7*, Documenta 5, Kassel, Germany, 1972

bottom right

A-frame structures built of plywood and cardboard housed the 5,000 people from across the country who came to advocate for policies helping the poor. Lee, Wiebensen, Goodell, and Jadin, *Resurrection City*, detail

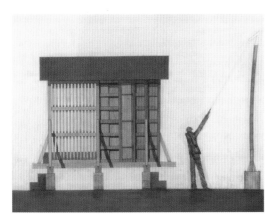

The architect Philip Beesley suggests that Pichler's "*Saint Martin* cluster had a great influence on the development of postmodern architecture, especially in Aldo Rossi's reworking of monumentality into a series of discrete formal elements."[11]

Also in Austria, the group Haus-Rucker-Co created a number of installations that took a critical look at urban life. The inflatable *Oasis No. 7* was built for the contemporary art show Documenta 5 (1972) in Kassel, Germany. The architects imagined the project as an emergency exit that leads from the museum's interior and becomes a pneumatic sphere emerging from its facade. The interior is a space for relaxing, with two artificial palm trees and a hammock strung between them. Like *Merzbau*, this project engaged intensely with an existing environment, offering a dream world nestled within it.

The use of inflatables was a popular approach for building installations in the 1960s. They were quick to erect, and the curvature of air-supported structures defied the rectilinearity of buttoned-down mainstream Modernism. In his book *The Inflatable Moment,* architectural historian Marc Dessauce traces a direct link between the accessibility of pneumatic structures and the grassroots protests of 1968: "Pneumatics and revolution agree well…they animate and transport us on the promise of an imminent passage into a perfected future."[12]

At the height of that year's student revolts, civil rights rallies, and antiwar protests in Europe and North America, the installation *Resurrection City* raised public awareness of the living conditions of the poor in the United States. Built as part of Martin Luther King's Poor People's Campaign, which was focused on economic justice, the project brought together four architects who provided the framework for a temporary city on the National Mall in Washington, D.C.[13] They also designed a set of simple components for A-frame buildings to house 2,800 protestors for two months—a large event that highlighted the political dimension of installations.[14]

In the 1970s many artists moved out of art galleries to create a public art movement. "We began thinking," says artist Mary Miss, "about the deconstruction of defined territories and disciplines and trying to put things back together in a different way."[15] She credits feminism with inspiring a shift in values and art practice—such as encouraging collaboration, expanding the art audience to include a wider public, and engaging viewers as active participants. She describes her work as grounded in the context of a place: she constructs situations where the visitor becomes aware of the site's history, its ecology, or aspects of the environment that have previously gone unnoticed.[16] In addition to Miss, artists such as Gordon Matta-Clark, Alice Aycock, and Christo and Jeanne-Claude introduced ways of working that would significantly impact subsequent installations.

The depressed economy of the 1970s forced many young architects to return to other modes of practice, such as paper projects, architectural criticism, and installations. The architectural firm Diller Scofidio + Renfro first achieved renown at this time with installations that explored their interest in technologies of vision, mechanical devices, and norms and aberrations. Only later did they seek larger, more permanent commissions. Ironically, as artists were beginning to leave the gallery, architects began to make their way into museums with drawings, models, and specially commissioned works designed for these institutional contexts. Mainstream art museums established architectural content as part of their programs, and the proliferation of architectural installations began in earnest. This allowed young architects to get their ideas into the public realm and participate in discussions about architecture.

Gradually, museum curators began to commission architectural firms to create installations for themed exhibitions.

top row
Rough wood panels with descending circular cutouts aligned if one stood in front of them (left); detail (right). Mary Miss, *Battery Park City Landfill*, New York, New York, USA, 1973

middle
In *Splitting*, Gordon Matta-Clark cut into a two-story house slated for demolition. As he and his partner painstakingly lowered one side of the house into the basement, a crevasse appeared at the center of the dwelling, letting a sliver of sunlight into the rooms. Gordon Matta-Clark, *Splitting*, New Jersey, USA, 1974

bottom left, right
The scale of the installation required years of planning and a lot of resources, but once installed, *The Gates* attracted thousands of people who saw the park in a different way. Christo and Jeanne-Claude, *The Gates*, New York, New York, USA, 2005, detail

The Wexner Center for the Arts, SF MOMA, P.S.1, and the Storefront for Art and Architecture in the United States; the Canadian Centre for Architecture and Jardins de Métis in Canada; Centre Pompidou and Archilab Orléans in France—to name but a few—are noteworthy for curating installations by architects.

**Our approach to the topic / selecting projects**

———

Since installations explore ideas through the design and construction of temporary environments, it is important to discuss the work presented in this book within a larger intellectual and theoretical context, a multidisciplinary context that includes psychology, philosophy, and geography.

Through an examination of the projects, we identified critical areas of discussion that could be grouped under the themes of tectonics, body, nature, memory, and public space. The decision to focus on these themes was not meant to be exclusionary but to reveal relationships between projects in terms of ideas, research topics, and communication techniques. Most of the projects shown here were developed with little knowledge of the others, but presented together in the book, they reveal shared concerns that are highlighted in our interpretation and commentary on the work.

Each theme is illustrated with eight to ten projects that were chosen based on their artistic merit and their varied connections with the theories and ideas that inform them. We interviewed the architects to find out more about their projects and the contexts surrounding their work. The resulting book brings together three sets of voices: the discussions of critics and theorists, our own interpretations of the installations, and the viewpoints of the architects who created the work.

The first chapter, "Tectonics," examines a wide range of experiments with new modes of assembly and materials. The second chapter, "Body," explores architects' ongoing engagement with the physical presence of people in the built environment, touching on topics as diverse as phenomenology and the gendering of space. The third chapter, "Nature," addresses the creative tensions between nature and culture. The fourth chapter, "Memory," includes installations that investigate the relationship between place and memory as society evolves. The fifth chapter, "Public Space," covers installations that are built on the street and explores architects' representations of, and public participation in, the public realm.

The fifty projects included in this book show a wide range of creative investigations. There is no doubt that installations have become a major mode of expression for the practice of architecture. We hope this book contributes to the role of installations in sharpening our critical understanding of the built environment.

# 1. Tectonics

"God is in the details," said Ludwig Mies van der Rohe with characteristic simplicity, neatly summarizing the Modernist belief that the expression of a building's construction could be an art. That well-considered assemblies of materials might elevate buildings to the realm of architecture was a revolutionary idea at a time when architectural artistry was exclusively reserved for facade composition and plan organization. Modernism revived and elevated the art of construction.

The term architects use to describe their interest in construction details is *tectonics*. The word *architect* itself is derived from this term, which suggests that tectonics is at the very core of the profession. Originally derived from the Greek word *tekton*, which referred to an artisan working with hard materials, the meaning of the word evolved around the fifth century BCE, according to Kenneth Frampton, changing "from something specific and physical, such as carpentry, to a more generic notion of making, involving the idea of poesis." Eventually, he continues, "the role of the *tekton* led to the emergence of the master builder or *architekton*."[1]

Tectonics has maintained a central place in the discipline as architects innovate with new materials and assemblies. This type of exploration is usually investigated with a full-scale "mock-up," which has a long tradition in architectural offices and can be tested for strength and performance or evaluated for appearance. Architectural installations that take tectonics as their subject build on this tradition. Although every architectural installation necessarily involves tectonics, the projects selected in this chapter push the boundaries of materials and assemblies. They are organized into themes that have historically interested designers: tectonics and materials, tectonics and ornament, and tectonics and the immaterial. The projects that follow range from building elements, such as columns or facade skins, to complete enclosures, such as pavilions.

# 1.1 TECTONICS AND MATERIALS

It would be difficult to speak about tectonics without referring to the contribution of the nineteenth-century German architect and theorist Gottfried Semper. Semper was interested in the simplicity of construction found in vernacular buildings in a wide variety of cultures. Rather than looking to the temples or tombs of Greek and Roman antiquity for inspiration, Semper turned his attention to the construction techniques used by non-Western cultures and in vernacular buildings. The result of using ethnographic references, according to architectural historian Sigfried Giedion, was a theory of architecture grounded in "an eternal present."[2] Vernacular constructions offered Semper a way of seeing outside the typical nineteenth-century understanding of architectural history as a progression of styles or an evolution of construction technologies. This was especially important at a time when industrialization was rapidly transforming modes of construction and architects were struggling to understand the implications of that transformation. Semper was among those who wanted to develop building systems that used industrial processes of manufacturing and found inspiration in the construction techniques of so-called primitive architecture.

Semper analyzed many methods of construction from countries as different as Tanzania and Japan, but he anchored his theory of tectonics on a Caribbean hut that he saw reconstructed in London for the Great Exhibition of 1851. His detailed study of this construction allowed him to develop a taxonomy that differentiated between heavy *earthwork*, lighter *framework*, and *enveloping enclosures*. He also related these categories to their respective crafts: heavy masonry, for instance, was associated with bricklaying, earth forming, and stonecutting; and wood (which works well in tension) with weaving, basketry, and textiles.

The first three projects discussed here can be interpreted using Semper's material categories as they rework vernacular traditions of construction. Mark West's fabric-formed concrete rediscovers concrete as a liquid material, revealing its astonishing capacity to mimic biological forms. Filum Ltd.'s *Gestures* uses traditional boat-construction techniques to transform laminated wood into continuous curves. While Semper's century was transformed by mechanized production, today digital media has brought an equivalent transformation in building design and production. *Gesture* employs motion-capture technology to reveal the shapes created by human movement. Finally, while decorative forms inspired by nature were seen to compensate for an overly mechanized world in Semper's era, today materials and assemblies are evaluated in terms of sustainability. Richard Kroeker's recycled phone book pavilion explores the structural and aesthetic potential of materials pulled out of the waste stream.

## Mark West, Fabric-formed concrete, 1991–2006 (see pp. 28–29)

Concrete—an amalgam of gypsum, clay, limestone, sand, and crushed stone—would be categorized as earthwork under Semper's classification system. Yet, while Semper associated earthwork with cutting and laying down masonry walls, concrete construction involves a very different craft process, using wooden forms to create a negative space into which liquid slurry is poured. Although concrete is one of the most widely used construction materials in the world today, its use in developing countries is limited by the cost of the formwork. This was one of the initial impetuses behind using fabric as formwork in West's experiments in concrete. Because of the lack of precedent, "the work has been as much invention as research. These two activities necessarily went hand in hand as problems were confronted and solved," West remarks.[3] Although fabric formwork has

been used since the 1960s for the submerged piers of large bridges, West's experiments focused on visible architectural elements such as columns, beams, vaults, and slabs. And by employing textiles that stretch and deform as they are filled with wet slurry, he maximized the plasticity of concrete.

West began his tectonic explorations with small-scale concrete forms cast in soft membranes. Concrete poured into a tube assumed the shape of a garlic bulb, but when poured into a tube with ties placed intermittently along its length, bulges formed between the restraints. This discovery resulted in the installation *Pressure Buildings and Blackouts* (1991)—exhibited at the Storefront for Art and Architecture in New York—in which amorphous concrete shapes projected onto the street through cutouts in the wood-paneled storefront. All the tubes used to generate the protruding shapes were made from simple, flat sheets of fabric without complex tailoring. All the resulting curves were a product of a negotiation between the fabric and the heavy, wet concrete. Like the disassembled dolls of Surrealist Hans Bellmer, disarticulated limbs oozed and drooped from the Storefront wall to casually flop on the sidewalk.

When West increased the scale of his experiments, he created a series of nine- to twelve-feet-tall (three to four meters) columns (1992) for the College of the Atlantic in Bar Harbor, Maine. The ties around the column acted like the girdles workmen wear to support their lower backs: the ties helped the columns become structural at their tops. For West, this "entasis has to do with the bulging of the columns when [they are] in compression both at the top and bottom."[4] Associations with the body were constantly present, which was "not a coincidence" but a "co-incidence [that] played out in a really graphic way."[5]

The exceptionally smooth and sensitive finish of the columns was the result of a permeable membrane that allowed air and water to bleed out gradually, leaving a cement-rich paste at the surface of the form. This meant the surface was a great deal more receptive and exact in its imprint of the formwork.[6] Once the concrete was dry, even the most delicate threads in the seams left their imprints in the cement paste, which gave stitching an important place in the final aesthetic of the columns. Critic Kenneth Hayes remarks that West's pieces often have "a particular quality between buoyancy and tumescence that evokes some strange underwater garden."[7]

The intuitive way in which shapes emerged from the pour belied the rigor of West's research process, which involved methods derived from both the fine arts and the laws of nature. In 2002 he established the Centre for Architectural Structures and Technology (CAST) at the University of Manitoba for the research and development of fabric formwork, and several years later he was invited to Open City—renowned for its experimental architecture—in the town of Ritoque, Chile, to introduce the techniques he had developed. Once there, he found that "everything [was] incredibly restricted because they have no actual roads—everything is just sand."[8] West decided to use standard construction tools and easily transportable materials. During his residency in 2006, West and his team experimented with embedding columns in wall surfaces and cutting openings in plywood sheets through which fabric-restrained concrete bulged out, creating reliefs. These reliefs added structural strength to the walls and acted as buttresses. *Bulge Wall* was repeated to create a new support building for the athletic fields of Open City.

**Filum Ltd. (Sarah Bonnemaison and Christine Macy),** *Gestures*, **Halifax, Nova Scotia, Canada, 2006** (see pp. 30–31)

———

The next two installations illustrate experiments in the tectonics of *framework*, which Semper associated with wood and iron

framing, particularly of roofs. In *Gestures*, the design-research office Filum Ltd. moved framework away from strictly angular geometries and toward complex double-curved forms. The installation, commissioned by the Maritime Museum of the Atlantic on the Halifax waterfront, was composed of two pavilions inspired by the nautical world. The curvilinear forms were derived from familiar sights on the waterfront, such as a flag waving in the wind and a sailor fastening a rope on a cleat. A dancer translated these mundane gestures into a dance that was digitally recorded through motion capture.[9] The designers then modified the traces of movement using the modeling program Maya and selected portions of the dance to form a structural framework for the pavilion. Stereolithographic models of the digital design served as templates for study models at a larger scale. Architecture students, closely following these large-scale models, carried out the actual construction of the pavilions.

Under the supervisory eye of experienced boat builders from the museum, and with the guidance of professors Sarah Bonnemaison and Christine Macy, students employed the traditional woodcrafts of boat building: steam bending, lamination, riveting, joinery, and net making all contributed to the final constructions. The material used was locally harvested white oak that had been milled into ribbons of varying thicknesses and widths. Although the lumber was freshly cut, it still needed to be steamed to increase the moisture content so it could be bent to the desired radius. The layers were then glued and riveted together to increase the mechanical bond and secure the curvature in place.

Making *Gestures* allowed the designers to experiment with materials, using the direction of the wood's grain to take full advantage of its strength and elasticity. Strips of oak were taken from the steam box and gently coaxed into shape, staggered, and reinforced with finer laminations in between the layers when necessary. The graduated thicknesses

of the finished members revealed differences in loading: the primary members were constructed with three laminations and the secondary members with two plies of narrower stock.

The differing curvatures of the wood expressed the forces that followed the twists and turns of the thin material in the same way compressive forces follow the curves of an arch. Semper's ideas about framework and enclosure took on lives of their own as they revealed the traces of the movements that were the origin of the form. The points where the pavilions met the ground evoked, again, Frampton's reading of Semper: "Semper's emphasis on the joint implies [that] a fundamental syntactical transition is expressed as one passes from the stereotomic base of a building to its tectonic frame, and that such transitions are the very essence of architecture."[10] In *Gestures*, the transition between the concrete footing and the wooden framework was clearly expressed in the way each was adapted to receive the other, both structurally and visually.

**Richard Kroeker, *Phone Book Shed*, Sackville, Nova Scotia, Canada, 2005**
(see pp. 32–33)

———

The third project addressing tectonics and materiality explores Semper's ideas of enclosure, with the significant new dimension that the materials employed were neither new nor industrial, but reused and recycled. Architects have begun to adapt and reuse not only older buildings but also building parts and even the residues of industrial processes—as we can see in work of offices such as Ant Farm in the 1970s to Lot-Ek today. Similarly, Richard Kroeker's thought-provoking *Phone Book Shed* made use of materials diverted from the waste stream.

The project began with an inquiry into the fate of the millions of telephone directories that are thrown away each year. Kroeker and his students explored these books'

potential for load bearing, insulation, and construction assembly. "The phone book is something that everyone is familiar with," says Kroeker. "There are thousands of them thrown out every year when the phone company comes and brings in a new phone book for the year. It occurred to me that they're more or less a building block."[11]

The outcome of the project was a small pavilion built out of seven thousand phone books and placed adjacent to a recycling depot in a suburban community in Nova Scotia. The phone books were ganged together into load-bearing wall sections using straps and threaded rods. To create a beam, two layers of books were assembled with a metal strap running along the top and bottom. Kroeker was skeptical about this model, but pleased to find that it worked. With the addition of tar-paper on the roof and building wrap on the walls, the building achieved an estimated insulation value of R-20. For the exterior rain screen, Kroeker interpreted Semper's notion of textile cladding literally, employing thin spruce lath woven into basketlike panels.

The installation captured the public imagination, and articles and radio interviews described the value of using recycled materials to build shelters. It spoke about the power of invention, but it also carried within its walls the names and addresses of people from the entire Atlantic region. An apparently simple shed was invested with a deeply poetic gesture, simply by using bricolage to transform the debris of modern society into a meaningful tectonic.

# Mark West

—

**Fabric-formed concrete**

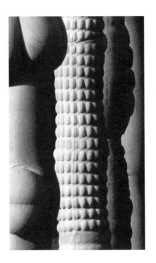

*"On the street people stopped. They looked, walked toward it, and then they reached out with their hand and touched. They were always surprised that it was hard, not soft. It happened all the time."*

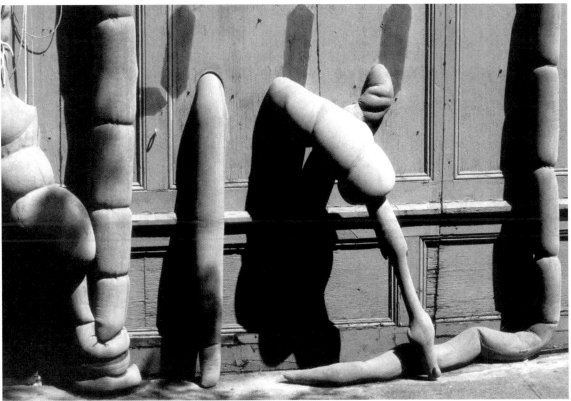

top
West, *Pressure Building Studio Constructions,* Carlton University, Ottawa, Ontario, Canada, 1992

bottom
West (with Victoria Jolly, Miguel Equem, David Jolly-Monge), *Bulge Wall*, Open City, Ritoque, Chile, 2006

*"The form decides what it wants to be— it physically makes itself."*

*"It is a sculptural play, but you have to get serious about where the reinforcement is, so you get ready to do a building."*

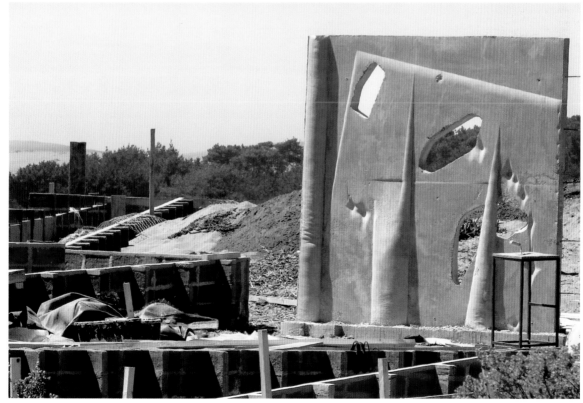

# Filum Ltd.

*Gestures*

top left
The structure was exhibited in the courtyard of the Maritime Museum, near the boat sheds. Its compound curves made new demands on materials and technology traditionally used in the craft of boatbuilding.

top right
Tracings of the dancer's movements recorded on a motion-capture stage (top); tracing of the choreography translated into a computer model (bottom).

bottom
Panoramic photomontage taken from the interior of the structure shows the continuity of line derived from the dancer's movements.

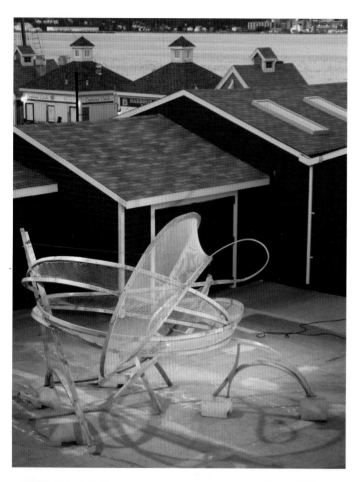

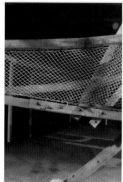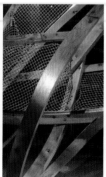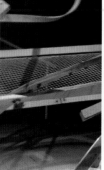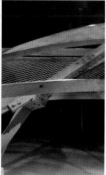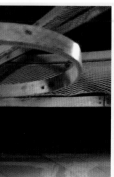

top left
The knot, an element of *Gestures*, shows how pliable green oak could become after steaming. Riveting also added mechanical strength to the lamination.

top right
Intersection of the laminated wood members and the tensile surfaces of the net

*"People come in the museum and find it easy to understand—motion leading to design, leading to something that is concretely there."*
*—John Hennigar-Shuh, director of the Maritime Museum of the Atlantic*

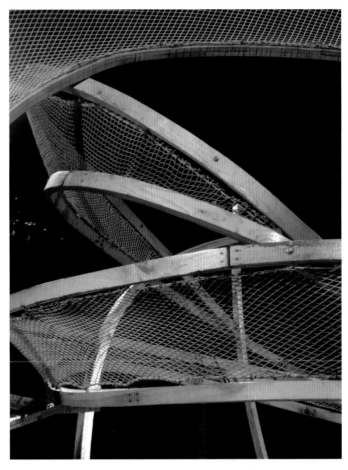

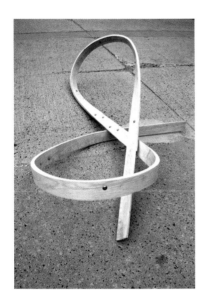

# Richard Kroeker

*Phone Book Shed*

below
The walls of the shed, made of stacks of phone books, were protected by a woven rain screen.

opposite top
East-facade view of the porch and the entrance showing how different types of rain screens protected the walls

opposite bottom
Both the load-bearing walls and the beams were built with discarded phone books.

*"I did not think it would work but it did!"*

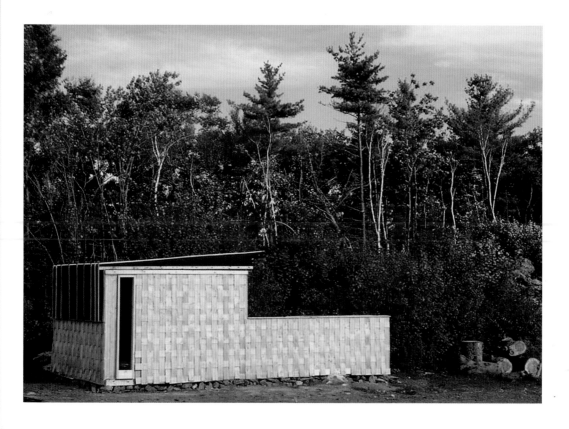

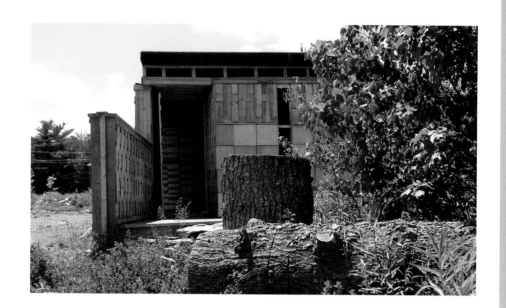

## 1.2 TECTONICS AND ORNAMENT

In the early nineteenth century, the architectural theorist Karl Bötticher proposed a philosophy of tectonics based on the relationship between ornament and structure. Bötticher envisioned an "armature of material and structural forces represented by an explanatory language of Greek ornamental forms. This reformulation of aesthetic ideas, coupled with [a] related advocacy for the visible expression of iron structure, had great significance for the pursuit of a system of architectural knowledge in modern Germany."[12] With great intellectual clarity, Bötticher divided the field of architectural forms into two groups: *art forms* and *work forms*. Art forms included ornament, a concept that helped him support his theory that tectonics was an intrinsic and necessary expression of the underlying hidden structure of the building. Bötticher viewed work forms as having a central role since they perform the material and static tasks of a building. Work forms as such are never seen in architecture, since they are always "clothed" in art forms. They are deduced from existing forms by a process of abstraction.[13] In this context, any connotations of ornament as superfluous are obliterated. Architectural theorist Caroline van Eck explains that "although art forms do not contribute to the material solidity and fitness of a building, they do have another important role. Thanks to their expressing and characterizing the invisible structural functioning of the building, the dead stones are transformed into a living work of architecture. Without such forms, the way in which the static forces work upon a building would seem dead: art forms are the visual language of tectonic forms."[14]

The idea of expressing structural forces through ornament endures through early-, high-, and late-Modernist architecture. The visible steel on Mies van der Rohe's buildings, for example, serves no structural function but is there merely to express the hidden steel structure within—an instance of art form directly representing work form. The skeletal armatures of Santiago Calatrava, by contrast, unite ornament and structure into one.

The following two installations illustrate Bötticher's argument for the tectonics of ornament. The first, by Mette Ramsgard Thomsen, falls squarely within this tradition. In Thomsen's work the role of ornament is taken by the expressive responsiveness of her textile structure to its viewing audience. The second installation, by Evan Douglis, challenges the relationship between ornament and structure, focusing instead entirely on the tectonics of adornment.

### Mette Ramsgard Thomsen, *Vivisection*, Copenhagen, Denmark, 2006 (see pp. 37–38)

As buildings are increasingly equipped with sensors, actuators, and other technologies that make up the "smart home"—a home that automatically responds to changes in ambient temperature and light for the comfort of the residents—architects have begun to create responsive architecture. This field of inquiry goes beyond thermostats that regulate heat-ing or air handling within a building and sensors that trigger lighting, sprinkler, or security systems. In order to increase the building's response to temperature, light, and so on, architects have begun to explore new ways of integrating communication technologies and robotics into structures and building materials.

The installation *Vivisection* is the result of research in this area at the Centre for Information Technology and Architecture (CITA) at the Royal Danish Academy in Copenhagen. Its designer, Mette Ramsgard Thomsen, is an architect and computer-systems engineer who researches the integration of technology into architectural textiles. Over the past two decades, textiles have been at the forefront of smart materials. Digital technology has been worked into woven, pleated, and knitted fabrics using conductive

threads, microprocessors, and materials that change color, emit light, or contract in response to electric current. With *Vivisection*, developed in collaboration with designer Simon Løvind, Thomsen explored how moving parts, triggered by a series of sensors and actuators, can become ornaments for an architectural textile.

As visitors approached the installation in a gallery of the Charlottenborg Museum in Copenhagen, the delicately suspended diaphanous fabric "breathed" in response to their movements. The structure mimicked the behavior of an organism in the way it acted and reacted to humans.[15] Miniature robots not only triggered movement in the fabric but also adorned its surface. The finely woven silk-and-steel textile conducted electric current across the entirety of its surface, making it a "sensing skin" that, when coupled with antenna-equipped sensor chips, was able to detect the presence of viewers. When the sensor chip was connected to the fabric, the material was able to register changes in the magnetic field around the antennae. As visitors touched or passed underneath the fabric, they triggered sensors that relayed information to a small network of microcomputers, causing fans to be switched on to inflate three airtight chambers. The chambers acted like lungs, altering the shape of the structure with each inhalation and exhalation.

Instead of conceiving of a distributed system as an aggregate of discrete units, Thomsen created a singular membrane with multiple levels of agency. Each "cell" or microcontroller bridged input with action, each reacting independently to changes in its environment. Nonetheless, the breath of the "organism" as a whole was created by the collective—generating complexity through overlay.[16]

Finally, the entire system was suspended in space by a network of lines fed through pulleys and counterweighted on one side of the gallery with fishing weights. As the structure altered its shape in response to visitors' movements, it triggered corresponding up or down movements in the weights along the gallery wall, giving visitors a linear registration of the complex changes taking place.

*Vivisection* reincarnates—in an original form—Bötticher's idea that decorations are an extension of the forces embedded in the structure. In this case the structural forces of the textile were extended through counterweights attached on long strings, while electric force fields were extended by electronic antennas and sensors that activated the decorative robotic elements.

### Evan Douglis, *Auto Braids*/*Auto Breeding*, New York, New York, USA, 2003 (see pp. 39–41)

The introduction of computers in design and manufacturing has provided architects with a seemingly inexhaustible array of new forms. Much like the nineteenth century's integration of industrial machines into the decorative arts—so beautifully solved by Arts and Crafts designer William Morris—today's CNC routers, plasma cutters, and precision casting machines have opened up new possibilities for production. But if the value of industrial machinery was to repeat the same pattern indefinitely, the value of digital production is the variation of forms according to algorithms or other input data. Contemporary design software also works with non-Euclidian geometries, such as fractals, which allows designers to create highly complex intricate patterns. The installations of Evan Douglis are emblematic of this revival in geometry, tiling, and patterns.

In his work Douglis elaborated on the Postmodernist argument that meaning is brought to a building by decorating its skin—an argument first put forward by Robert Venturi and Denise Scott Brown in their book *Learning from Las Vegas*. In the information age, Venturi explains, "what is beautiful is not the sculptural effects of the architecture but

the signage on the form."[17] Additionally, Scott Brown remarks,

> As we were beginning to study Las Vegas, I began to realize that the decoration over a doorway was a much more direct way of signifying in architecture than distorting the whole building to make it look modern. We're interested in the notion of doing architecture in a plain, straightforward way, then putting an appliqué of message on the outside. In the end that's more direct than distorting the structure and function of the building to convey a message.[18]

In this spirit, Douglis's *Auto Braids/Auto Breeding* added complexity and visual interest to an architectural surface.[19] Essentially a "displayscape" for an exhibition of Jean Prouvé's prefabricated and modular designs, the installation was a long carpet of undulating waves unfolding along the floor of the gallery, with a passageway at the center through which visitors traveled to reach the opposite side of the exhibition. As the undulating "tiles" lifted off the ground plane to form the tunnel, they appeared to be acted on by gravity—if one looked closely, they deformed ever so slightly as one's eye traveled over the waves. The reason, says Douglis, is "you have to sustain variation."[20]

During his design process, Douglis shuttled back and forth between physical and digital modeling. Digitizing the rubber units with a three-dimensional scanner, he imported them into the Maya modeling program to explore how they nested in the field and deformed with surface transformations. Although the finished installation appeared to be a celebration of digital design and production, physical modeling was an important step in Douglis's development of this tectonic language. He remarks, "I like working with physical materials because they have a certain

resistance."[21] In fact, he likened the process of forming the units to "producing Chinese dumplings."[22]

The intricate shapes of the sixteen different modules of the installation were sculpted out of foam by using a five-axis CNC milling machine equipped with a 360-degree rotary head. The modules were hand sanded until smooth and then lacquered with twelve coats of sky-blue auto-body paint, creating the luscious high-gloss finish associated with consumer products, pop art, and, more recently, the anime sculptures of Takeshi Murakami. As with Bauhaus design, the illusion of machined perfection was accomplished through exacting manual craftsmanship.

By designing this surface specifically as a backdrop for a display of the work of Prouvé, Douglis created a contrast between the stripped-down functionalism of canonical Modernist design and the luxurious ornamental possibilities of contemporary computer-driven design. He proposed *AutoBraids/Auto Breeding* as an homage to Prouvé's use of cutting-edge technology and his development of modular systems for mass production, saying: "A full circle is finally achieved with the arrival of Prouvé's artifacts, paying tribute to the timelessness of his work and the relevance of his ideas for a new generation."[23] Yet while Prouvé's buildings always expressed the static forces of the supporting structure, Douglis challenged the traditional separation between structure and ornament by focusing on the surface and discarding the rest. The hidden reality was that the structure of his installation was supported by aluminum and medium-density fiberboard, but it was visually suppressed. The glossy ripples of his surfaces are the art forms of his tectonics. They speak of the promise of flexibility, variation, and digital mass customization in lip-lickingly glossy surfaces.

# Mette Ramsgard Thomsen

### *Vivisection*

top
The lung was constructed like a box kite with chambers. Diagram describing the multiple systems

bottom
Movement sensors triggered inflated chambers to change the shape of the hovering cloudlike fabric structure.

*"The three lungs were independent, but they knew about each other."*

*"My research focused on building an installation that had qualities of an organism."*

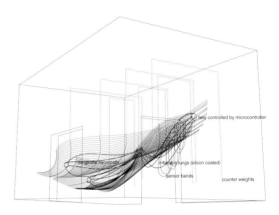

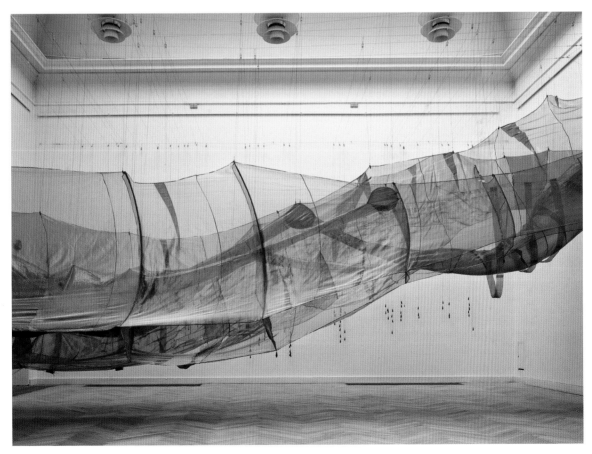

top

The same fabric of woven silk and steel threads was used for the entire structure, but some areas were structural, some conductive, and others airtight. The black dots in the background were fishing weights strung together to act as counterweights to the sculpture.

bottom

Computer chips were fed electricity through the wires embroidered on the fabric.

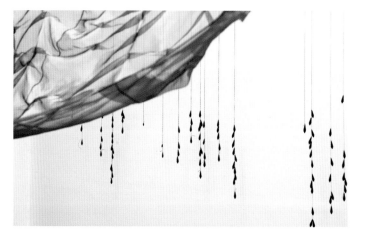

# Evan Douglis

### *Auto Braids/Auto Breeding*

Installation view

*"I am really fascinated with the question of excess—this is almost Rococo. There are subliminal codes embedded in the work that can be received in many different ways."*

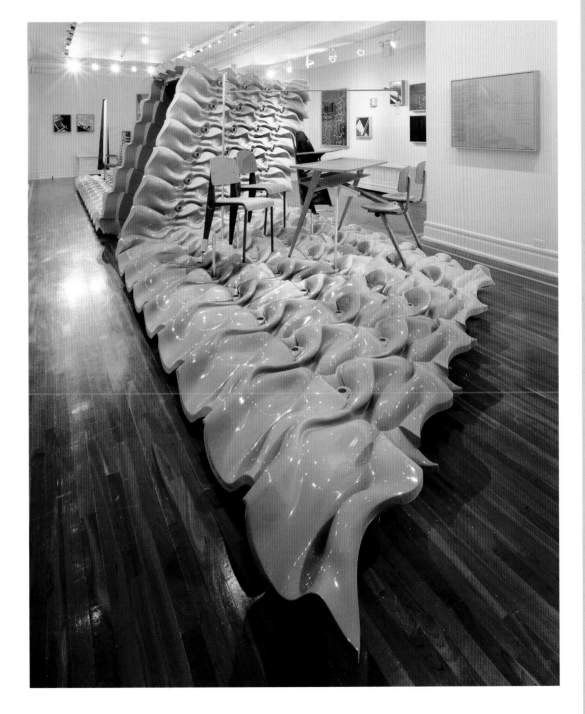

top
Computer drawing showing
the various components and
their relationships to each other

bottom
The CNC router carved away the foam
to create the modules.

opposite
The Prouvé pieces were embedded in
the blue field of *Auto Braids*.

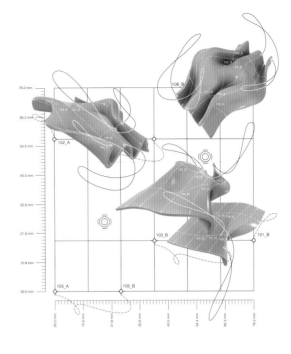

*"In the computer I explored how
the unit nests in the field."*

*"I like working with physical materials
because they have a certain resistance."*

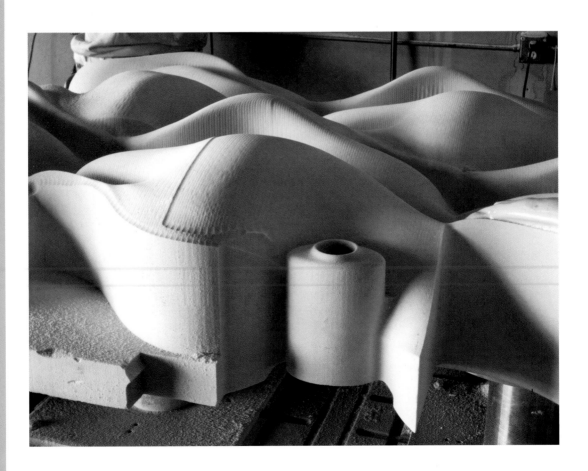

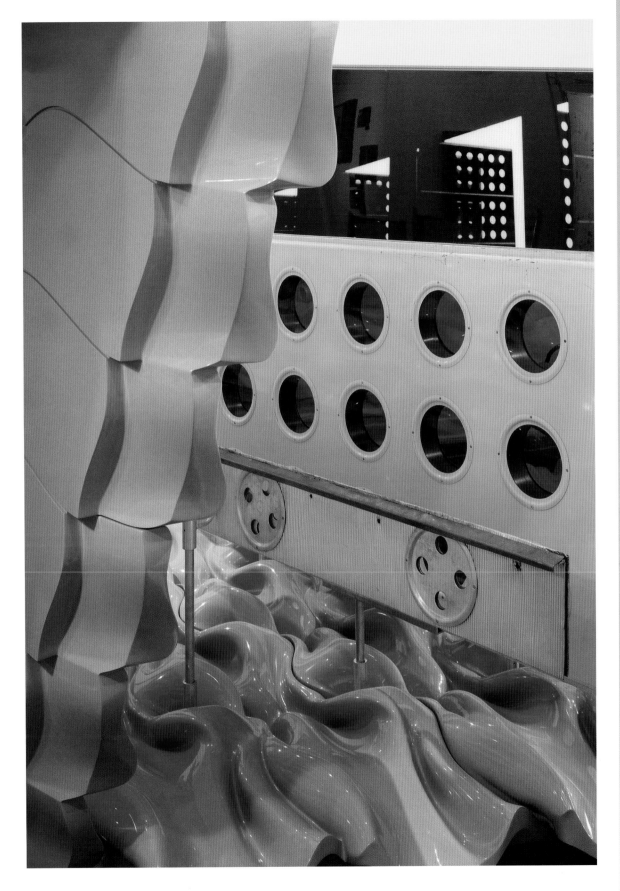

## 1.3 TECTONICS AND THE IMMATERIAL

It may seem a contradiction to link tectonics—which is about making—to the notion of immateriality. Yet architects have long explored the art of construction in order to reveal and celebrate immaterial forces: such as with the extreme dematerialization of masonry of Sainte-Chapelle in Paris that celebrates light. Architecture, as Le Corbusier reminds us, is "the masterly, correct, and magnificent play of masses brought together in light. Our eyes are made to see forms in light; light and shade reveal these forms."[24] The next three installations are about architecture's intersection with the sublime.

### Chris Bardt, *Sun Box*, Providence, Rhode Island, USA, 1995 (see pp. 46–47)

A garden sundial reminds us of the connection between time and the rotation of the earth. In the most familiar design, the sun's trajectory over the course of a day casts a moving shadow on a flat tablet inscribed with the hours. *Sun Box* was the product of Chris Bardt's commission to build a sundial for the Convergence Arts Festival in Providence, Rhode Island, in 1995. Long intrigued by the movement of light across a room, Bardt created a box in which the light of the sun, not the shadow of a gnomon, would mark the passage of time. He designed the locations and sizes of the apertures into the thirteen-foot-high (four meters) box so that the path of the sun would cast sunspots at specific locations on the ground corresponding to set times of day. The dim environment inside the box created sufficient contrast for onlookers to see sunspots generated by the openings. "This is comparable," he says, "to the difference between looking at a clock and hearing it ring."[25]

Constructing a sundial brings two worlds together: celestial geometries intersect terrestrial, material conditions. The primary goal of *Sun Box* was to translate celestial data into a tectonic strategy, to make a construction of sunlight from a "drawing" of the sun's motion.

Bardt's tectonic concern was to determine the necessary depth of each opening in the wall and to calculate the location and quantity of light allowed to fall on the ground. Fins projecting into each opening altered the size of the aperture, much like a shutter of a camera. The fins prevented light from spilling onto a neighboring opening, and their angle and depth created a meticulous record of the changing path of the sun over the course of the year. Some of the openings allowed the sunlight to penetrate five minutes a day, while others provided hourly or monthly markings.

The tracing of time through apertures in a building is one of the oldest purposes of architecture—from the burial chambers of ancient Egypt to the Sun Dagger of Chaco Canyon or Hadrian's Pantheon in Rome. Who has not watched a skewed rectangle of sunlight slowly moving across a floor and been aware of the slow passage of time as these light paths inch their way over the seasons?

But it was not its practical dimension that attracted the many onlookers who gathered during the installation of *Sun Box* in Roger Williams Park. Rather, says Bardt, these people came "to witness light falling through onto its markers—making an event of something that has become inconsequential— [suggesting] that forgotten relations between earth and sky, light and time, may still have a place in architectural work."[26]

### James Cathcart, Frank Fantauzzi, and Terence Van Elslander, *Resistance*, Grand Rapids, Michigan, USA, 1990 (see pp. 48–49)

*Resistance* did not call on the powers of the sun but on the power of electricity: the modern energy source to generate light. The goal was to make visible the amount of electrical power that can be harvested in a building

by running all the electrical current through resistance wires, which became bright red when current flowed through them.

The three architects were invited to a weeklong residency in the gallery of the Urban Institute for Contemporary Arts in Grand Rapids, Michigan. It was a typical white-wall gallery, with maple floors and an immense electrical grid on the ceiling. Next door, there happened to be an electrical substation, where electricity was being parceled out to the houses of the neighborhood. Influenced by the Situationist International, Cathcart, Fantauzzi, and Van Elslander applied the idea of the situation to architectural installations. The group decided to follow a set of rules: to come to the site of the future installation without any preconceived solution in mind, to limit the introduction of new materials, and to minimize repetition.

The designers began by hanging wires from the electrical grid with the intention of redirecting all of the building's electricity into the gallery. As each circuit reached its maximum load, they rerouted additional circuits from the building into the gallery until all available power was harnessed. "It was like a parasite that took all the energy from the building," Fantauzzi writes. "In the end, we were able to activate most of the outlets and calculate the resistance of the building to the electricity coming into it as 13.739 ohms."[27]

The resulting installation was made of thirteen-foot-long (4.3 meters) Nichrome resistance wires hanging throughout the space. Nichrome wire—found in toasters and hair dryers—is made of nickel-chromium and offers a great deal of resistance to the electricity passing through it. As a result, it generates heat and glows with a deep red color. When the current was turned on, the harvested electricity transformed the vertical wires into thin, red columns dispersed through out the space.

Unfortunately, the heat expanded and contracted the wires hanging in the gallery. In order to maintain their tension, they needed to be weighed down. The group attached plastic bags filled with water, which then moved up and down with the contraction and expansion of the wires. "There was something powerful and strange about water that is close to electricity. If [the bags] had burst, it would have activated the entire floor," Fantauzzi comments. He continues:

> The wires generated an enormous amount of heat. You felt like you were in a toaster. It was an incredibly intense experience. You turned it on and then within minutes you would heat up slowly. You had the feeling like you were compressed by heat. Your body would feel strange, almost atmospheric. There was no need for lighting. There was a sensuality and beauty that goes way beyond the scary part. What does it meant to coexist in a space like that under those conditions?[28]

**Kourosh Mahvash, *Albedo*, Halifax, Nova Scotia, Canada, 2002** (see pp. 50–51)

———

In the early part of his career, the German architect Karl Friedrich Schinkel suspected a link between construction and spirituality: "Architecture could not represent directly the infinite and the eternal. It can only refer to it by a profound spiritual and organic unity achieved in the design."[29] For millennia, architects have expressed spiritual immateriality in architecture by filtering or controlling sunlight. In his postgraduate thesis in architectural research at Dalhousie University, Kourosh Mahvash proposed the new idea that electric light could be as spiritually moving as natural celestial light. With simple materials including fluorescent tubes and fishing wires, Mahvash created seven distinct and interconnected environments that illustrated the spiritual path of Sufism.

Mahvash constructed and revealed his installation over a seven-day period, based on the astrological configuration of the moon on these particular days. The title of his work, *Albedo*, refers to the faint but highly

directional reflectivity of the sun's radiation on an astral body. The shimmering emanations retain a mere hint of the sun's original power. In the hands of Mahvash, Albedo became a metaphor for the spiritual awareness in the Sufi belief system: all the world's manifestations are but weaker reflections of the prime creative force of God. The seven-day period corresponded to a Sufi conception of the seven stages of spiritual enlightenment. Each stage had a specific color associated with it: the first is dark gray, the second blue, then red, white, yellow, and luminous black. The last and highest stage—when one reaches the Truth of one's being—was represented by the color green.

These seven stages relate to seven major Prophets of Semitic monotheism. When one reaches the truth of one's being, one has become the universal prototype. In other words, one has been transformed into the Muhammad of one's being. These seven Prophets and seven stages correspond to seven colors, described differently by various orders.[30]

The installation took place in a long corridorlike space painted entirely black, a blank slate for the gradual introduction of colored light—one color dominating each day of the installation, with a small residue of the previous day's color to indicate what one had already experienced. The sources of light, gel-wrapped fluorescent tubes, were concealed, but the light was captured by the shimmering surfaces of the nylon fishing lines that formed the undulating walls.

The walls created by fishing lines were set according to a pattern that inscribed the movement of the moon on that day and in that place—making the work site-specific. The location of the moonrise and moonset in Nova Scotia, and the points of transit between the two, provided the geometrical information that determined the configuration of the luminous wall. As the trajectory of the moon changed each day, the resulting shapes of

the luminous walls in the room were altered accordingly. This meant that the installation was entirely transformed each of the seven days the space was opened to visitors.

For Sufi mystics, says Muslim author and translator Laleh Bakhtiar:

> Light is a manifestation of Divine knowledge; and so, when these cosmological symbols are transferred to the microcosmic plane, the soul of the mystic is symbolized by the moon, which reflects the light of the sun. The ray of light that passes between them is the symbol of the intellect, and that light which is reflected by the moon symbolizes the spiritual institutions of the mystic.[31]

Each day, visitors to the installation experienced a gradual progression from darkness to light, and from lowliness to elevation. The stages of that progression were formally characterized by the construction system. The result was a unified experience of spiritual and structural unity conveyed by a single set of tectonic principles.

The magic of this installation was its ability to manifest light solely through reflection. While *Sun Box* and *Resistance* displayed the actual paths of sunlight and electricity, *Albedo* addressed the philosophical dimension of light through a layering of reflections: the path of the moon was traced onto the earth, and these tracings were then represented by colored electric light, again reflected off hundreds of filaments stretched in the room. This was an attempt to depict the mysterious albedo through the simple means of electrical light and wires—a phenomenon dear to Sufism as one sees the refraction of light and not its source.

There are many ways to explore contemporary issues of tectonics—from building materials to ornament and the immaterial. Tectonics is core to the practice of architecture, and theories of tectonics are always revisited as construction technologies and aesthetics evolve. If Semper and Bötticher

were key actors in working through these issues during the industrial revolution, contemporary thinkers and practitioners are now confronted with digital design, waste, and global warming. The next chapter turns away from materials and modes of assembly as the primary focus of the installation and moves toward the relation between built materials and the human body.

# Chris Bardt

*Sun Box*

*"The longer we were there, the more we were accepted. The tough kids got used to it; they began to own it. There was one place to squeeze in, and people found it right away."*

*"To put a door would be a whole different thing. When you get inside, you change to viewing the landscape instead of the light. The sunlight fell through the east, south, and west walls onto markers located on the ground at the center of the Sun Box."*

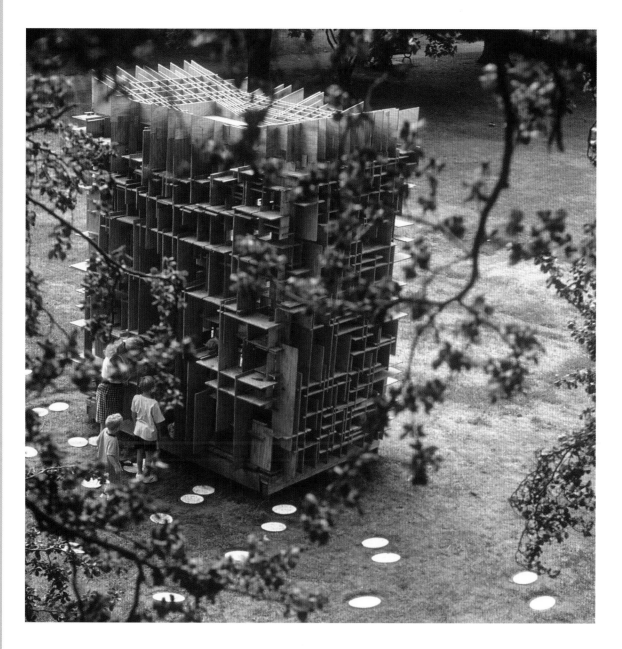

opposite
Bird's-eye view with ceramic discs on the ground locating where light falls on the twenty-first day of each month

top
Interior view

bottom left
Each opening was designed to allow sunlight to pass through it each hour for five minutes, on the twenty-first day of each month (plus a few days on either side). Detail of the north wall

bottom right
The sequence of a light spot moving across a ceramic disc was about five minutes from the initial appearance of light to its disappearance. The sunspot fell on the disk twice yearly, on the spring and fall equinoxes at 3 o'clock in the afternoon. Sunspot at 2:58 pm / sunspot at 3:00 pm / sunspot at 3:02 pm

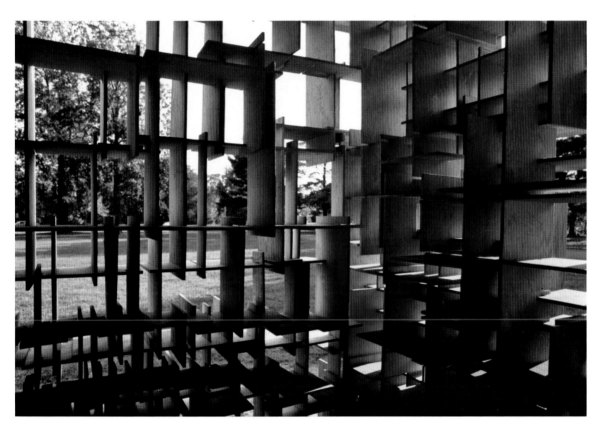

# James Cathcart, Frank Fantauzzi, and Terence Van Elslander

### *Resistance*

The Nichrome wires hanging from the electrical grid turned red when electricity was running through them, because they provided a great deal of resistance.

*"There was an incredible sense of danger in the space. If you touched a wire, you would get burned. We spaced the wires so that people could move between them." —Frank Fantauzzi*

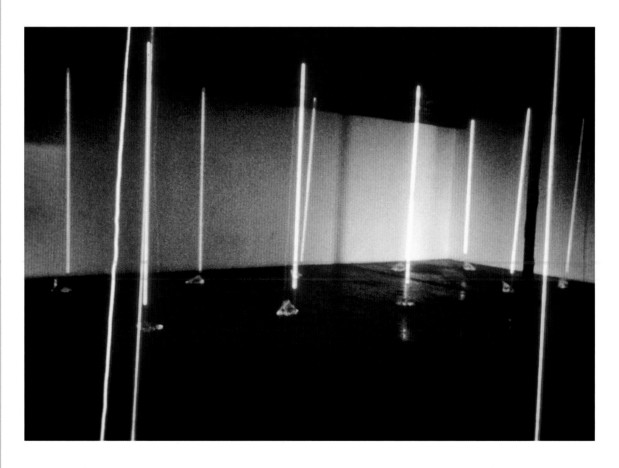

top
A plastic bag filled with water was
attached at the end of each wire.

bottom
View toward the front of the gallery

*"Each loop of wire was weighted down with a
plastic bag filled with water. This allowed for the
wire to expand and contract by maintaining
the tension. Water made so much sense because
it was something you wouldn't associate with
electricity." —Frank Fantauzzi*

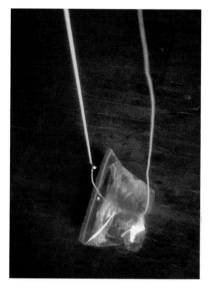

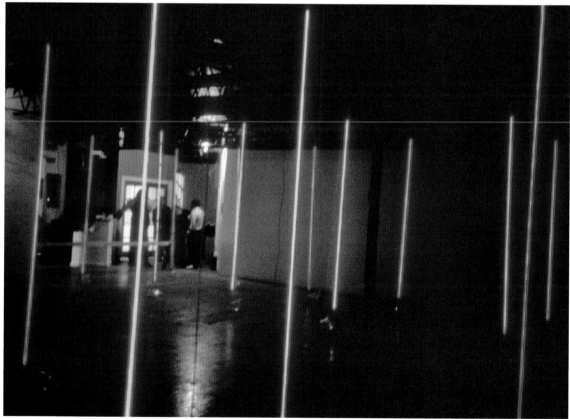

# Kourosh Mahvash

—

*Albedo*

*"The third subtle organ is the spiritual heart, which exists in an embryonic form in the potential mystic as the pearl within a shell. It is none other than true I, the personal individuality. The spiritual relates to the Abraham of one's being as Abraham was the intimate friend of God. This stage is red…"*
—al Simnani, fourteenth-century Sufi poet

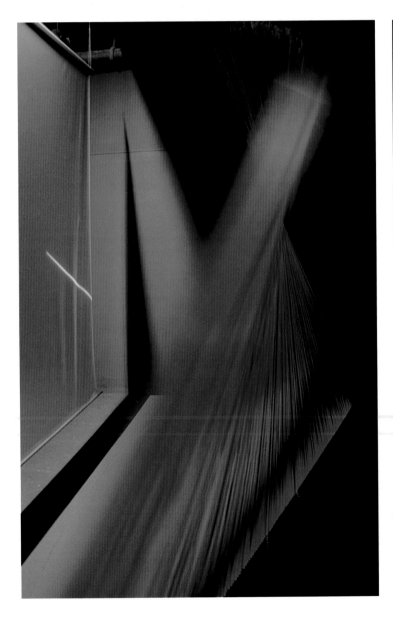
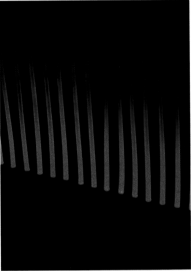

opposite left
The colored light was caught by
the fishing lines stretched to create
screens.

opposite right
Each day had a residue of the
dominating color of the previous day.

below
Diagram showing the path of the
moon from moonrise to moonset on
June 26 and its transcription into a
curved veil of light

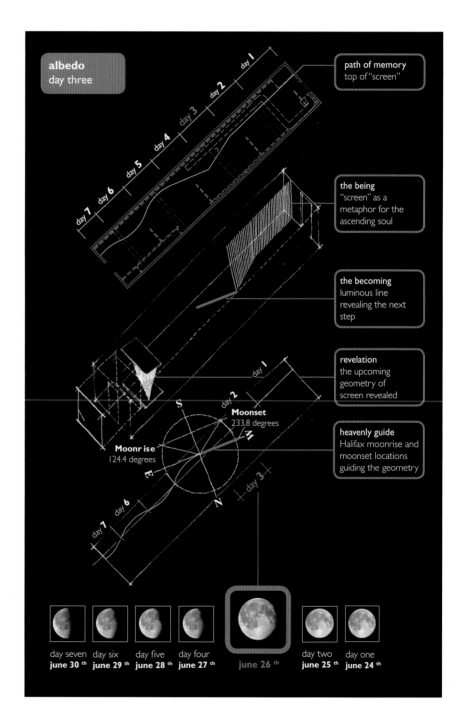

albedo
day three

path of memory
top of "screen"

the being
"screen" as a
metaphor for the
ascending soul

the becoming
luminous line
revealing the next
step

revelation
the upcoming
geometry of
screen revealed

heavenly guide
Halifax moonrise and
moonset locations
guiding the geometry

Moonset
233.8 degrees

Moonrise
124.4 degrees

day seven  day six  day five  day four        day two  day one
june 30 th  june 29 th  june 28 th  june 27 th    june 26 th    june 25 th  june 24 th

# 2. Body

The figure of the human body has been inscribed on building surfaces from the very beginnings of architecture. The Athenians supported the entablature of their Erechtheion on the sculpted bodies of women and modeled their architectural orders on men, matrons, and maidens. The plan of major religious Christian buildings often integrated the body of Christ—consider thirteenth-century French master builder Villard de Honnecourt's overlay of Christ's body on the plan of the Reims cathedral, or Leonardo da Vinci's inscription of a man with outstretched limbs in the center of the circled square in the Renaissance. Historian Joseph Rykwert's search for metaphors of the body led him to the very origins of Western architecture, finding evidence in the form of columns.[1] *Body and Building*, a collection of essays dedicated to Rykwert, revealed how the body metaphor has woven its way through architectural thought over the centuries.[2]

The body is no less present in the Modern era. Measured, mapped, traced, and ergonomically codified, the human body was pressed into the service of

Rationalism and Futurism as much as Functionalism and Taylorism. We can think of Le Corbusier's architectural promenade, Lilly Reich's efficient kitchens, Eileen Gray's choreographic architecture, and Moisei Ginzburg's user-path diagrams. Under the playful watch of the Surrealists, the body in architecture rediscovered its animal origins, evoking sexuality, perversion, excess, and uncontrollability through Hans Bellmer's drawings, Marcel Duchamp's sculptures, Alexander Calder's mobiles, and Frederick Kiesler's *Endless House* (1960). Bodies became like machines and vice versa—architectural examples of this include Pierre Chareau's elegant Maison de Verre (1927) in Paris in which, as Frampton memorably analyzed, valvular passages allow the husband in his study to communicate with his "bride" in her boudoir, reenacting, in a floor plan, human intercourse.[3] Such a fascination with motion in architectural spaces continues to the present in Steven Holl's "hinged space" in his apartments in Fukuoka, Japan (1991), or public spaces in his student dorms at MIT (2002). Since the 1980s architects have been particularly drawn to the human body and its relationship to design. Michael Feher's three-volume collection of essays, *Fragments for a History of the Human Body* (1989), was followed by a number of books about spatial experience, phenomenology, and sexuality and space that expanded and deepened the conversation.[4] The following eleven installations demonstrate the influence of Feher's writings and illustrate the current discourse about the relationship between the body and architecture.

The primary Modernist paradigm for relating the body to architecture was motion studies, a scientific analysis of human movement and behavior—it was widely employed in the early years of the twentieth century by industrialists who wished to increase the speed of production through rationalization. In exploring the legacy of motion studies in the present era, one encounters the seemingly inevitable downside of such methodologies: a trajectory toward human engineering and exploitation. Architects Dan Hoffman, Liz Diller and Ricardo Scofidio, Taeg Nishimoto, and Mark Goulthorpe share a fascination with the mapping, tracking, and measuring of the body but also retain a critical view on their human implications.

Reacting to the reductivity of such a science-based view of the human body, many architects have looked to human experience as a vehicle for understanding our relation to the spaces we inhabit—what could be called the "phenomenological turn" in body architecture theories. Inspired by the concepts of philosophers Gaston Bachelard, Martin Heidegger, and Maurice Merleau-Ponty, these architects have designed spaces for the future inhabitants: perceiving, experiencing, and sensual beings. They have focused on materials, light, texture, surface, heat, sensation, and all that which Juhani Pallasmaa has poetically described as "the eyes of the skin" in his book of the same name. The installations of Craig Hodgetts and Hsin-Ming Fung, Byron Kuth and Elizabeth Ranieri, and Thom Faulders are grouped because they all explore these ideas. Building on Merleau-Ponty's belief that we all have underlying physical tension, this methodology catapults the sensory body into a kinesthetic realm. The installations by Frances Bronet and Anna von Gwinner escalated and intensified human movement through dance, which allowed a forceful engagement with the architectural space in which they performed.

Additional projects by Yolande Daniels and the partnership of Arturo Torres and Jorge Christie address gender issues and the particular ways that women

## 2.1 MOTION STUDIES: A SCIENTIFIC RECORD OF THE BODY IN SPACE

**Dan Hoffman, *Recording Wall*, Bloomfield Hills, Michigan, USA, 1992** (see p. 58)

The history of construction techniques is intimately related to the body of the builder. Tools are shaped to be handled, as are construction materials: bricks are made to be placed with one hand, concrete blocks with two, and so on. Through the tools and machines that extend human capabilities, the body of the worker is present in the building at every stage of the construction process. In the early years of mechanized industrial production, the worker's body became a focus for scientific research. Using cameras and stopwatches, time-motion specialists recorded the repetitive movements of the laborers in factories and in kitchens, dissecting the movements of skilled craftsmen and housewives into intervals.

Early pioneers in this research, such as the husband-and-wife team Frank and Lillian Gilbreth, used time-lapse photography and electric lights fastened to the limbs of their subjects (an apparatus they called the "cyclograph") to create striking photographs that captured the traces of movement. With their cyclograph the Gilbreths traced the hand of a surgeon tying a knot, a mason laying bricks, and a factory worker folding a handkerchief. Such subtle or rapid movements, invisible to the naked eye, were recorded as a pattern of light on photographic plates.[5] The Gilbreths' aim was to reduce inefficiencies and worker fatigue and increase production:

> After analyzing the movements of a master bricklayer, [the Gilbreths] built an adjustable scaffold for piling up bricks to be used on the job. As a result, the bricklayer did not have to bend over and raise the weight of his body a thousand times a day, thus almost tripling a man's daily output from 1,000 bricks to 2,700 bricks.[6]

Dan Hoffman's *Recording Wall* (Cranbrook Art Museum) explored and deconstructed the scientific view of the human body at work. By systematically photographing each step in the construction of a masonry wall, Hoffman offered a reinterpretation of time-motion studies, mechanical-reproduction processes (such as photography), and repetitive labor.

An eight-by-sixteen-foot (2.4 by 4.8 meters) concrete wall was erected without mortar. As a mason set each block into place, a remote shutter release activated cameras positioned on either side of the wall: The wall was photographed each time a block was placed. Light-sensitive emulsion painted on each block allowed the photographs to be printed directly on each respective block's surface. As a result, each of the 105 blocks carried a photographic record of the progress of the wall being built. It also documented the physical effort required to build it as we see the man working away, block by block.[7] Hoffman describes people's reaction to the project:

> They smiled. People got it and that is what pleased me the most. They got that each block contained an image of the whole and that they were sequential. They got the idea that it started with the first one and ended with the last one.... [People realized that] architecture could talk about itself.[8]

The photographs showed the mason slightly changing his posture as he placed each block, adapting his range of movement to the increasing height of the structure. As he laid his first blocks on the ground, he bent over deeply; when the wall was nearly complete, he reached high to place the last blocks. Hidden in the apparent monotony of the construction technique was constant variation in the body movements. Because the wall was eight feet tall, the mason gradually

disappeared from sight behind the wall as he completed his work. The effect was both comical and tragic, contrasting the human qualities of the worker with the incessant monotony of the blocks and their small photographic figures.

The modularity and simplicity of the wall also reinforced the repetitive task of construction. The accumulation of images encouraged the viewer to reflect on the mason, his body, and its relationship to the wall, the fundamental architectural element. The result was an entirely self-referential installation that presented a perfect fit between content and form, underlining the association between body and material, between craftsman and concrete blocks. It was a construction about construction.

### Diller + Scofidio, *Bad Press*, *Dissident Ironing*, traveling exhibition, 1993
(see p. 59)

Another project that directly addresses the Modernist involvement with time-motion studies is Elizabeth Diller and Ricardo Scofidio's *Bad Press, Dissident Ironing*, a traveling installation. *Bad Press* examined the act of ironing, a household task guided by motion-economy principles developed by efficiency engineers at the turn of the century.

Diller and Scofidio comment:

Good pressing of a shirt involves using a minimum of effort to reshape a shirt into a two dimensional, repetitive unit, which will fit economically into standardized orthogonal storage systems—be it a shipping carton, display case, dresser drawer, closet shelf, or suitcase. The standard ironing pattern always "disciplines" the shirt into this flat, rectangular shape.[9]

The installation was dominated by a video projection of a man wearing a white shirt slowly turning in place like a mannequin. The wrinkles on his shirt have been ironed out, leaving three distinct gridlines (creases). This was the example of a perfect ironing job—representing conventions and expectations—and it provided a ready terrain to explore disruptions, distortions, and desires. Below the video screen, there was a series of white shirts displayed on horizontal surfaces. In contrast with the first shirt worn by the man in the video, these were "misironed" in all sorts of ways: One had the bust folded inside the sleeves; another had its sleeves crumpled into swirls. Others were folded into origami shapes. All the objects remained open for interpretation in their twisted, often grotesque forms.

The installation was also about the rituals of everyday life. "The art of Diller + Scofidio," says Aaron Betsky, "consists of making us aware of such rituals by perverting them, structuring them so they have a logic that is believable, productive, and yet profoundly disturbing."[10] By intentionally mis-ironing shirts in multiple ways, the designers pursued the possibility that deliberate misinterpretation could redeem seemingly constraining social conventions.

Both *Recording Wall* and *Bad Press* revisit Modernist architects' attraction to time-motion studies and their love affair with efficiency, modularity, and standardized units. These projects stand as a criticism of the scientific analysis of the body at work and the illusory promise of a better world through human engineering.

### Taeg Nishimoto, *Re-f(r)action*, Brooklyn, New York, USA, 1994, and Paris, France, 2000
(see pp. 60–61)

Two additional installations also work with time-motion studies, but for a very different purpose. Drawn to the unexpected beauty of time-lapse photography—as it was captured in the pioneering work of the Gilbreths and French photographer Étienne-Jules Marey— Taeg Nishimoto and Mark Goulthorpe created their installations around traces of movement. Taeg Nishimoto's projects, gathered under the

umbrella name *Re-f(r)action,* were installed in galleries in the United States and France between 1994 and 2000. They explored the idea of absence by translating simple movements into form. The results were long, curved wooden arcs built out of white poplar suspended within the white world of the gallery.

Nishimoto begun his projects by sketching a plan of his movement through the space of the gallery: "Like a downhill skier, who prepares for a competition by mentally acting out all the moves beforehand, I imagine moving in the space before actually being there. At the beginning the lines are entirely spontaneous, and at some point they become more precise."[11] Wood strips were first placed in the room according to his drawing; their forms and positions gradually evolved as they were constructed and tensioned. In addition, Nishimoto built temporary partial-height walls in the gallery, setting them in dialogue with his arcs. He explains that the "presence of the wood bows, which meander through the articulated spaces, as well as the shadows the bows cast on the vertical surfaces, amplified the sense of spatial dynamism, tectonically, tangibly, and conceptually."[12] Weaving in and out of the rooms and around the suspended arcs, the viewer could feel the movements as Nishimoto imagined when he drew his first sketch.[13]

Lastly, he added horizontal dashed lines, squares, and sweeping shadows on the gallery walls. Nishimoto used drawing—both in his architectural drawings and the drawing on the walls of the gallery—as a way to further interpret the space created by the installation. For the drawings, he deconstructed each curve into lines and dots until they created a field, and added hatch marks to the curves in plan. He then transcribed these marks into three dimensions by attaching short sticks to the sweeping arcs. One of the sticks was always painted black and pointed to a black square—the registration of the vector of the black stick as it encountered the wall.

Through such obsessive recording and registration of vectors, one could measure the settlement of each bow from the time they were first set in place to days later when the whole installation had settled.

This way of working pushes the traditional architectural activities of measuring, dimensioning, and recording to their extremes, tipping them into the realm of the absurd. Like Daniel Libeskind's fantastic architectural drawings from the 1980s or Peter Eisenman's recombinatory *Houses One through Ten* of the same period, Nishimoto's installations are fields of black squares, dashed lines, and shadows that constantly play between the volumes implied by the arcs and their intersections with the orthogonal world of the gallery. By registering and projecting one line onto another and translating movement into form and form into line, Nishimoto enacted a rigorous process of measurement to create an all-encompassing visual field. Projecting geometry on, into, and through space, his installations offered a sense of poetry through the dynamic tension between an object and its trace, a form and its shadow.

### Mark Goulthorpe, *Ether*/1, Geneva, Switzerland, 1995 (see p. 62)

(see p. 62)

———

*Ether*/1, built in a park, was commissioned in 1995 to commemorate the fiftieth anniversary of the United Nations. The project was collaboration between Mark Goulthorpe, principal designer for the firm dECOi, and the well-known choreographer William Forsythe. Together, Goulthorpe and Forsythe revisited the work of Rudolf Laban, an early-twentieth-century pioneer in choreology (dance analysis) who invented a system of dance notation known as labanotation.

In a series of ballets through the 1980s and '90s, Forsythe examined the inherent limitations of Laban's movement system, which relied on pure geometries centered on the dancer's body.[14] He updated Laban's Modernist choreographic principles with a

Postmodern worldview, effectively decentering the source of motion so that it no longer was necessarily located in the body of each dancer but could be anywhere in space. In this way the geometries of axes and alignments could be located, translated, exchanged, inverted, and mirrored—in short, they could constantly evolve in space. Thus, the established spatial grammar of movement would be subtly but profoundly reconfigured. Forsythe's choreography developed a generation of unexpected and destabilized movement patterns, coherent within themselves, but unthinkable within the classical canon.

To create *Ether/1* Goulthorpe videotaped dancers performing the same portion of Forsythe's *Quintet* multiple times and transferred the motion data to a computer to develop digital models. The ultimate goal, however, "was not to capture the positive trace of the dancers movements through space, but the difference between several attempts at the same sequence.[15]

The installation was based on the poetics of human performance—the slight differences that inevitably occur when the same sequence is repeated again and again.

This process focused on the interpretive qualities of the dancer, including uncertainties, hesitations, and tempo changes. The final form of the project—built out of a double layer of tessellated aluminum strips that created a moiré effect—was an architectural expression of human dissonances in repetition. These vibrant extended forms seemed on the edge of losing control, although—like Forsythe's choreographies—they were perfectly balanced, effortlessly hovering above the ground.

All of the preceding installations address different aspects of movement, showing a desire to examine the Modernist tenets underlying motion studies. By recording the motion of the mason as in Hoffman's *Recording Wall*; by resisting the rules of proper ironing as in Diller + Scofidio's *Bad Press*; by needlessly complicating measuring and marking as in Nishimoto's *Re-f(r)actions*; by focusing on the unseen alterations in a dancer's interpretation as in Goulthorpe's *Ether/1*, all these projects reinvent movement through a critical, personal eye that disturbs the canon and brings desire and sensuality into the picture. In short, they invest poetry into the scientific process of motion studies.

# Dan Hoffman

## *Recording Wall*

top

Like the motion studies done by the Gilbreths in the early twentieth century, the systematic photographic recording revealed how the placement of each block required the craftsman to perform a different motion.

bottom left

Stacked concrete blocks form the wall. Eight feet (2.6 meters) high and sixteen feet (5.3 meters) long, the wall's proportions corresponded to those of a single block.

bottom right

As each block was set in place, Hoffman photographed the wall. The image was then printed on the block using photosensitive emulsion, and the process repeated until the wall was complete. Detail of top image, fifth row down, fifth from the right

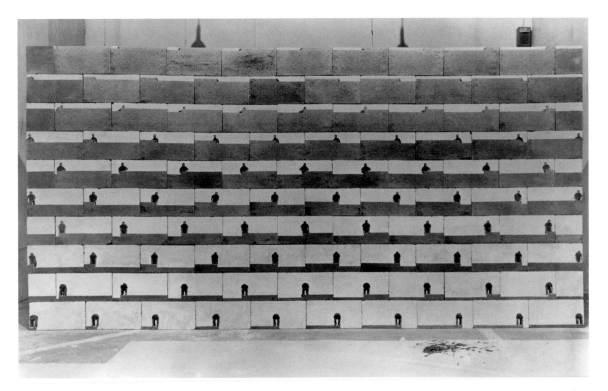

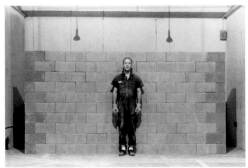

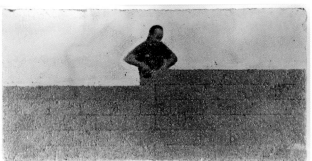

# Diller + Scofidio

## *Bad Press, Dissident Ironing*

top
A model wears a white shirt that has been perfectly ironed according to the rules of the trade.

bottom left
Misironing highlights the rituals of ironing by perverting them. In their negative dialectic, the shirts spoke of social conventions and the work involved in maintaining them.

bottom middle
Connection to the human body disappeared as the shirt went through different transformations. Viewers redeemed the misironed shirts by creating their own associations.

bottom right
*Bad Press* created entirely new forms in a way that was believable, yet also disturbing. After the difficult task of unfolding it, the shirt would be full of creases.

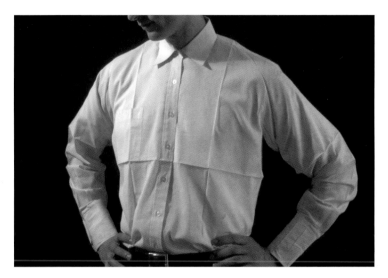

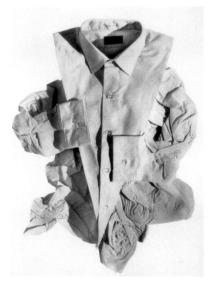

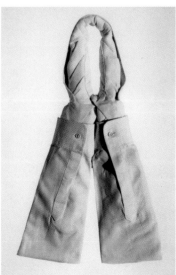

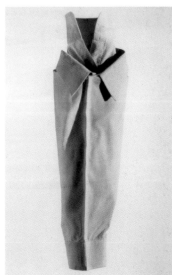

# Taeg Nishimoto

## *Re-f(r)action*

*"I generate the drawing through a set of rules,
and within these rules, things happen. There is a
sequence in the lines I draw, from the first line
to the last; they gradually articulate and occupy
the two-dimensional field."*

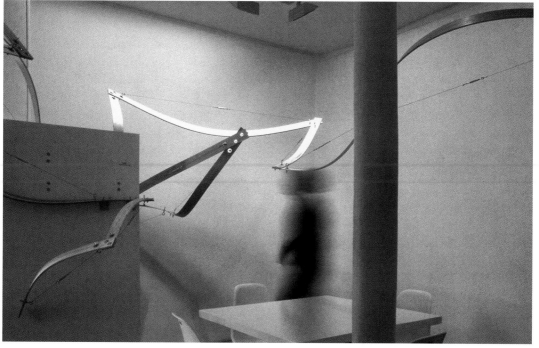

top

The white poplar pieces curved into bows were held in place by wire cables. Stainless-steel tensioning devices held the curved elements together and also created an anchor point for the cables. Nishimoto, *Re-f(r)action #2,* Higgins Hall, Pratt Institute, Brooklyn, USA, 1995, construction detail

bottom
*Re-f(r)action #4*

*"I use the sketch drawing like a map, but the actual construction of the installation evolves gradually as the elements start to occupy the space in a continuous set of action and reaction."*

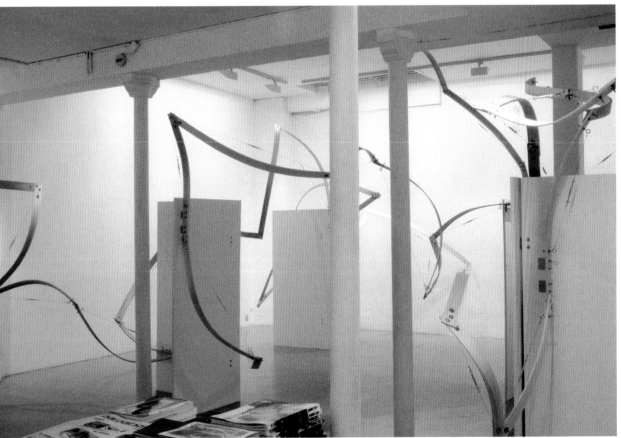

# Mark Goulthorpe

*Ether/1*

top
Video cameras captured a series of
performances of the same dance
duet. Mark Goulthorpe then translated
the information into frozen traces.
The slight variations reflected the way
each performance happened a little
differently.

bottom
The layers of aluminum strips
created a moiré effect that revealed
differences of traces generated
by each performance. A double
tessellated surface of aluminum was
built using four thousand nonstandard
components cut and welded.

## 2.2 PHENOMENOLOGY / PERCEPTION AND BODILY EXPERIENCE

——

We now turn away from the traces left by a body evolving through space and shift our attention to the way human bodies experience and perceive space. This discussion has been greatly influenced by the philosophy of phenomenology, which theorized the phenomenon of perception and experience.

**Hodgetts + Fung and Kuth/Ranieri Architects, Projects for Body Building exhibition, San Francisco, California, USA, 1998**

(see pp. 67–68)

——

The following two installations were a part of Fabrications, an exhibition about architectural installations coordinated by Mark Robbins, which was mounted in 1998 at the Museum of Modern Art in New York, the Wexner Center in Ohio, and the SF MOMA simultaneously.[16] Exhibited at the SF MOMA exhibition and collectively called Body Building, two installations were intended to represent or engage the human body in four different states: in action, in repose, in equipoise, and "the somatic" body. Two of these installations allowed visitors to feel, in their own bodies, a simple yet profound relationship to the way buildings function. The first illustrates a body in action (breathing), and the second, in repose.

*Body in Action*, by Craig Hodgetts and Hsin-Ming Fung, was a large fabric bag attached to an air-conditioning grille inside a gallery of SF MOMA. The cream color of the fabric allowed the object to become part of the gallery setting, making it seem like an extension of the building's breathing system. "The apparatus was like a lung, and the only exit for the air was through little tubes that were like flutes of a piccolo. They are wheezing away. So, when the pressure mounted sufficiently to lift the orb, the jaws opened and the air came out with a whistle," explains Hodgetts.[17]

The apparatus essentially worked like a bagpipe, with a suspended ball acting as a counterweight causing the "mouth" to open and close. "The idea came from a Greek treatise called *Pneumatica* by Heron of Alexandria on the use of air to create temple miracles. When they sacrificed a lamb, the heat of the fire would create a vacuum underneath that activated bellows, which would then magically trigger a musical instrument."[18] *Body in Action* brought this theatrical device into the space of the gallery, and the soft complaint generated by the movement of the bellows gave visitors a feeling that the building had a spirit.

In the same gallery space, *Body in Repose*, by Byron Kuth and Elizabeth Ranieri, created an environment for a body to rest. Layers of soft, thick gray felt were sculpted to create a series of womblike cubicles for sitting or reclining. The felt absorbed ambient noises, and the enveloping forms created small, dark shelters. Kuth explains that reducing environmental stimuli allowed the visitor to rest: "The idea was to drop you in an environment that would affect your senses—tactile, aural, visual. The change of sound level was really profound, nearly ecclesiastical. The environment was entirely accessible, it was right there, sized to your body."[19] By embedding the row of soft cubicles into the cavity of the museum wall, Kuth and Ranieri created an opposition between the cool white gallery and the soft intimacy of the felt enclosure:

> We had stripped everything off, and we were into the cavity of the wall. As you leaned against the felt, you could see the steel columns, the HVAC systems. Our intent was to explore what would it be like to inhabit your psychological self and your physical self at the same time. Those two worlds are always rubbing one against the other, so we tried to make that seem visible.[20]

The installation was uncanny because of the overt physicality of its construction: the felt incessantly pinched with C-clamps and

the exaggerated ribs providing support for the cubicles. The ambiguity between skin and structure, inside and outside, disturbed multiple boundaries between body and building, allowing visitors to physically experience the area that was the thickness of the wall. From the gallery, visitors could see down the length of the cubicles and observe nineteen people sitting in their enclosures with their legs hanging out.

These two projects isolated a physical experience of the museum building and created a situation where the public could reflect on it. They revealed the enduring appeal of phenomenology to architects—especially as it was presented in Bachelard's *The Poetics of Space* (1958) or Merleau-Ponty's *The Phenomenology of Perception* (1945). In the late 1960s and '70s phenomenology provided a way out of the oppressive and reductive world of positivism and a way for architects to place value on people's actual experiences of buildings and places.[21]

The Body Building installations reinvested experience with meaning unrelated to facts or data. One could have wired visitors up with sensors to measure their degrees of relaxation in the felt cubicles, or calculated the velocity of air flowing from the breathing bag. But the point of these installations was to recognize the conscious, feeling person, aware of his or her surrounding environment. By helping us to make sense of perception, these works suspended easy answers and assumptions and revealed the world in all its concrete richness.

**Thom Faulders, *Mute Room*, San Francisco, California, USA, 2000** (see p. 69)

———

The *Mute Room* was installed at the Wattis Institute for Contemporary Arts as a part of the Rooms for Listening exhibition. In this project, Thom Faulders of Faulders Studio designed an environment that reacted to the human touch. He calls these types of spatial experiments "meatspace," and they are like laboratories.[22] This installation illustrated phenomenology in its heightening of the viewers' senses to increase perception. *Mute Room* was a temporary performance space for electronic music. In order to create a specific acoustic, the floor surface of *Mute Room* was entirely covered with memory foam.[23] As Faulders recalls, "I was interested in the physicality of the music itself, the length of the waves and the way it is absorbed. The memory foam had the right dissipating qualities."[24]

The installation bracketed the acoustic experience, marking it clearly through texture, color, and light, and inviting the visitor to investigate. Sixteen hundred square feet (150 square meters) of pink foam were laminated to a plywood substructure, transforming the floor into a continuous wave. The weight of the body would leave an imprint on the surface of the foam, which would disappear after a minute or so. In this playful way, the visitor had a direct and personal impact on the room. The pink color of the walls mimicked the appearance of the subcutaneous flesh of the eyelid—evoking a peaceful ambience as when the eyes are closed. "Memory foam, a self-healing material," Faulders suggests, "creates an environment that attracts people who need to do the same."[25]

Since the room was a temporary space for an electronic music concert, the research focused primarily on the auditory experience of the audience that would lounge on the soft, curved surfaces. The combination of the sound baffle and the memory foam created an acoustic environment that had transitory qualities. Sounds lingered until fully erased by the slow action of the memory foam. The foam was laid on an elevated floor to create a wavy surface that supported the audience as they leaned back during the concert. "The hilly lump beneath the foam's surface was analogous to an overgrown larynx and operated as a fixed sound baffle. It enhanced acoustic clarity, similar to the way a musical note 'decays' in the air before dissipating."[26]

As described by its designer: "the room's absorbent textures and warm, soothing colors gave the visitor the impression of being suspended in a boundless haze as floor becomes wall becomes colloidal space."[27] The room was the perfect place for reading and napping. Although CCA students wanted to keep the *Mute Room* as a "hang out" space, it stayed true to form as an installation and remained only as a memory. Its success lay in the power of "bracketing"—one of the key concepts of phenomenology. Here, the room bracketed auditory perception in order to allow people to listen "as if for the first time."[28] In other words, the design of the room was intended to isolate one of the senses—in this case hearing—and intensify that experience.

**Frances Bronet, *Space in the Making*, Troy, New York, USA, 1997–2001** (see pp. 70–71)

———

The preceding projects in this chapter focused on a relatively passive interaction between the user and the environment. Yet people more commonly experience environments actively, by moving through and around spaces. Linking the idea of movement to that of the experience of the self, philosopher Merleau-Ponty stated, "every movement is, indissolubly, movement and consciousness of movement."[29] He criticized the mechanistic idea of action and reaction, in which the body is seen as a simple set of motor actions. Drawing from Gestalt psychology of the 1920s, Merleau-Ponty proposed that the potential for movement is constantly present in the body as "movement-tension." This potential for movement, he said, develops out of the repetitive physical activities performed every day. Installations by Frances Bronet and Anna von Gwinner explored this relationship between the built environment and the inner potential energy of the body in action.

Paul Klee, perhaps the artist most able to convey meaning, humor, and emotion with a simple line, held that "pictorial art springs from movement, is in itself interrupted motion and is conceived as motion."[30] If architecture is substituted for pictorial art, these words could illustrate the views of Bronet. Working in collaboration with the choreographer Ellen Sinopoli and others, Bronet explored the interplay between the kinesthetic body and architecture in motion. Her desire was to challenge the overemphasis on the visual sense by widening the range of experiences possible in a space.[31] "Just by moving through a space we change it," says Bronet.[32] Likewise, Sinopoli is drawn to unpredictable movements that confront the physical limitations imposed by architecture. "The floor," she says, "what a hegemony! When you want to leave the room you go through the door because that is the way it was designed, but if you go through the window, you might find out something you didn't even know existed."[33]

Working in an old warehouse in Troy, New York, from 1999 to 2001, Bronet and her students from Rensselaer Polytechnic Institute designed and built a number of experimental dance environments inside a building that could take some abuse. A large hole was cut into the floor, and a necklace of inner tubes hanging between floors through the hole gave dancers a chain of reactive supports on which to climb from one floor to the other. This was a truly responsive architecture, with the inner tubes reacting to any contact made by the dancers. In another project, a forest of vertical bungee cords anchored at both ends allowed the dancers to hang upside down and explore a wide range of movement. A floor made of tilting platforms was the most successful design. Each platform could tilt independently as the dancer's weight shifted—lending an unpredictability that responded to the body in motion. Audience members also participated, says Sinopoli: "a man was watching the performance, his hand was tightly clinging onto the handrail—that was his body participating."[34]

## Anna von Gwinner, *Trampolinist*, Karlsruhe and Berlin, Germany, 2001 and 2005

(see pp. 72–73)

———

Anna von Gwinner's *Trampolinist* was a video installation that brought the movement sequence of a trampolinist into a set of different architectural spaces. These associations generated entirely different meanings for both the video and the building where it was projected. The installations began with the videotaping of an athlete jumping on a trampoline. The video was then projected at two sites: a Catholic church in the center of Karlsruhe, Germany, in 2001 and a bunker at the site of the former Berlin Wall in 2005. The architect analyzed the spatial conditions and psychological associations of each particular place and altered the manner of projecting the video in order to heighten or counteract these conditions.

The Karlsruhe installation was in the nineteenth-century Church of St. Stephan, whose impressively high dome had been rebuilt in concrete after the Second World War. This dome—where the screen was set up—became the setting for the trampolinist's extraordinary exercises. By projecting the video into the vaulted space, von Gwinner wanted to evoke a sense of reaching for spiritual enlightenment. The athlete's leaps and bounds allowed the viewer to see the space in a new way—in simple, straight jumps he sprung toward the apex of the dome, toward the light descending through the oculus. The generous vault demanded that his movement be expansive.

Von Gwinner videotaped her trampolinist with two cameras. One recorded his upper body in the air and the other his legs landing on and springing from the trampoline. In this installation, only the upper part of the movement sequence was projected, giving a sense of flight as the body floated into ever-higher realms of the dome. Since visitors never saw the athlete's moment of impact with the trampoline, he appeared to float effortlessly, like an angel.

Depending on the level of light, von Gwinner says,

> The trampolinist becomes more or less important. During the day his appearance is faint, his outlines unfocused. He seems to submit himself to the space. As light falls, the emphasis shifts from the space to the trampolinist. At night, when the church is completely dark, he becomes the center of attention, the acrobat who defines the atmosphere in the church. It seems that only the screen can detect the trampolinist as we lose sight of him as he moves outside the frame. The virtual position of the trampoline is on the floor of the church below the screen. The time lag in between disappearing and reappearing the screen is calculated to register that position.[35]

The second location for the project was a subterranean bunker under the "death strip" at the former site of the Berlin Wall. There, von Gwinner projected the other half of her video footage onto a screen at the end of a corridor. The concrete walls, floor, and ceiling of the bunker framed the trampolinist's body—this time the lower part of his jump—as he rhythmically descended onto the trampoline and bounced up to disappear into the ceiling. This time he was not an angel, but a man who could accomplish what the viewer's entire body wished most—to break through the oppressive mass of earth above the bunker.

Seen through a phenomenological lens, the two installations matched Bachelard's description of the axis in a house between the attic and cellar—one associated with air, light, sky, and daydreams, the other with earth, darkness, memories, and primal fears.[36]

# Hodgetts and Fung

*Body in Action*

The fabric bag was hooked up to an
air-conditioning unit, which blew air
into the "lung."

# Kuth/Ranieri Architects

---

## *Body in Repose*

left
Cubicles sculpted out of felt allowed
visitors to rest in a quiet, womblike
environment. The soft enclosures
muffled sound and permitted visitors
to withdraw into a state of light
contemplation.

right
Construction detail

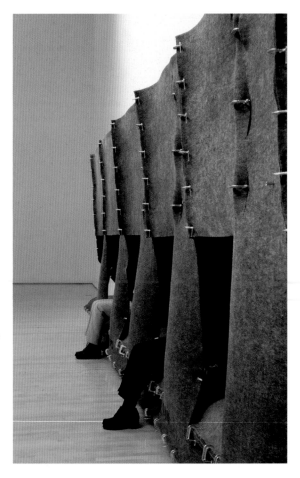

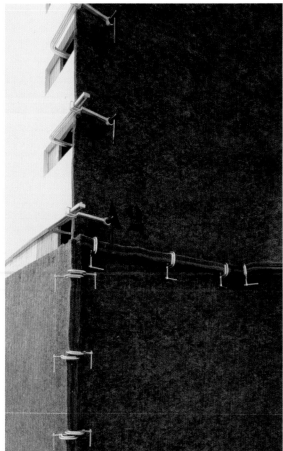

# Thom Faulders

## *Mute Room*

top row
The properties of the material—its form and texture—responded to the human touch. Like traces in the sand, footprints are remembered but also quickly forgotten.

bottom
Memory foam (familiar as earplugs) covered large surfaces of the floor on which the audience could sit. The foam absorbed sounds more slowly, altering the acoustics of the room.

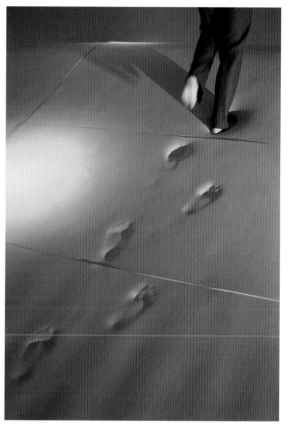

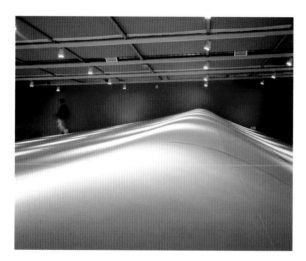

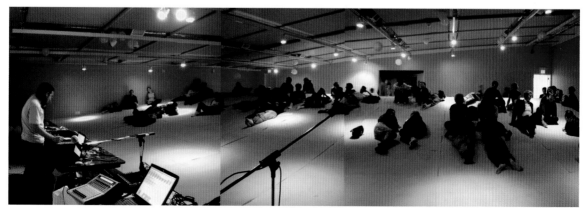

# Frances Bronet

### *Space in the Making*

top

Like open pods, these translucent fabric structures invited dancers to enter. Frances Bronet (with Terry Creach Dance Company and Bennington College), *Dichotomy, RPI Dance Infusion, Design 1*, Rensselaer County Council for the Arts, Troy, New York, USA, 1997

bottom

*Spill Out* was created by hand weaving a thousand strips of spandex into a structural frame. Bronet (with Sid Fleisher and Ellen Sinopoli Dance Company), Historic Gasholder Building, Troy, New York, USA, 1997

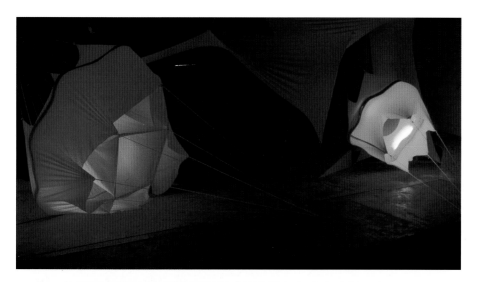

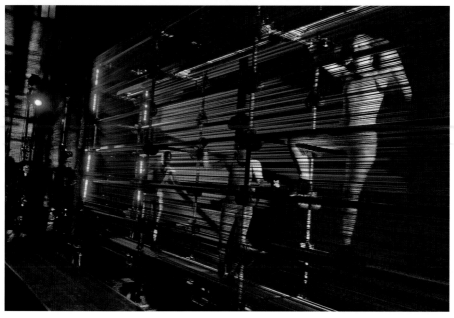

top

A necklace of inner tubes gave dancers reactive supports on which to climb between floors. Bronet (with choreographer Elizabeth Streb), *RPI Embodied, Design 1*, Boardwalk Center, Troy, New York, USA, 2001

bottom left

A series of glass platforms moved as dancers shifted their weight across the surface, giving the dance an unpredictable quality. Bronet (with Ellen Sinopoli Dance Company), *Beating a Path,* Storefront, Troy, New York, USA, 1999

bottom right

Detail of *Dichotomy, RPI Dance Infusion, Design 1*

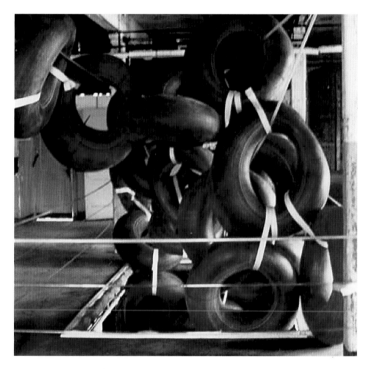

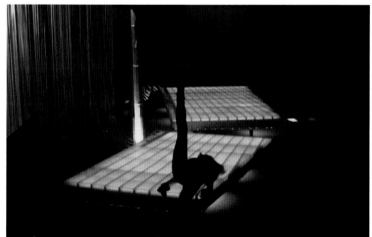

# Anna von Gwinner

***Trampolinist***

*Trampolinist 1*, Church of St. Stephan,
Karlsruhe, Germany, 2001

*"The priest drew inspiration from the video installation and left it running
during mass. Some of the heads of the worshippers were moving up
and down, following the movement of the trampolinist as he appeared and
disappeared on the screen. Oddly enough, their gaze followed the movement
implied beyond the screen and onto the floor."*

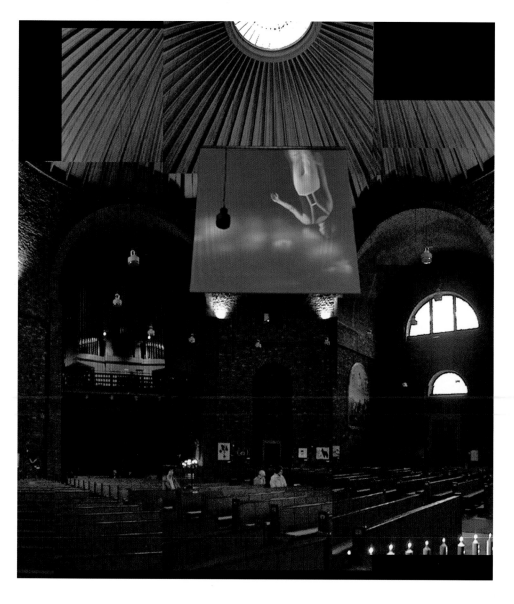

right (1–7)

This version of *Trampolinist* used only the bottom part of the video. The body of the trampolinist disappeared in the most liberating manner through the thick mass of the ceiling of the bunker: each time the body penetrated the concrete ceiling of the bunker, he appeared to achieve the impossible feat of defying the laws of physics. What remained was the slow reverberation of the net, trapped in the bunker…until the next jump.
*Trampolinist 3,* Berlin, Germany, 2005

bottom

The trampolinist was filmed with two video cameras. One framed the movement of the athelete above the net and the other focused on the net.

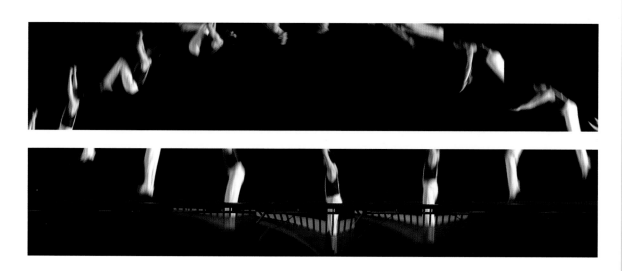

## 2.3 POSTMODERN BODIES: THE PERSONAL IS POLITICAL

——

A phenomenological approach to art can be a useful tool, especially when it is applied to the study of an installation about architecture and its relationship to the human body.[37] But phenomenological analysis requires an awareness of the criticisms that have been leveled at the philosophy, particularly its assumptions about the universality of human experience.[38] Philosophers Martin Heidegger and Jacques Derrida each challenged the attempt to ground phenomenology in the presence of an individual subject, arguing that the subject is partly constituted by elements that are external to it: history, tradition, a shared world, a relationship to other individuals, and language. Strictly speaking, the phenomenological method asks one to experience an object as if encountering it for the first time, with no presuppositions. According to Heidegger, an early critic of the philosophy, this is not possible because the very process of creating meaning through language inextricably preconditions individuals, securing them in relation to each other and to language itself. "We belong to a language," he says, "that has been shaped and formed by others before we arrive on the existential scene."[39]

This criticism has worked its way through many fields of thought today, and architecture is no exception. A person's experience of the world is greatly influenced not only by language but also by social conventions and traditions specific to gender issues and culture. The last two projects in this chapter explore the ways in which women experience and interpret space. These installations challenge architectural conventions and standard practices predicated on the universality of architectural experience, deconstructing and criticizing longstanding assumptions.

In 1996 a group of feminist architectural historians wrote *The Sex of Architecture*, a polemical book intended to challenge assumptions "such as man builds and woman inhabits; man is outside and woman inside; man is public and woman is private; nature, in both its kindest and its cruelest aspects, is female and culture, the ultimate triumph over nature, is male."[40] That same year, Yolande Daniels created *FEMMEpissoire*. And two years later, *The Nautilus Project* by Arturo Torres and Jorge Christie addressed gendered notions of privacy. Working through issues of gender, public space, and privacy, they provoke viewers to question what is seen as normal, and ask why this is so.

### Yolande Daniels, *FEMMEpissoire*, New York, New York, USA, 1996 (see p. 78)

——

Yolande Daniels's *FEMMEpissoire* was first installed in a guest room of the Gramercy Park Hotel. Daniels developed the project because of her frustration at encountering long lines for access to women's public washrooms while men zipped in and out of their facilities. Her installation confronted the gender bias embedded in the building codes that mandate an equal number of stalls for men's and women's washrooms but allot additional fixtures for men in the form of wall-mounted urinals.

*FEMMEpissoire* addressed this issue head on, asking what a women's urinal would look like if it existed. The project, installed in the bathroom of the hotel room, included a straddle-style urinal supported by pipes, a mirror, and a pair of rubberized black pants designed to be worn by the woman using the urinal while standing up. Daniels explains the "politics of standing": "Why stand? My interest was generated, on the one hand, by long queues at public restrooms for women and, on the other, by a query as to whether the act of controlling the flow of urine constitutes an essential personal freedom for men."[41]

The aesthetics of the object, constructed of stainless steel, suggest a medical instrument rather than a fixture. "The gynecological exam," Daniels says, "has been inscribed as the proper place for knowledge of female

anatomy and functions."[42] The charge in this work came from the way it fetishized the medical apparatus—a feature that linked it to such notable architectural works as Pierre Chereau's gynecologist's office inside a house. Daniels's personal interest was in empowering women by exploring the "essential personal freedom" implicit in the use of a urinal. Daniels proposes the fixture as a place of self-discovery, with a strategically placed mirror that allows the woman straddling the fixture to see her own face as she urinates. For Daniels, the experiment encourages a "new view of female subjectivity."

The physical context of the project reveals a reworking of the traditional opposition between public and private realms. The installation transformed the bathroom of a room at the hotel into a public gallery dedicated to viewing. The simultaneously personal and public character of the *pissoire* (slang for "public urinal" in French) has long attracted the attention of moralists. In the 1880s, for example, public toilets in Holland were specially designed to prevent homosexual acts.[43] But it was not until the 1990s that the gender politics of these marginal spaces began to be analyzed in a critical manner. At the time Daniels was creating *FEMME-pissoire,* men's public washrooms were being reclaimed as important cruising grounds for gay men.[44] In that context, the semiprivate status of the hotel bathroom, rendered public for the duration of the installation, highlighted not only gender but also sexuality.

### Arturo Torres and Jorge Christie with Daniela Tobar, *The Nautilus Project*, Santiago, Chile, 2000 (see p. 79)

————

*The Nautilus Project* also addressed the intersection of gender and private space by turning the privacy of the home inside out. Its architects Arturo Torres and Jorge Christie (part of an architect's co-operative) built a small one-room house made entirely of glass on a vacant lot in downtown Santiago. The transparent

skin left its inhabitant, a woman who went about her everyday tasks in the house, fully exposed to passersby. A provocative project, it challenged assumptions about privacy and publicity, specifically in relation to women's position in Chilean society.

The building of the installation followed the standard protocol for the construction of a normal, everyday house. The architects, who won a government competition that paid for the materials, obtained a regular building permit for its erection. It was strategically situated across from a church, near major banks, and down the street from the presidential palace—symbols of religion, capitalism, and the state.

The inspiration, Torres recalls, "came from reading surrealists texts from around 1945, especially poetry, which we find extremely strong. We were interested to take up these ideas again in the context of today."[45] Like Meret Oppenheim's fur teacup, which upset the china cart, Torres and Christie provoked the viewer into reassessing his categories of public and private. The glass house was as transparent as Ludwig Mies van der Rohe's Farnsworth House (1951) or Philip Johnson's Glass House (1949), both built in richly landscaped private estates. By placing the transparent dwelling in the centre of urban Santiago, Torres and Christie juxtaposed transparency and urbanity, modernity and history, privacy and publicity. "In Chile, Modernity is equated with tech-nology," Torres says, "but where does the idea of Modernity come from? It comes from Baudelaire; it is essentially a cultural transformation. Being Modern for Baudelaire is to be immersed in city life."[46] Thus, for *The Nautilus Project* to really address Modernism, it had to be in the center of the city, not in the middle of nature.

To find a resident, Torres and Christie pinned up posters around the city. Five women answered the call. They chose actress Daniela Tobar, the woman who looked the most ordinary to them. Torres explains,

We wanted the person and the house to be as ordinary as possible. There was no script. Each day, she went out to work, she invited her friends over for dinner, and so on. It started on a Saturday evening. But after three days, photographs of the house were published in the newspapers, and the television cameras descended on *The Nautilus Project*. When Daniela would come out of the house, there were a lot of people and the street was blocked.[47]

Tobar was asked to lead her routine, daily life in the house. But her use of the bathroom drew voyeuristic crowds and howling criticism that the architects never imagined.[48] Fervent Catholics threw stones at the house, which was fortunately built out of shatterproof glass. Others sued the architects for practicing in this manner.[49] Torres and Christie, like the Dadaists, wanted to place something in the street to see what would happen and to confront Chilean conservatism head-on. But the reaction was much greater than they had anticipated: "Tobar had to move out before the scheduled two months were up, after someone attacked a woman who had been mistaken for her, and death threats sent the architects into hiding."[50]

The issues of transparency and overexposure are at the heart of the project. The term *nautilus* refers to a strip club in Santiago where nude women swim in large aquariums. Clients sit and drink in the dark, while the aquariums are brightly lit. Torres had been involved in a plan for renovating the city's red-light district and had seen the working conditions for sex workers in Santiago firsthand. By bringing the "aquarium" into the daylight and exposing the ordinary, everyday lives of women, they hoped to emphasize their fundamental humanity—in contrast to the display of female bodies as consumable objects in the Nautilus club.

Leftist critics complained that the architects could have selected a less attractive or older woman. But, as Torres responds, "this would have been neo-Marxist" in that it would have been too obvious a choice.[51] Their aim was "to challenge Chilean society's 'troubled relationship with sex and nudity,'" which Torres attributes to an oppressive, hypocritical society and Catholicism's institutional hold on the country's moral structure."[52] Yet, for many viewers, the project's charge laid in its occasional exposure of nudity. Though the architects intended to reveal the fundamental humanity of women, they could not avoid the societal transformation of Tobar into an object of curiosity and desire. In an effort to maintain control over the proliferating interpretations of their installation, Torres and Christie refused to give TV interviews, which they felt would inevitably corner them in a defensive position, and instead they created a web page.

But Tobar held a very different position on the project. While Edith Farnsworth memorably described her experience in the glass house designed by Mies as making her feel "like a caged animal," Tobar, a professional actress, relished her time in the spotlight.[53] "I think Daniela did not understand the project," Torres says. "She did an interview with a major television channel without telling us. She knew we would not agree, and this brought on the break up. She thought she had become Marilyn Monroe."[54] Torres and Christie had difficulty accepting Tobar's exploitation of the project's potential to bolster her career.

We close by reflecting on how the installations chosen for this chapter illustrate the primary argument of the book—that installations are a way of thinking about architecture in a critical manner. Freed of the normal requirements of a building (to enclose and support activities) and focused entirely on ideas, installations allow architects to reflect on their discipline and to critically analyze it. The installations exploring the body in architecture examined the science of motion studies that was so central to early Modernist architects. Rather than accepting such studies

as accurate depictions of human activity, the architects used the installations to probe into the artistic and poetic qualities of motion studies research, to identify its intrinsic biases and fragmentary nature, and to explore the psychological and political implications inherent in any attempt to quantify human activity. Similarly, the installations that build on phenomenology reveal the centrality of human experience in architecture and explore the nature of that experience—the point at which people encounter buildings—by amplifying the sensory potentials of architecture (with memory foam, a felt wall, or a breathing "lung"). Finally, installations can help their audiences question the notion of the universal human experience, and to confront assumptions regarding gender and space.

# Yolande Daniels

###### —

### *FEMMEpissoire*

A room of the Gramercy Park Hotel
was temporarily outfitted with a
female urinal and special pants.

*"The politics of exposure: the mirror, lipstick, pants.
Outside the female water closet, we risk immodesty and
lose privacy. Perhaps we will be liberated as well."*

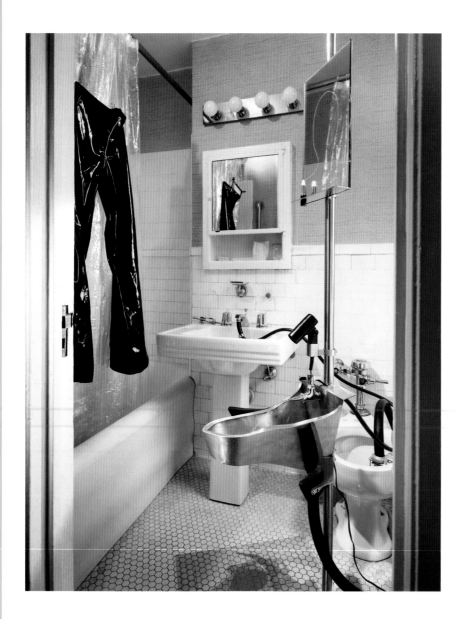

# Arturo Torres and Jorge Christie
# with Daniela Tobar

*The Nautilus Project*

top left
Pushing the Modernist idea of transparency, the little house brought issues of gender to downtown Santiago.

top right
Daniela Tobar performed scenes from everyday life. Here, she was applying her makeup.

bottom
The glass house quickly attracted crowds of onlookers.

*"We wanted both the house and its occupant to be typical." —Arturo Torres*

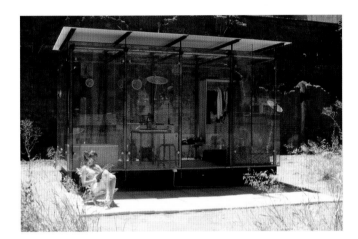

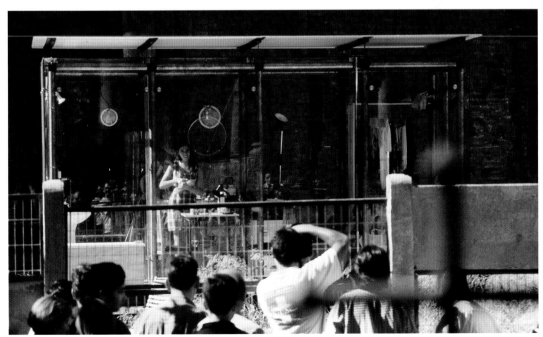

# 3. Nature

The installations in this chapter focus on the representation of nature in architecture, and in so doing, they remind us that architecture can help shape a more responsible attitude toward nature. In different ways, all these installations argue for an ecology that recasts the relationship between the built and natural worlds as one of symbiosis and interdependency, rather than mastery and exploitation.

Nature has been a constant source of inspiration to architects from crystalline geometries in the Renaissance to the curved forms of Art Nouveau in the *fin de siècle*. One can still trace the search for form into the organic world. But today, there is a strong awareness and a desire to show the beauty of interdependency between artifice and nature.

The projects in the first section, "Marking the Land," were all indebted to the directness of land art; this section includes works by Pierre Thibault, Marianne Lund, and Philip Beesley. The second section, "Viewing the Landscape," illustrates the role of perspective in framing the landscape and contains works by Mark Robbins, Anderson Anderson, and Ronit Eisenbach. The final two projects in the chapter rework the archetype of the primitive hut: Tanja Jordan Architects and TK Architecure collapsible dwelling is made for living in total wilderness, and Allan Wexler's seasonal pavilion evokes festivities and simple gardening.

## 3.1 MARKING THE LAND

In the well-known installation *Cadillac Ranch* (1974), a group of architects, who called themselves Ant Farm, buried ten Cadillac cars tailfin-up in front of a wheat field in Texas. This strange and provocative installation became a full-blown roadside attraction and was celebrated by art critics who said that "by using the Cadillacs as mere component parts of their art work, Ant Farm subverted their symbolic function. The piece functions as a kind of cemetery, a comment on social values as well as their deathly polluting effect on the environment."[1]

Like other land-art works of the 1970s— artists also included Robert Smithson, Nancy Holt, and Christo—*Cadillac Ranch* explored the relationship between nature and artifice. Rather than restricting art to canvases and museums, land artists made their marks directly on the land through giant earthworks—often geometrical patterns created by repeated elements. Even years later the issues raised by land artists continue to influence contemporary installations about nature. For architects, the excitement is not about working outdoors (which they are used to doing) but in exploring their relationship to the natural environment.

**Pierre Thibault Architecte, *Winter Gardens*, Québec, Canada, 2004** (see pp. 86–87)

In 2004, Le Parc National des Grands-Jardins commissioned Pierre Thibault to design six winter installations for a nature reserve in the mountainous regions of northern Québec. Wishing to create a collective experience, Thibault invited dozens of people to participate in creating the work. He always went into the park with an open mind and with few preconceptions about what the installations would look like, because the weather conditions greatly affected the technical aspects of the piece.

In *Caravan*, the first installation, a series of dome tents extended from the edge of a lake up a hill, creating a line of light in the desolate landscape. The fifty participants each carried a tent and a flashlight and spent the night in the park, becoming "very close as [they shared] this extreme experience for two days."[2] To Thibault the project revealed the idea that "nomadism is constantly with us, and that everything is in motion all the time."[3]

Each night about fifty participants went to a frozen lake to create *Constellations*, the second installation. Over ten consecutive nights they lit two thousand candles placed onto an orthogonal grid atop the ice of the lake. A small well dug into the snow protected each flame from the night breeze. "We always had to adapt to the weather conditions. Sometimes it was too cold and we could not light the candles because the fuel was frozen. Other times it was too windy so we made little wells in the snow to protect the candles."[4] The stronger the wind, the deeper they made the wells. Each day after the candles were lit, the group remained to watch the light transform. The process was a very important part of this installation. To Thibault, "it is like a large choreography. It can transform our perception of a sunset. At the beginning the lights of the candle are nothing and then it becomes like stars in the landscape."[5]

This installation interrupted the sweeping panorama of the Québec winter landscape by structuring it. It harnessed natural elements like the frozen ripples of the lake and also drew from land art projects that contrasted sublime nature with imported industrial materials.[6] The introduction of a foreign element into a pristine landscape raised the question of what is natural. An unsuspecting viewer might have found the exquisite stillness and perfection of a frozen lake enhanced by the thousands of candles reflecting off the ice and snow. From a distance, visitors could see lines of small lights glowing, and only as they approached did

they realize that fire was the source of the light. The juxtaposition of fire and ice created a surreal image. The burning candles melted the snow and left imprints on the icy surface of the lake, marks that might have left future hikers pondering over who might have placed them there.

**Marianne Lund, *Speaking to a Stone*, West-Agder, Norway, 1997** (see pp.88–89)

———

The location of architect Marianne Lund's *Speaking to a Stone* was the southernmost tip of Norway in West-Agder, adjacent to the Nordberg Fort, in a relatively remote coastal community, which has recently become a vacation destination.[7] The project exposed the way nature is always lodged in a complex web of cultural practices. Traditionally, in this region of glacial moraine, shelters, bunkers, and fences were built with local stones. But one giant rock outcropping next to the fort, explains Lund, "was never used for war, because it was too big. It was a silent witness for all ages."[8] Her desire was to make it speak. She covered this boulder with sheets of lead in order "to stop time" by protecting it from erosion and to give it what she calls "concentration." Every weekend over the summer-long duration of the installation, she stood at the top of a wooden staircase placed next to the boulder to read aloud from the *Farsund*, the local paper. Speaking into a cone she inserted into the boulder, the artist allowed new information to enter the stone through a hole drilled 1.5 meters (5 feet) into its core. There, a microphone picked up the sound of her voice and transmitted it through speakers in the adjacent building.

Lund used the boulder as a way to displace the act of reading the paper, an act that normally takes place at home, into the land itself. Drawing on performing strategies developed by conceptual artists, she placed a microphone inside the boulder as a way to transform the bodily experience of speaking. She activated the inside of the stone with

her voice to "investigate the inaccessible."[9] The performance brought contemporary text, in this case the news of the day, into an ancient material—it brought culture into nature. In so doing, Lund referred to another aspect of land art: the ritual involvement of the body with its environment. According to art historian Lucy Lippard:

> Of those who have tried to replace society's passive expectations of art with a more active model, many have chosen to call their activities "rituals." The word is used very broadly, but its use indicates a concern with that balance between individual and collective, theory and practice, object and action that is the core of any belief system….Images and activities borrowed from ancient or foreign cultures are useful as talismans for self-development.[10]

Although Lund had not considered the spiritual aspect of the stone but viewed it simply as a metaphor for the human mind, the installation called on animistic and shamanistic practices of the Sámi, a people indigenous to the area from Norway to Karelia. Lund's speaking stone deserves comparison to the *sieidi,* rock formations used as places of worship by the Sámi. Drumming and throat chanting (*yoik*) held a central role in Sámi ritual, and the shaman used the sounds produced by the drum to travel between the ancestral and present-day worlds to bring advice from ancestors.[11]

The transformation of Lund's voice as it made its way through the cone, the boulder, and the amplifier was mysteriously and strangely compelling for the visitors, who also climbed the stairs to speak to the stone. Lund recalls with delight that people were fascinated: "They ran back and forth from the barrack to the stone to experience the sound."[12] In Sámi culture the shaman saw into the future by putting an ear to the drum and listening to its "speech." In *Speaking to a Stone*, the tympanum of the speaker transmitted the reading of the newspaper from deep

within the boulder not to foresee the future but to tell about events that had past.

## Philip Beesley, *Geotextiles*, 1998–2007
(see pp. 90–93)

———

Alongside Thibault's formal explorations and Lund's performance art, another strain of work inspired by land art looks at the environment as an ecosystem. Artists such as Hans Haacke, Alan Sonfist, and Joseph Beuys take on environmental issues by contesting the idea that artists can only depict nature. In the same vein, the work of Philip Beesley uses a redemptive strategy to demonstrate how humans' relationship to nature is based not only on perception but also on empathy.

Since the late 1990s, Beesley has created a series of installations he calls *Geotextiles.* These are assemblies of aggregated individual elements that form an addition to ground surfaces and cloudlike forms. While his earliest installations, such as *Erratics Net* (1998), were set in natural landscapes and his more recent ones, such as *Implant Matrix* (2006) and *Hylozoic Soil* (2007), were placed in gallery settings, all of these installations pursue the same desire to create an expanded layer of earth that people can experience and even inhabit.

*Erratics Net* was a sprawling net lightly hovering over a glacial moraine of live rock and moss in the coastal landscape of Nova Scotia:

> The net is made with wire joints clamped by sliding flexible tubes that lock each link to its neighbor, making a tough, resilient structure. This artificial reef encourages turf growth by means of a myriad of hooked clips catching wind-blown plant matter, holding and amassing a matted matrix serving as synthetic soil. These anchors hold the net just above the bare rock, making a shallow film of still, sheltered air allowing delicate growth to emerge.[13]

*Erratics Net* pushed the viewer to look beyond the extremes of seeing the land as either pure wilderness or exploitable resource (like a cultivated landscape). Beesley explored nature as a dynamic and interactive system that includes humans within its purview. By constructing an artificial layer just above the earth's natural surface, Beesley suggested that nature and artifice were intertwined—that artifice may even provide valuable help where the ground surface has a tenuous hold on survival. Yet *Erratics Net* is more than an engineering proposal. By offsetting the net several centimeters from its supporting ground, Beesley introduced a discourse about the relationship between the natural ground surface and the artificial textile hovering above it. In this installation human relationships with the natural environment were based on empathy as much as utility, with exploitation, production, and waste—all linked into a sequence of nourishing transformations.

The complex geometries of artificial landscapes found in Beesley's most recent installations, *Implant Matrix* and *Hylozoic Soil*—which he describes as "hungry," even "carnivorous"—unsettled viewers. For Beesley, the "life force" of the earth and its constant need for nourishment are at the very root of geometry because the etymology of the word *geometry* is the measurement of earth or land. So, he argues, it relates directly to *Gaia*, meaning earth, matter, mother— the underlying fertile whole.

> I loved the idea of geometry having at the root a life force, rather than a dry, cutting quality that I associate with Platonic absolutes. That gave me a certain attitude toward engineering *Geotextiles*—using a generative approach rather than a controlling one.[14]

Seen through the lens of biomimicry, these later installations take on their full meaning. Biomimicry is a design process that imitates the way nature works, rather than the way it looks, in order to create new technologies—for example, a solar cell imitates the

way a leaf photosynthesizes solar energy. "It is innovation inspired by nature," says Janine Benyus, a prominent theorist on the subject.

> In a biomimetic world, we would manufacture the way animals and plants do, using simple compounds to produce totally biodegradable fibers, ceramics, plastics, and chemicals. In each case nature would provide the models: solar cells copied from leaves, steel fibers woven spider-style, shatterproof ceramics drawn from mother-of-pearl, perennial grains inspired by tall grass, computers that signal like cells, and closed-loop economy that takes its lessons from coral reefs and oak-hickory forests.[15]

Biomimicry is the design principle behind the mobile, sensible, and reactive elements of Beesley's *Geotextiles*. In *Implant Matrix*, for example, "the basic unit is an individual pore that is designed to have a breathing motion and a whisker that reacts to touch. These two units are connected to a light mesh, so the whole membrane functions like a lung."[16] The whisker, like a Venus flytrap, has a valve that is drawn shut by Nitinol wire, with its surface deeply scored like a feather, which enhances the lifelike effect. When a visitor brushes against one of the whiskers, there is a chain reaction with a slow rippling effect throughout the matrix. Each element communicates with the next, and the resulting network enhances its animate quality.[17]

Unlike the sublime Canadian coastline setting of Beesley's early installation, the later ones were gradually brought indoors and into the subliminal inner landscapes of the mind. The later installations have grown in size, becoming large enough for the viewer to be absorbed into the matrix, entering into these animate landscapes.

> *Erratics Net* worked with the body of the earth directly. The depth of the earth seen in the foamlike earth was literal. It had a prosthetic relation to the earth. *Implant Matrix*, on the other hand, was a lab in a gallery setting. Work in the gallery is like a fetus—it is germinal. In that sense they are complementary. Gravity works at a small scale, but it is free from light and wind. *Implant Matrix* is the inner landscape of the psyche. The ground became the underground like the unconscious. It was clinching and grasping; it made for a very curious experience.[18]

The experience of interacting with one of these installations was overwhelming. The *Geotextiles* are all encompassing, and yet the gaze is never enclosed. On the contrary, one can see through a maze of organic geometries that are constantly reacting to the movements of the visitors. In the nineteenth century, philosopher Robert Vischer coined the term *empathy* (with regard to art) to describe a viewer's active engagement with a painting or a sculpture. When I look at a work of art, Vischer says, "I seem to adapt and attach myself to it as one hand clasps another, and yet I am mysteriously transplanted and magically transformed into the other."[19] The sense of immersion, or empathy, experienced upon entering into Beesley's completely synthetic *Geotextiles* brings one into an emotional as much as rational understanding of the inner landscape. The subtle, slow movements of the matrix, animated by sensors, heighten one's sense of empathy—an emotional place where the viewer can listen and simply be. A beautiful text by Honoré de Balzac points the way to this new form of empathy:

> I speak for those who are in the habit of finding wisdom in a falling leaf, enormous problems in smoke that rises, theories in the vibrations of light, thoughts in the trees, and the most horrific movement in stillness. I place myself at the point where science touches madness, and I cannot put guardrails.[20]

# Pierre Thibault Architecte

*Winter Gardens*

> *"The idea of nomadism is constantly with us.*
> *Everything is in motion all the time."*

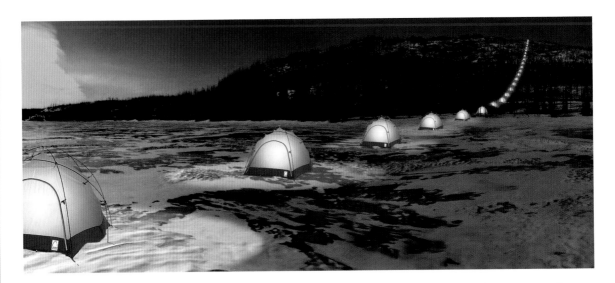

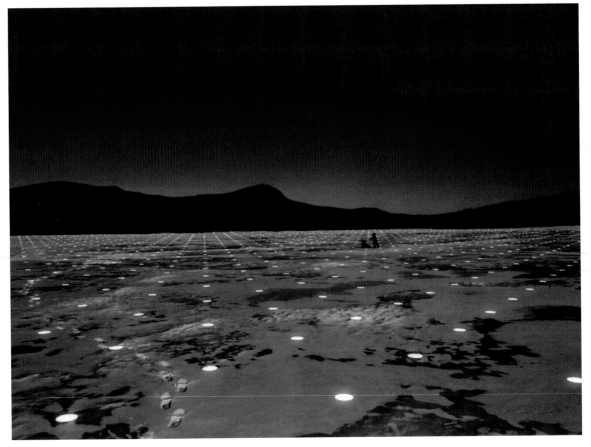

opposite top
*Caravan*, rendering of fifty camping tents erected in a straight line

opposite bottom
Each candle was protected from the wind by a small well dug into the snow. *Constellations*

Fires illuminated a fence built from ice blocks extracted from the lake. *Blue Line*.

*"Sometimes at night the temperature is extremely low, so we have to physically be close to one another to survive. We get very close as we share this extreme experience."*

*"You mark, you transform the landscape, and you create chambers without a roof, like in an Italian garden."*

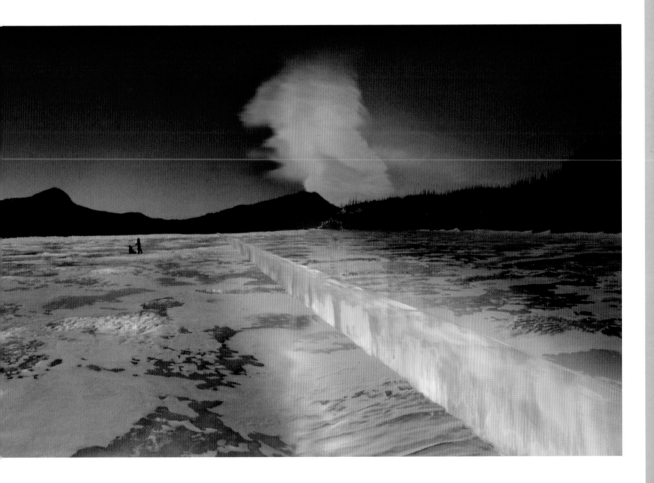

# Marianne Lund

___

## *Speaking to a Stone*

The boulder was covered with
lead and had a microphone inserted
into its core.

*"The stone was a silent witness
  for all ages."*

Marianne Lund read from a local
newspaper, the cone carrying the
sound of her voice into the center of
the boulder.

General view with the barracks
in the background

Visitors standing inside the former
barracks could listen to what
the stone "heard" through speakers
transmitting the sound from the
boulder's core.

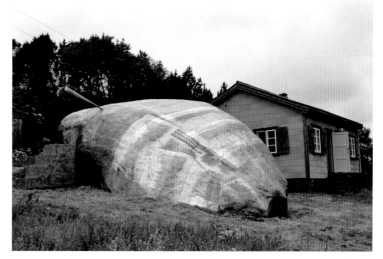

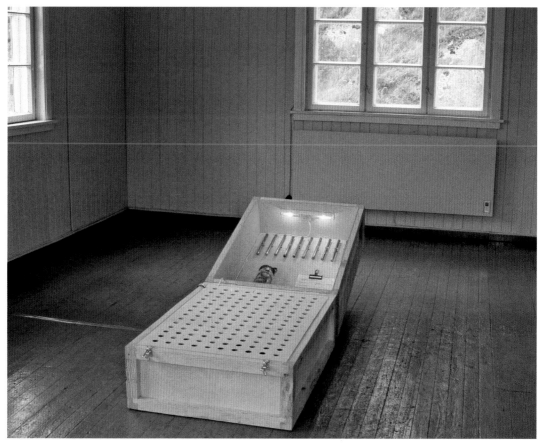

# Philip Beesley

## *Geotextiles*

Flexible tubes attached each link
of the net, crafted with metal wire
and joints, to its neighbor. Philip
Beesley and Caroline Munk, *Erratics
Net*, Peggy's Cove, Nova Scotia,
Canada, 1998

*"This artificial reef encourages turf growth by means
of a myriad of hooked clips catching wind-blown
plant matter, holding and amassing a matted matrix
serving as synthetic soil."*

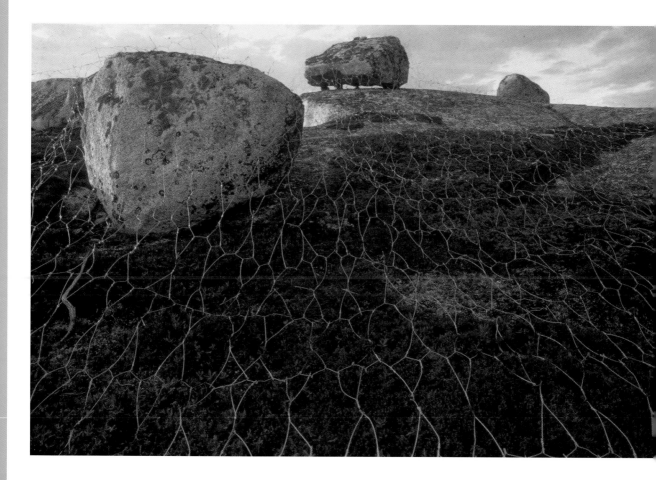

top

A rendering showing fluid-collecting bladders, barbed traps, and whiskers actuated by memory wire with capacitance sensors embedded within the filter layer. Beesley and Will Elsworthy, *Implant Matrix*, Interaccess Gallery, Toronto, Ontario, Canada, 2006

bottom

A diffused cloud of interlinked elements hovers in space. The upper layer is a lightweight skeletal structure of interlinking rhombic units with active pores collecting airborne organic matter. The lower layer is a quilted Mylar filter populated with whisker-sensors. Beesley and Elsworthy, *Implant Matrix*

## 3.2 VIEWING THE LANDSCAPE

First there is land and then comes landscape. Landscape, in the artistic world, is an interpretation of the land through paintings, poetry, garden design, or photography. In the European tradition, two major schools of landscape interpretation have left their marks on the ways in which artists represent landscapes: the Italian tradition, mediated through the English picturesque, and the Dutch tradition, based on mapping and measuring the land.

Since the Renaissance, architects have been pressed into designing buildings that picturesquely frame views of the landscape. As geographer Denis Cosgrove convincingly showed in *The Palladian Landscape,* wealthy landowners of Italy's Veneto area hired Palladio to design their villas with large windows that would frame their lands and allow them to keep watch over their fields and vineyards.[21] Artists would then be hired to paint the connecting landscapes between the windows.

The Romantic movement transformed the once-feared wilderness into a place of spiritual inspiration. Out of that Romantic movement, which turned nature away from the value associated with its production into a place for personal inspiration, came Modernist houses that framed large views of their environs, such as Mies van der Rohe's house for Edith Farnsworth, which reveals the deciduous forest surrounding it.

In the last quarter of the twentieth century, cultural critics took a hard look at the act of looking at the landscape, investigating the power relations between the observer and the observed. From the view out to the Veneto landscape came a discussion of the relationship between the Veneto landowners and farm workers; from the scene outside the Farnsworth House came Edith Farnsworth's declaration that her house was unlivable because she felt like a caged animal.[22] Writers such as Jonathan Crary and Rosalind Krauss argued that vision had its own history, ranging from the theory of perspective developed in Italy during the Renaissance to the Modern scopic regime of scientific observation.[23] The following installations critically explore two different perspectives for viewing the landscape, one from the Italian and the other from the Dutch tradition.

### Mark Robbins, *Utopian Prospect*, Woodstock, New York, USA, 1988 (see pp. 98–99)

Mark Robbins's *Utopian Prospect* was an instrument for viewing the landscape. The installation was flanked by a bluff facing the Catskill Mountains on one side and the ruins of the Byrdcliffe Art Colony on the other. The installation recalled the English picturesque tradition of the pleasure garden punctuated by small pavilions, which were based on Italian landscape paintings, by adding a pleasure pavilion in the midst of the ruins of the utopian colony. In *Utopian Prospect,* as Robbins describes it,

> The smooth side of the block wall supports a steel shutter which can be pivoted by hand into positions that either mask or frame views through a large window at eye level. On this side of this wall, a flight of stairs descends into a cool recess in the earth. It provides access to views through a smaller window located two feet above the ground on the reverse side of the wall.[24]

Thus, one window was at the eye level of an adult and the other at the eye level of a child. In framing views of the landscape, these windows refer to the canonical Hudson River School paintings of the Catskill Mountains as a mythical and pristine landscape. Perspective, originally conceived in the Renaissance as singular and static, produced a view of the countryside as a "transparent canvas" (to use Leon Battista Alberti's metaphor). In *Utopian Prospect*, such a notion worked well on one side of the wall, but not the other. As the viewer descended the stairs,

a small window framed the landscape beyond. These viewing positions immediately made clear the power relations between viewer and viewed embedded in architecture. The windows in the wall both framed the landscape and framed fragments of the body. As a result, a person looking through the windows also became the object of the gaze of the person on the other side of the wall. "I am interested in abstraction," Robbins says. "In the atomization of body, you get these different pieces of the body, maybe that works to enhance this voyeuristic gaze that takes in pieces of the body."[25]

Robbins used the openings and a series of mirrors that were attached to the wall with metal arms, which allowed them to rotate, in order to deconstruct the regime of vision. The wall acted as a screen for looking at the surrounding landscapes from different points of view. Robbins explains,

> Most of the installation really uses quite a conventional notion of one-point perspective. The station points are fairly fixed and the horizon line is also fixed. All the activity happens like a kind of tennis game over and above that net. It's really the wall that acts as a sort of seam affecting what you can see or cannot see.[26]

On the side of the wall without the stairs, there was a bench made of bleached wood, which invited viewers to sit and lean against the wall to enjoy unobstructed views of the Catskills. The viewer's entire body would be in complete contact with the expansive panorama. This viewing position referred to the utopian agenda of the Byrdcliffe Colony—of living a simple life in unity with nature. The wall was versatile: it could either be a setting for interaction or it could be a protection from the rest of the colony, allowing solitude and contemplation.

> On the upper corner of wall, a metal rod holding a frame at either end would spin with the wind. As it moves the mirrored frame reflects, alternatively, the forest and the brown weathered structures [of the

colony]. It inscribes the view from behind into the landscape ahead of the viewer."[27]

Like an ever-changing collage, the mirror reflected a section of the forest or the buildings, and that reflection was inserted into the panorama of the landscape beyond. This device transformed the natural through the technology of optics but also allowed the viewer to appear in it, to "somehow always be inserted into the landscape away from which you were facing."[28]

As a deconstruction of perspective viewing, this pavilion reframed the utopian spaces of the Catskill Mountains. There are two distinct visions of utopia present in the project: one is of the natural landscape as depicted in the paintings of the Catskills by the Hudson River School, where nature is presented as "a fundamental reconciliation of man with all forces, that is, the primal Edenic state before man got there"[29]; the other is of a "very specific type of building for an arts colony, an utopian village, an ideal workers' colony without hierarchies, without standard societal views."[30] Both utopian visions meet in the line marked by the wall of *Utopian Prospect.*

### Anderson Anderson with Cameron Schoepp, *Prairie Ladder*, Plano, Texas, USA, 1994
(see pp. 100–101)

———

*Prairie Ladder* offered a different viewing position, one elevated forty-two feet (thirteen meters) above the ground on the uncultivated landscape of the Connemara Conservancy, a land trust in northern Texas. At the top of a steel ladder, set at a slight angle from vertical, sits a rectangular steel box clad with translucent fiberglass and shaped like a boat at the bottom. Visitor could climb the ladder and enter the box, from which they would see the great wilderness expanse of the Conservancy.

According to architectural critic Glen R. Brown, *Prairie Ladder* was a vertical axis set in contrast with the natural horizon of

the prairie, and as such it was "the defining characteristic of place-making and human settlement."[31] *Prairie Ladder* makes a direct reference to the *axis mundi*, the belief that the world is structured on a vertical axis, which, according to historian of science Giorgio de Santillana, takes on many forms in different cultures. Indeed, the myth of the heavenly mill, which rotates around the pole star and grinds out the world's salt and soil, is also associated with such an axis.[32]

*Prairie Ladder* altered "the viewer's physical and psychological perspective on the environment" and tapped into a fundamental, nomadic desire to move across wide, open spaces where the earth seems infinite.[33] In the words of Henry David Thoreau, "There are none happy in the world but beings who enjoy freely a vast horizon."[34] In contrast to *Utopian Prospect*, which worked on the meaning of framed views, *Praire Ladder* was about the view from above, the bird's-eye view of map-makers and land surveyors.

In the seventeenth century, Dutch painters developed a way to precisely represent the landscape from above in order to claim the value of place and polity. This is in contrast to the Italian (Albertian) perspective, which places the "viewer at a certain distance looking through a framed window to a putative substitute world," as the art historian Svetlana Alpers explains.[35] As one can see in Dutch landscape paintings, Dutch artists laid out a nonhierarchical grid over the landscape, whereas point perspective conceives of a "picture as a flat working surface, unframed, on which the world is inscribed. The projection is, one might say, viewed from nowhere. Nor is it looked through. It assumes a flat working surface."[36]

In Holland's golden age—the seventeenth century—the Dutch saw their landscape imbued with meanings inscribed by custom in the land. These customs were at the heart of the political, legal, and cultural issues that were debated at the time. In a similar way, the view from *Prairie Ladder*

also made a political statement: the ladder revealed the "inherent dangers of human intervention in a primal environment."[37] The result was a good fit between the conservation agenda of the Connemara Conservancy and the intentions of the architects involved in this installation. Both the architects and the Conservancy believed that wilderness should be isolated and preserved outside of its own history as a way to hold a mirror to society. Clearly, the message would be quite different if the ladder were erected in another locality, such as a strip mall.

Hovering far above the pristine landscape, *Prairie Ladder* clearly minimized its impact on earth by touching the ground at only a few points. This attitude toward the landscape recalled the Romantic tenets of the early conservation movement in the United States, in which conservationists were keen to designate land parcels that should be preserved as natural monuments. The Grand Canyon and Yellowstone River, for example, were chosen for their sublime qualities and because they corresponded to certain archetypes of grandeur. According to its architects, *Prairie Ladder* explored the "physical and psychological meanings of human settlement on the archetypal American landscape of the western prairie."[38] Here, the Romantic sense of grandeur has shifted to the western prairie as a symbol of the frontier, the discovery of new lands, and a sense of renewal and possibility.

### Ronit Eisenbach, *filum aquae: The Thread of the Stream*, Windsor, Ontario, Canada, 2000 (see pp. 102–3)

Rather than looking at the landscape through an opening in a wall, as in *Utopian Prospect*, or climbing a tower to view the land from above, as in *Prairie Ladder, filum aquae: The Thread of the Stream* opens the gap between the direct experience of being in a place and its cartographic representation. The installation explored the importance of narration in

the formation of national identity as argued by Homi Bhabha in his book *Nation and Narration* (1990). Before a boundary line is drawn—at which point the narratives of national identity take over—any territory is continuous. With the arrival of the division, undercurrents of tensions appear: tensions about border control, immigration rights, and cultural differences.

The installation began with the existence of a line on a map—the international border between Canada and the United States, which falls partly on the Detroit River—and the desire to physically inhabit this divider. This line divides the river as it marks the boundary between the city of Windsor in Ontario and the city of Detroit in Michigan. As the river flows south from Lake Saint Clair to Lake Erie, it is layered with multiple cultural, national, and international narratives. To follow her desire to inhabit this borderline, the architect and her crew traveled upriver in a small motorboat, systematically photographing the landscape on both sides and filming the wake of the boat drawing the borderline into the water.[39] Since there was no physical marking of the border on the river, they traveled along a series of invisible dashed marks equipped only with a navigational chart, a global positioning device, and a set of coordinates indicating the borderline's location. Pushed by the wind, currents, and yielding to large commercial boats, the team was continually pushed off course.

A series of documents, including images taken on the journey, were assembled and presented at the Art Gallery of Windsor in Ontario. Upon entering the gallery, visitors could compare the front pages of two newspapers, the *Windsor Star* and the *Detroit Free Press*, published on the same day on either side of the border, bringing attention to the ways in which similar events were portrayed differently by the media on either side of the border. The photographs of both shores taken during the boating expedition were assembled to create a ninety-foot-long (27.5 meters) photomontage—an alternate map—depicting the landscape of the United States below and of Canada above the centerline that stood for the border. In addition to the long photomontage, the projected video footage of the boat's wake allowed viewers to experience the occupation of the line between the countries. The installation captured the ephemeral and contradictory qualities of the border, to render the cultural and political fissures drawn through a flowing body of water.

# Mark Robbins

——

## *Utopian Prospect*

left
The stair descending to one side of the wall allowed for different positions in viewing and in being viewed. Here, dancers improvise in and around the installation.

right, top
There were ruins of the artists' colony present all around the site.

right, bottom
Lower frame

"*Utopian Prospect is a fragment…it's not just a fragment of the actual architecture, it's in some way a kind of distillation of the experiences of architecture.*"

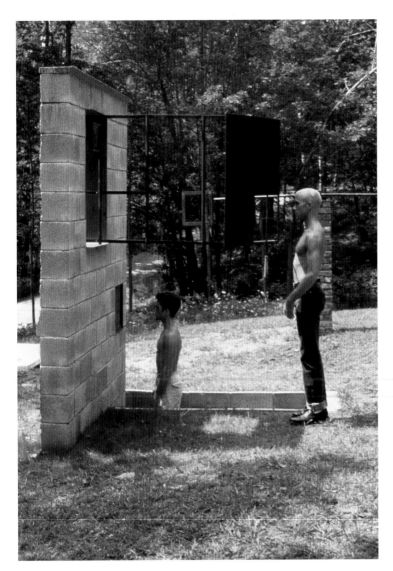

left
Rotating frames and mirror

right
Openings framed views of the
Catskill Mountains beyond.

*"The simplicity of the wall was somehow adjusted or
changed by the ability to move the shutter device and the
mirror. One moved with human agency; the other, more
mercurial, moved with the wind."*

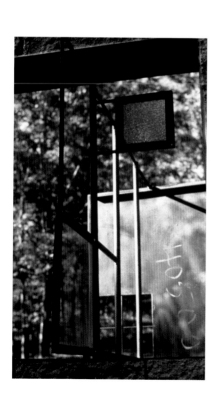

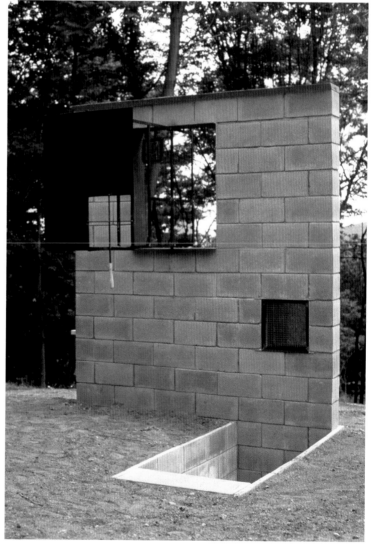

# Anderson Anderson with Cameron Schoepp

*Prairie Ladder*

top
The ladder allowed visitors to the park
to view the landscape from above.

bottom left and right
*Prairie Ladder* was built off site and
then brought in.

*"We wanted to increase our
understanding of the basic need
to alter natural space."*
—*Mark Anderson*

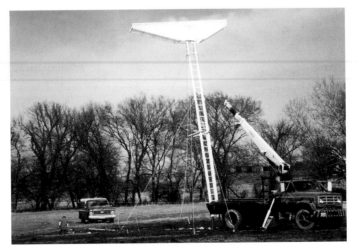

left
Night view

right
Day view

*"I found myself suddenly neighbor to the birds; not by having imprisoned one, but having caged myself near them. I was not only nearer to some of those which commonly frequent the garden and the orchard, but to those wilder and more thrilling songsters of the forest which never, or rarely, serenade a villager— the wood-thrush, the veery, the scarlet tanager, the field-sparrow."*
*—Henry David Thoreau,* Walden, or Life in the Woods

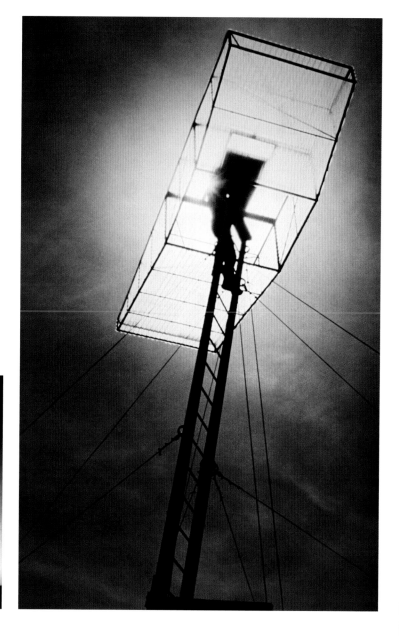

# Ronit Eisenbach

### filum aquae: The Thread of the Stream

right
Map of the Detroit River, with an inset of the motorboat's wake tracing the borderline in the river.

below
*Filum aquae*, the "thread of the stream," is a term used in the negotiation of territorial boundaries within a body of water between two countries. In the photomontage it is the central dividing line between the upper and lower half of each. It is also the deepest part of the watercourse and the international shipping lane for maritime traffic along the Great Lakes.

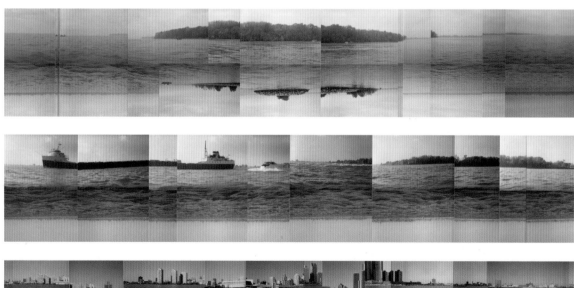

left, top
Visitors reading newspapers
published on the same day—the
*Windsor Star* above and the *Detroit
Free Press* below

left, bottom
Highway tape, referring to the
borderline, linked the various
elements of the installation and
took visitors on a journey through
the gallery.

right
View of the border room. The video
depicted the wake of the boat as
it sailed on the international border
on the Detroit River from Lake Erie
to Lake Saint Clair. The luminous
white tape created the illusion of a
glass pane dividing the room in two.
While listening to the sound of the
motor-boat, visitors straddled the line,
enjoying the paradox of standing
in two countries at once.

*"What does the world look like when one
inhabits and traces an idea?"*

## 3.3 THE PRIMITIVE HUT

For necessity or for enjoyment, people often dwell in small shelters surrounded by nature. Forms vary from the Japanese tea pavilion, to an ice-fishing shelter, to the Jewish *sukkah*, used for the harvest festival (the Feast of the Tabernacles). The simple hut is a cornerstone of architectural design and theory, and numerous debates on the origin of architecture have focused on it. One major reference in such debates is Abbé Laugier's *Essai sur l'architecture* (Essay on Architecture) of 1753, a philosophical meditation on the origins of architecture. Among the illustrations is included an image of a primitive hut. The engraving depicts a simple shelter built out of four tree trunks, with a roof made of branches. In the foreground a female figure (an allegory of architecture) calls on the viewer to interpret this rustic structure as the very origin of the building arts. Laugier argues that architecture was an art of mimesis, copying nature. He says that man "leaves the cave determined to compensate by his industry for the omissions and neglect of nature. Some branches broken off in the forest are materials for this purpose. He chooses four of the strongest, and raises them."[40] From this simple hut, Laugier derived all the essential elements of architecture, the rules governing them, and the combinations that may arise from them: "the upright pieces of wood suggest the idea of columns, the horizontal pieces resting on them, entablatures. Finally, the inclined members which contribute the roof provided the idea of pediment."[41] Since Laugier's hut does not resemble a real one, it is clearly an artificial construct, an abstraction that reduces architecture to its essential principles.

The next two installations can be seen as contemporary reworkings of Laugier's hut. Both installations reinterpreted the design of the primitive dwelling and its relationship to nature. *NhEW* by Tanja Jordan Architects and TK Architecture was a small mobile home intended for use in the wilderness;

and *Gardening Sukkah* by Allan Wexler relates to the outdoor pastimes of tending a garden and feasting.

### Tanja Jordan Architects and TK Architecture, *NhEW*, Copenhagen, Denmark, 1999 (see pp. 107–9)

*NhEW* was a minimalist transportable shelter for nomadic life in the Danish province of Greenland—"a cross between an anorak and a cabin," a second skin in a Nordic environment where clothing also serves as cushion and insulation. [42] The Modernist interest in lightweight materials and collapsible technology meshed with new technologies present in nomadic culture, such as wireless technologies and convertibility, in this installation. The installation was made of aluminum honeycomb panels and designed so that a future client could choose from a kit of parts over the Internet and get his mobile home delivered in a small crate. The design would allow the future inhabitant to travel, unpack the contents of the crate, and erect the *NhEW* within a day by snapping panels into place.

In an interview, architect Linda Taalman remarked, "I used to make forts in the backyard when I was little. Making *NhEW* with Tanja [Jordan] has been a little like that. *NhEW* feels like a backyard fort."[43] If the pediment and classical columns were the obvious choices for Laugier's "kit of parts," Taalman and Jordan cobbled together the elements dear to high Modernism: off-the-shelf hardware and materials that were not originally intended for building houses.

The mobile home was meant to be experienced in the midst of a natural environment, creating an association between the purity of nature and the simplicity of the shelter. The location of the *NhEW* was on the russet-colored grass of the park southeast of Copenhagen in wintertime. There, Taalman and Jordan fussed "over a string or a grommet, trying out a different sequence of panels or re-hanging the diaphanous nylon liner so that

it caught the light or billowed more beautifully."[44] The photographic record of the two architects setting up their house for the night is at the core of this installation. Many of the ideals of the project—transportability, lightness, affordability, honesty of materials—receded into the background as the two women built their shelter among the high grasses.

The architects designed the structure not to maximize technical sophistication but to highlight the concept of nomadism and to intensify the experience of winter within a shelter. The hut put the inhabitant face to face with the harsher aspects of nature, such as cold and wind, and pushed acceptable boundaries of endurance in order to increase contact with the environment. In this sense the transportable *NhEW* offered a counterproposal to outdoor temporary shelters that promise efficiency and comfort, a humble gesture set in opposition to expensive high-tech designs for winter camping.

In fact, Taalman and Jordan are actively suspicious of the idea of comfort, which they describe as "an undifferentiated state of triviality where the absence of stimuli engenders a numbness to the surroundings…. Discomfort is an alert, vigilant state."[45] As journalist Matthew Stadler wrote in his review of the work: "NhEW looked seductive even if it didn't actually promise to be comfortable. It looked like a pair of excellent shoes, cut so tight every painful step forward is also a delicious pleasure."[46]

**Allan Wexler, *Gardening Sukkah*, Ridgefield, Connecticut, USA, 2000** Installation commissioned by the Aldrich Museum for an exhibition called Faith. (see pp. 110–111)

———

The harvest is a time when farmers gather the produce that has been growing on the land to store it for the coming winter. Across cultures, harvest rituals bring communities together to share and celebrate the bounties of nature. The Jewish people celebrate the harvest by building a sukkah (" booth" in Hebrew), where people share meals, entertain guests, relax, and even sleep throughout the week. The sukkah is a memory structure that links back to a mythic narrative of the Exodus and reminds people of their gratitude for divine sustenance. Rebuilt and dismantled annually by individual families, it can be made of any material, but the roof must always be partially open to the sky in order to encourage a connection with nature.

Allan Wexler's *Gardening Sukkah* was a shed structure designed to dramatize the link between farming and dining. It was "a portable structure that contains all of the equipment for gardening and all the utensils for dining. So the *Gardening Sukkah* has the shovels and the picks and the hoe and a wheelbarrow as part of the shed."[47] His desire to connect nature and culture expressed itself through the tectonics of the shed, as he used ash for the floor joists—a wood commonly used for its strength and durability in the handles of gardening tools and wheelbarrows. In many ways the installation supported both the rituals of celebration and everyday activities of gardening. In creating it Wexler drew inspiration from the Japanese tea ceremony ("How can you make something really special out of something so ordinary like drinking tea?"[48]) and the pavilion that usually houses it:

> The level of detail is astonishing, every decision is made with incredible conviction and yet it looks like it's so easy and there was really no decision to be made. During the tea ceremony each minute step is isolated and reassembled as if one continuous action, like Muybridge's [photograph] that deconstructs a human action. This is a kind of deconstruction.[49]

As required, the *Gardening Sukkah* opened up to the sky during the festival and closed up for the rest of the year, with the table and chairs folded onto the walls so the space could become a storage shed for garden tools. In order to underline the

portability of his sukkah, Wexler extended the floor joists beyond the building envelope. The joists became three pairs of handles on one side and held axles for three wheels on the other, which enabled three people to tip the building and roll it around like a wheelbarrow. Traditionally, Wexler says, the sukkah hovers between natural and constructed, refined and rustic, home and homelessness. It is also about "being incomplete because it's about ideas of fragility, of being temporary, the idea of escaping from slavery and oppression and being on the run. It's a reminder of the fragile nature of our life."[50]

*Gardening Sukkah* also revisited and reworked Laugier's primitive hut. Unlike the minimal *NhEW*, which updated the primitive hut according to Modernist tenets, Wexler's installation referenced the rituals that occur within the sukkah as well as the ritualistic transformation of the hut each year from a common building to a sacred place. Gottfried Semper was the first to theorize the dialectic between ritual and form, says architectural historian Mari Hvattum. Semper was instrumental in arguing that architecture was an imitation not of forms or styles, but of human action. According to Hvattum the ritual—in this case, Christian rituals—was at the very center of both architectural form and the craft of architecture for Semper:

The ephemeral decoration of the altar, the precarious architecture of the procession or, in Semper's words, the "haze of the carnival candles" were not just phenomena at the margins of architectural discourse but constituting the very essence of architecture. Such ephemera were seen as primordial examples of the mimetic transformation from the ritual act to its built embodiment.[51]

In an interview Wexler rhetorically asked, "What does it mean to make a building that houses six people? How do you take a ceremony, a biblical requirement, and turn it into architecture?"[52] Wexler investigated these questions by exploring his own culture and creating a sukkah that, like the Japanese teahouse, speaks to the relationship between culture and nature.

The sukkah is a temporary hut, a prop that assists in the commemoration of the harvest and the forty years during which the Israelites wandered in the desert. Memory is explicitly embedded in its form and in the rituals taking place in and around the construction. The following chapter, "Memory," takes us into the mysterious and sometimes difficult realm of the remembrance of things past and shows how installations can act as vehicles to aid in this process.

# Tanja Jordan Architects and TK Architecture

*NhEW*

*NhEW* was a one-room dwelling, and its construction materials included fiberglass- and resin-faced aluminum honeycomb panels, felt, wool, fur, fleece, foam, nylon, Tyvek, and aluminized polyethylene.

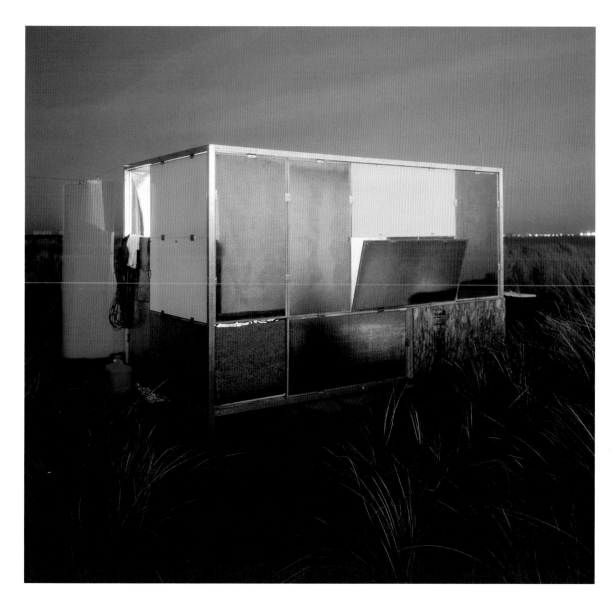

Photomontage of setting up
on the bluff.

*"The state of discomfort rouses the senses."*
—*Matthew Stadler*

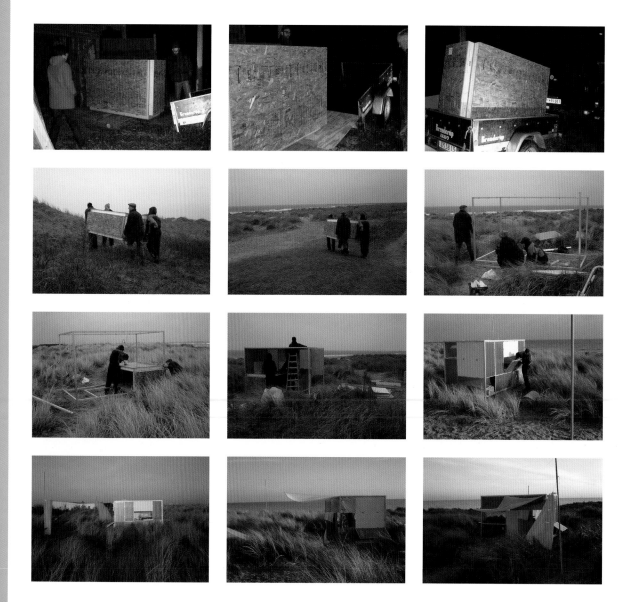

top
Detail of the house with its store-
front opened

bottom
The tiny house was erected to
provide shelter on a winter's night.

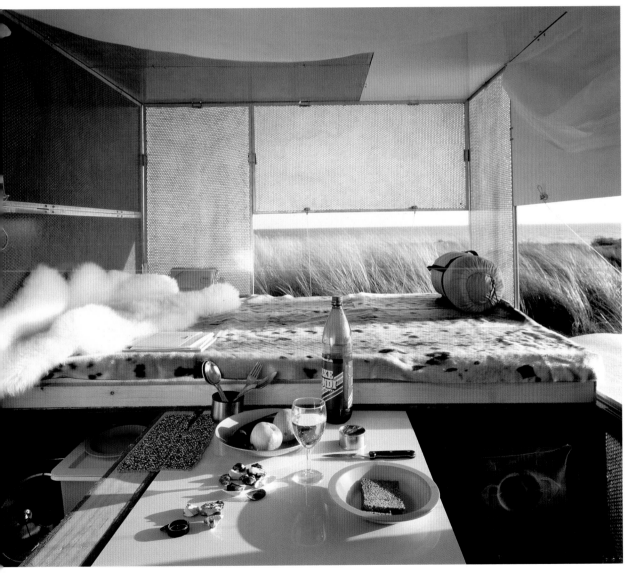

# Allan Wexler

---

*Gardening Sukkah*

top left
Opening the roof

top right
Cross section

bottom
Roof in open position for
the holiday

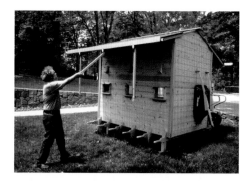

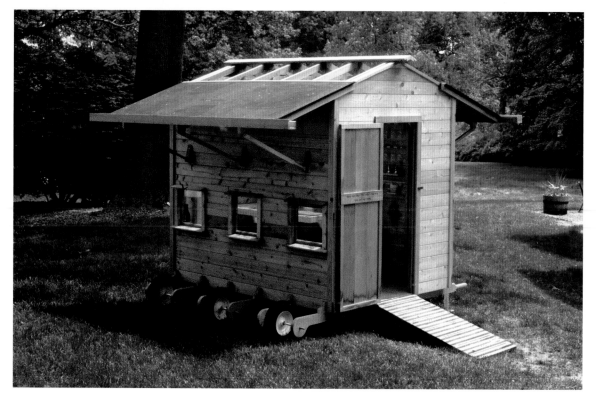

top
Interior view showing gardening tools
carefully set on the inside wall

bottom
Interior view showing dining utensils
on one side, gardening tools on the
other, and verdant boughs visible
through the open roof

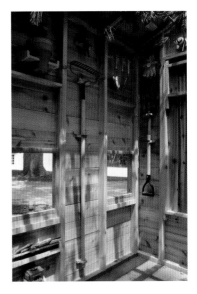

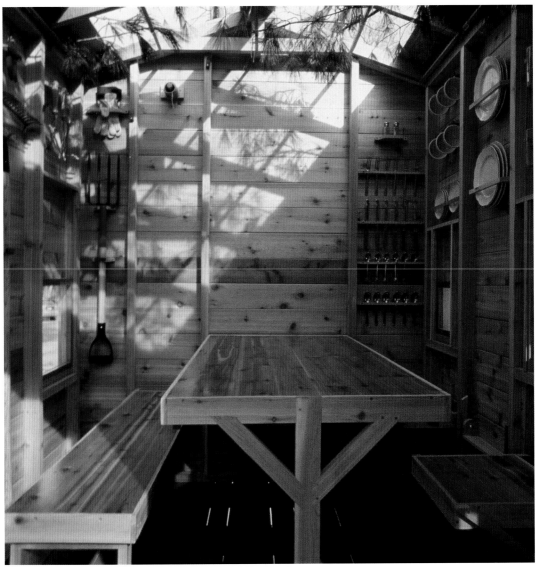

# 4. Memory

The last chapter closed with a sukkah, a ritualistic shelter that is a mechanism for reinforcing collective Jewish memory. The installations in this chapter also engage collective memory, and sometimes involve ritual. These projects do not focus on proposals for new buildings that embed memory into the built environment through conscious and unconscious references. Instead, they are ephemeral works that explore how the "relationship between memory and place is at once intimate and profound," as the philosopher Edward Casey puts it.[1] They create deeper understanding and generate public awareness of ways in which architecture conveys the past, and also test how such insights might eventually feed back into the design process. This thematic focus reveals these works as reflective of a larger zeitgeist. Rejecting the idea of the tabula rasa, architects are working to understand ways in which places are already burdened with pasts full of complex and conflicting meanings.

The following projects share the focus on change with which urban theorist Kevin Lynch begins *What Time Is this Place?*: "Change and recurrence are the sense of being alive—things gone by, death to come, and present awareness. The world around us, so much of it our own creation, shifts continually and often bewilders us. We reach out to that world to preserve or to change it and so to make visible our desire."[2] The works invite us to consider ways in which memory is a critical component in how people experience the built environment and understand change. They grapple with the promise of transformation and renewal, as well as the attendant sense of loss.

These installations are, to a greater or lesser degree, political actions. The architects' efforts generate public discourse about societal change, the stories societies tell themselves about such change, the effects of such change on the cultural and physical landscape, and the need to bring the stories and the built environment into harmony. With this work, these architects engage the question posed by James Young in his book *The Texture of Memory: Holocaust Memorials and Meaning*: "What is the relationship of time to place, place to memory, memory to time?"[3]

Through designed artifacts, environments, and orchestrated rituals, architects empower communities to address the transformation of their world, to counter dominant narratives and better reflect present-day values, and to imagine a future that incorporates and acknowledges both the erasure of memory and the traces of the past embedded in place. In the first section, "Abandoned Landscapes," architects, through their installations, create rituals that engage communities and allow societies to mourn loss, while continuing to move forward. "Reframing History: Counter-Memory," the second section, includes projects that confront dominant historical narratives of certain societies, forcing us to remember victims of aggression and injustice. In the final section, "The Once and Future City: Collage Strategies," architects use imagery to communicate to a larger public their ideas about urban memory and the relationships between the past and the future of the built environment.

## 4.1 ABANDONED LANDSCAPES

Whether we consider dramatic changes, like the Great Fire of London in 1666 or the desolation of New Orleans in the aftermath of Hurricane Katrina in 2005, or incremental changes—such as the construction of a new subdivision, the adaptive reuse of an industrial area, or the porch added to our neighbor's house—we expect the built environment to transform with time. The first two installations in this section comment on landscapes that have been radically affected by economic forces and depopulation—rural Finland and urban Detroit—and reflect on the relationship between change and loss. When large numbers of people leave their homelands, whether willingly or by force, the abandoned landscapes pose challenges—in the form of deserted buildings—to those who remain.[4] For the people who inhabit or once inhabited these places, these spaces and abandoned buildings are not empty. In their minds' eyes, these spaces are filled with images of places that are no longer, with people who once were neighbors, and with stories of events that once took place.

Fire is the metaphorical agent of transformation in these two installations. It is at once destructive—it can be used to terrorize people and destroy their homes—and civilizing— when controlled in a hearth, it is the center of a home, and, used purposefully in controlled burns, it can renew a field, stop other fires, and catalyze change.

**Marco Casagrande and Sami Rintala, *Land(e)scape*, Savonlinna, Finland, 1999** (see p. 119)

Although the depopulation of the rural areas of Finland began after World War II, it greatly accelerated in the 1990s, when the government began to invest in high technology over food production. Following Finland's entry into the European Union, the country has experienced the most rapid rate of rural depopulation in Europe, leaving fields neglected, farms abandoned, and houses emptied. As architect Sami Rintala has noted, this phenomenon has expelled meaning from the Finnish landscape.[5] Consequently, the centuries-old distinction between rural and urban life is disappearing as it has in many other areas of the world. In Finland, as a result of this emigration, the agricultural environment has been replaced by a suburban landscape—big-box stores are built on former potato fields. The once-ubiquitous wooden barns, traditionally used for sheltering the few animals spared from harvest slaughter over the long winter, are still found here and there, but they are slowly disintegrating into overgrown fields.

In *Land(e)scape,* Marco Casagrande and Sami Rintala chose to dramatize the radical transformation of rural Finland, focusing on the loss of farm buildings. "One day," says Rintala, "I awoke having dreamt that the barns in the area had begun to follow their owners to the city. They had long splayed out legs that elevated their torsos up above the abandoned fields."[6] This image guided Casagrande and Rintala's work in the Savonlinna region of southeastern Finland, where there are hundreds of handmade wooden barns. They placed a newspaper advertisement offering to remove unused barns, and, to their surprise, they received fifteen responses. Three of the most dilapidated barns, which weighed 3 to 4 tons (3,000 to 4,000 kilograms) each, were stabilized, lifted, and driven to an abandoned potato field adjacent to a highway. There, the barns were lifted five meters (fifteen feet) above the ground. After years of being invisible, the barns again garnered attention.

The installation culminated in a performance by the renowned dancer Reijo Kela in which the barns were "sacrificed" on September 29th, the night of St. Michael's Day, the traditional day for slaughtering animals. A large audience—who celebrated by roasting sausages around bonfires—

watched Kela end his performance amidst the structures by setting them on fire. The performance created a charged, cathartic atmosphere. As the buildings burned, they not only released people's feelings about changes in their lives and the culture of Finland, but for many of the elderly onlookers, it also unexpectedly evoked memories from the Winter War with the Russians, when buildings were burned and people were killed.[7] According to Rintala:

> We felt that burning was an appropriate way to end the life of a building that was handmade fifty or a hundred years ago. It gave the structure a way to speak out.... We wanted to acknowledge and show what the specific effects are on people, on culture, on places, and on a way of life with big political decisions. The question for us was, how to give an image to a process that nobody sees but everybody feels.[8]

By burning buildings rather than building them, Casagrande and Rintala emphasized both loss and catharsis. The installation and its final, destructive and transformative ritual gave people a way to experience that loss together and to reflect on its significance.

To understand installations that deal with the memory of vernacular culture, rather than monumental events, Pierre Nora's comprehensive study *Rethinking France: The places of memory* is a particularly useful reference.[9] Nora argues that the dissolution of traditional societies forces its members to identify places of memory and define what is memorable. As traditional societies disintegrate, and their rituals linking past and future are forgotten, we no longer inhabit a landscape infused with memory; rather, we inhabit one in which memories are deposited in particular isolated sites. As he states, "there are *lieux de mémoire* [sites of memory] because there are no longer *milieux de mémoire* [real environments of memory]."[10] As traditional cultures disappear, lived memory becomes history. Similarly, vernacular architecture shaped by traditional life and cultural values will soon be recorded only in history books.

The impact of *Land(e)scape* was farther reaching than the architects had imagined it would be. The timing of a meeting of the European Union agricultural committee, taking place near the Savonlinna airport, coincided with the duration of the installation. Because of the proximity of the meeting to the installation, some of the EU representatives visited the work and were inspired to add the issue of rural depopulation to their agenda. As the dialogue continued for two weeks, the project became a symbol of this phenomenon, stirring a national debate—covered by the national news—on the loss of traditional agriculture in Finland and in the European Union. Although there was ultimately no change in either EU or Finnish policy, and Finnish barns and the culture that created them continue to disappear, this installation created a space that acknowledged the idea of loss and marked the end of a tradition of memory and its entrance, through the journalistic coverage, into history.[11]

**Detroit Collaborative Design Center, University of Detroit Mercy School of Architecture, *FireBreak*, Detroit, Michigan, USA, 2001–ongoing** (see pp. 120–22)

In the first half of the twentieth century, the population of Detroit grew sixfold, from under 300,000 to over 1.8 million. Over the next fifty years, it shrank just as rapidly, as half of the city's inhabitants fled to outlying suburbs. Depopulated Detroit suffers from excess and lack—it has too many buildings and too much land, and inadequate schools and a decimated tax base. On the east side of the city, over 60 percent of the houses have been demolished or abandoned—carcasses of homes sit like junked automobiles by the side of the road.

Detroit's population loss is felt most keenly in residential neighborhoods and on long avenues that were once lined with

businesses. Arson has contributed significantly to the feeling of urban decay: during the 1990s the city lost 1 percent of its housing stock each year to fire. Fire—either set intentionally by arsonists or lit accidentally by squatters—has destroyed millions of abandoned homes. The skeletons of burned-out buildings linger for years before they are removed, becoming havens for crack addicts, refuges for criminals, and shelters for the homeless. For Detroit's remaining citizens, the buildings are both a psychological burden and a physical threat. In a recent mayoral election, one of the most pressing issues was the amount of public money each candidate would commit toward the removal of these abandoned structures. In this climate it is difficult for anyone—architect or resident—to imagine how one could effect change.

It is a particular challenge for architects to work in a city where demolition, or unbuilding, surpasses building, and where architecture has lost its value. In his essay "Erasing Detroit," architect Dan Hoffman frames this dilemma within the context of the profession, stating that "much of the ideology of architecture supports the organization of materials and energies toward the positivist idea of a building as a perfected instrument, however temporary as it may be."[12] In Detroit's current state, where many homes have no value and building demolition holds a major share of the construction market, it is necessary to reverse the assumption that construction is the only measure of progress. Dignified erasure or un-building and the public display of building remains in art venues became a means for architects to call attention to this situation and prepare the ground for the future. Examples include Jean-Claude Azar, James Cathcart, Frank Fantauzzi, Terence Van Elslander, and Michael Williams's methodical deconstruction of 9119 St. Cyril into its component materials and their display at the Willis Gallery (1989); Lorella Di Cintio and Jonsara Ruth's delicate display of paint curls collected from an abandoned home juxtaposed with priceless paintings at the Detroit Institute of Arts (2001); and Kyong Park and Dan Pitera's dismantling of 24260: The Fugitive House and its reassembly in art galleries internationally (2001–8).[13]

In 1995 the University of Detroit Mercy School of Architecture established the Detroit Collaborative Design Center (DCDC), a nonprofit center that offers architectural services to other nonprofit organizations and community groups in Detroit and that regularly conducts meetings with citizen activists to address the physical environment of the city. In one community meeting whose intended focus was a long-term planning effort aimed at imagining the city's future, frustrated participants shifted the conversation and raised a number of questions about their current predicament: "What can we do to change our physical environment tomorrow?"; "I have a burned-out building next to my house, what can I do about that?"; "The city certainly isn't doing anything…"[14]

DCDC's FireBreak project was born out of this frustration. It was a series of quick, simple, celebratory installation-performances fabricated and constructed with community artists and residents in burnt-out homes on Detroit's East Side that galvanized community members.

The four FireBreak installations—Skinned House, Sound House, Hay House, and Poem House—used simple acts of habitation, such as listening, hanging laundry, and decorating, along with more social activities, such as painting, music making, and poetry reading, to bring activity and life back to the abandoned homes. Twenty to thirty people worked for six hours to erect each of the projects. Like barn raisings, harvest festivals, or block parties, these installations built on the tradition of community gatherings to celebrate shared work and strengthen the bonds between neighbors. By reintroducing activity to abandoned homes, even fleetingly, the FireBreak installations involved the

**top left**

In this aerial view of Detroit's East Side, "the sites of removed dwellings are covered with black paint. The resulting patterns indicate that un-building overwhelms building and makes us consider erasure as a significant force in the urban environment." Dan Hoffman, "Erasing Detroit," Detroit, Michigan, USA, 1991

**bottom left**

A small Detroit dwelling was dismantled, shipped overseas, and reassembled. Kyong Park with Dan Pitera and University of Detroit architecture students, *24260: The Fugitive House,* Archilab, Orléans, France, 2001

**top right**

The architects purchased this Detroit house, slated for demolition, for one dollar. Jean-Claude Azar, James Cathcart, Frank Fantauzzi, Terence Van Elslander, and Michael Williams, *9119 St. Cyril*, Detroit, Michigan, USA, 1989

**bottom right**

The house traveled all over Europe. At each new installation site, it was reassembled and given a new context. The interior contained a video by Park describing Detroit's physical and economic condition, reflecting his perception of the injustice and political motivation behind this deterioration. Park with Pitera and University of Detroit architecture students, *24260: The Fugitive House*

**middle right**

The architects dismantled the house by carefully undoing the work of each trade in reverse order. As Dan Hoffman describes, "The piles of material were weighed against the body of memories that once made the house a home. The erasure of the evidence of this memory was the subject of this work." Azar, Cathcart, Fantauzzi, Van Elslander, and Williams, *9119 St. Cyril,* remains of the home exhibited at the Willis Gallery, Detroit, Michigan, USA, 1989

community and celebrated the historic vitality of the neighborhoods. As remarked by Dan Pitera, DCDC's director: "What motivates these artistic actions is the intense desire to transform a particular and distinct blight on the landscape into an asset—a way to turn a negative condition into a positive one."[15]

The installations also catalyzed action, bringing public attention to the problems of abandoned houses. Within a few days of each *FireBreak* installation, city contractors magically appeared to demolish not only the particular house that was the focus of that piece, but all abandoned houses within several blocks—houses that, for years, neighbors had unsuccessfully lobbied to have removed. Inspired by the success of the projects, other community leaders appealed to the design center to create *FireBreak* installations in their neighborhood.

While it is unusual for architects to help demolish houses, in this case razing was a necessary and welcome means to improve the environment. Disencumbered of their abandoned houses, residential lots become clearings, which were concrete signs of the neighborhood's capacity to effect at least minimal changes. Aptly named after the clearings cut into forests to stop fires jumping from tree to tree, the *FireBreak* projects impeded blight from consuming whole neighborhoods. The *FireBreak* actions united the physical and the spiritual remains of a series of Detroit neighborhoods, strengthening them in the process.

# Marco Casagrande and Sami Rintala

## Land(e)scape

top
The "walking" barns reminded people of the transformation of the landscape and surrounding culture.

bottom left
On St. Michael's Day, the traditional day for slaughtering animals, dancer Reijo Kela ended his performance by sacrificing the barn.

bottom right
Like a torch held aloft, the spectacle of burning buildings was amplified by their elevation above the ground.

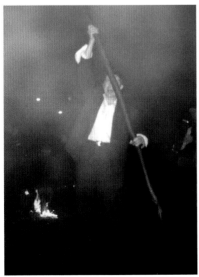

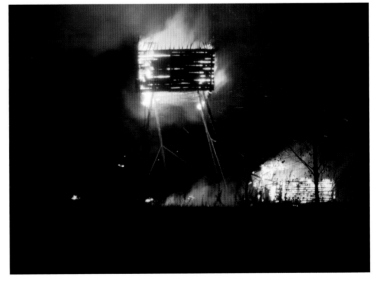

# Detroit Collaborative Design Center, University of Detroit Mercy School of Architecture

## *FireBreak*

As homes were razed, residents turned vacant lots into fields and gardens, and crack houses became barns. *Hay House* honored Detroit's urban farmers; one house was covered with three thousand miniature bundles of hay, which were ritualistically nailed to the facade by one hundred residents. DCDC and UDMSOA, *Hay House*, Detroit, Michigan, USA, 2001

top

For a few hours during the course of the installation, Cajun music joined the wind blowing through the empty structure to reanimate *Sound House*. Motown's citizens gathered to listen to the music. The billowing orange drapes hung in the openings, shielding the interior from view, restored in a small way a sense of decorum and privacy. DCDC, *Sound House*, Detroit, Michigan, USA, 2001

bottom

The last coat of paint *Skinned House* received preserved the haptic memory of the home, but not the house itself. Like a rubbing that takes a direct image of a gravestone, the liquid latex produced a shroud that bore the traces of labor and decay. DCDC, *Skinned House*, Detroit, Michigan, USA, 2004

left, top
Denise Sedman's untitled poem
challenged the American Dream
of owning a single-family home with
a white picket fence. Community
members wrote words from the poem
with lighter fluid on cotton cloth and
were audiotaped reciting their line of
poetry. Sara McDuffee and Jessica
Schulte with DCDC and UDMSOA,
*Poem House*, Detroit, Michigan,
USA, 2002

left, bottom
Like Tibetan prayer flags, this
"laundry line" of torched words was
ceremoniously hung around the
perimeter of the torched house.
McDuffee and Schulte, *Poem House*

right
This house merged word and
structure, as the poem was "re-sited
and recited" onto the burnt building.
An audiotape that spliced together
each participant's reading of one line
of the poem was played loudly and
projected for all to hear from within
the house. McDuffee and Schulte,
*Poem House*

*"As people wrote their lines, the words seeped into the fabric
and evaporated. Initially, the burning pulled the words out
of the cloth, but, quickly, the fire distorted them."*

*"When we placed the voices reading the poem inside
the house, it was as if the house was reading to us."*
*—Sara McDuffee and Jessica Schulte*

## 4.2 REFRAMING HISTORY: COUNTER-MEMORY

———

While we often think of memory as a personal experience, this is not the case with public memory of larger social events. The way events are recalled has a political dimension that both shapes and reflects the identity of a community. In their introduction to "Memory and Counter-Memory," historians Natalie Zemon Davis and Randolph Starn remind readers of this condition and suggest that whenever memory is invoked, one should ask what is being remembered "by whom, where, in which context, against what?"[16] Their suggestion is enacted in recent considerations of artists and architects considering the intertwining of memory and place.

The built environment is inscribed with complex cultural, political, and social histories that are often in conflict. In contrast to the two previous installations, the following installations bring attention to suppressed versions of the past. By raising the voices of those previously silenced, the installations reveal the fundamental biases of official histories and acknowledge a politics of memory. In remembering those who are unlikely to be heard or can no longer speak for themselves, these projects foreground controversies that urban theorist Dolores Hayden considers critical:

> Architecture, as a discipline, has not seriously considered social and political issues, while social history has developed without much consideration of space or design. Yet it is the volatile combination of social issues with spatial design, intertwined in these controversies that make them so critical to the future of American cities.[17]

By recognizing the politics of memory, these installations help forge a more inclusive "cultural citizenship," as anthropologist Renato Rosaldo and historian Rina Benmayor have defined it. Cultural citizenship is an identity that "is formed not out of legal membership but out of a sense of cultural belonging....It draws upon difference as well as commonality and helps us understand the heterogeneity of constructed identities."[18] This more inclusive conception of cultural citizenship expands the definition of *public* to include groups historically marginalized, and reshapes our understandings of the spaces that we share.

**Richard Kroeker, *Eye Level*, Halifax, Nova Scotia, Canada, 2002** (see p. 129)

———

In North America there still exists a cultural fault line between the continent's aboriginal inhabitants and colonial settlers. In Canada it was not until 1982 that existing aboriginal and treaty rights were recognized in an act modifying the Canadian Constitution, setting the stage for a profound change in the relationships among the nation's peoples. After five hundred years of a relationship primarily characterized by domination, paternalism, and assimilation, the change toward partnership and cooperation with aboriginal people was one that most provincial governments have found difficult to embrace.[19]

*Eye Level* reexamines the way a history of domination is written into the environment. In the center of Cornwallis Park in Halifax, Nova Scotia—named after the city's founder and first British governor—is a bronze statue of Edward Cornwallis, erected in 1931. The larger-than-life figure stands three meters (nine feet) tall atop a stone base with a plaque describing his contributions to the city. Though revered in colonial narratives as Halifax's founder, he is remembered differently by the aboriginal Mi'kmaq population: shortly after his installation as governor, he infamously placed a bounty of ten British pounds on all Mi'kmaq, including women and children. This genocidal campaign continued for more than a decade until 1761, when the Mi'kmaq negotiated the Treaty of Peace and Friendship with the British crown.

Richard Kroeker, an architect who works closely with the Mi'kmaq community,

designed *Eye Level*—a hybrid medieval siege weapon and elevated pulpit—to counter the official memory represented by Cornwallis's statue. Constructed from scavenged wood with the aid of students from Dalhousie University, the heavy scaffold was wheeled down the steep streets of this port city and pulled into position directly in front of Cornwallis's statue. Raised to its full height, it formed a five-meter-high (fifteen feet) staircase that brought participants eye-to-eye with the statue. One by one, people climbed the rickety stairs. From the top of the scaffold, Corwallis's infamous proclamation in which he placed a bounty on Mi'kmaq people was read aloud. A critique of Cornwallis, and the observation that his proclamation was depicted neither in the monument nor elsewhere in the park, was then presented to the public.

Since the goal of this installation was to spur public reevaluation of Cornwallis and generate a debate about the recollection of the past, the group planned a demonstration and notified the press. Members of the group passed out leaflets providing an alternative history of Cornwallis to the citizens who came to witness the event. The press covered the demonstration, which provoked lively discussion in Halifax. In Kroeker's words, the project "jump-started a discussion that needed to take place and got people to express publicly what they would only say in private."[20] On one hand, word reached members of the Mi'kmaq community, who "felt some joy" that others generated the protest without their involvement.[21] On the other, Kroeker received a number of phone calls from people objecting to the installation. The callers asked him questions such as: "Should we hold Cornwallis up to contemporary standards?" (implying that by the standards of Cornwallis's time, his actions were not immoral); "You do know that the Mi'kmaq also killed the British people?" (suggesting that there was a symmetry between defending one's territory and being invaded);

"Where are you from?" (indicating that since Kroeker was from another part of Canada, he was inappropriately hoisting imported values upon Nova Scotians).[22] These reactions disclose the difficulties faced when providing an alternative to a dominant narrative, even in the context of the altered legal status of Canada's First Nations. Changing law is one thing, but not everyone is ready to change the story. Philosopher and sociologist Maurice Halbwachs's insight that we construct and reconstitute the past as a way to reinforce identity in the present reminds us how critical it is to challenge accepted history. For without these revisions, it is unlikely that Canada will ever fulfill the promises that the legal change in status implies.

*Eye Level* offers a corrective lens that reveals the distortions in the victor's history. Although the group did not have to face Cornwallis in person, their public act—challenging his reputation and a story revered by many—was a courageous one. This work reminds us that while we cannot change the past, we can shape how its history is told and take responsibility for the values carried forward. In Kroeker's words: "It is an issue for everyone. When there are atrocities committed, it is not just the wronged party that's called on to restore justice. If we're in this place, we are part of its history."[23]

**Craig Barton, Nathaniel Quincy Belcher, Lisa Henry Benham, David Brown, Yolande Daniels, Mario Gooden, Walter Hood, Scott Ruff, William Daryl Williams, and Mabel Wilson, *Places of Refuge: The Dresser Trunk Project*, traveling exhibit, Eastern Seaboard, USA, 2007–9** (see pp. 130–31)

The smallest installations included in this book are these eleven works placed within dresser trunks that have traveled up and down the eastern seaboard of the United States. *Places of Refuge: The Dresser Trunk Project* brought ten architects, artists, and

landscape architects together to create works that shed light on the black experience in America. According to curator and organizer William Daryl Williams, these "memory boxes" collectively chronicled "the lost stories, memories, and places of refuge for black travelers during segregation."[24]

Travel allowed for the central thread of the exhibit, the showcase of African American communities along the Southern Crescent rail line that linked New York City to New Orleans. The traveling exhibit then followed the path of the Crescent Line to venues along the eastern seaboard and throughout the southern states. Each participant, save one, produced a trunk that told the story of the places of respite and culture for black travelers during segregation. Buildings highlighted in the installation included the Glory Hole club in Harlem, New York; the Coleman Hotel in Newark, New Jersey; the Whitelaw Hotel in Washington, D.C.; the Carver Inn in Charlottesville, Virginia; the Littlejohn Grill in Clemson, South Carolina; and Rickwood Field in Birmingham, Alabama, America's oldest ball park, which was shared by two professional baseball teams—one black, the other white—on and off from 1923 to 1960. A few trunks focused on cities or black districts within cities, such as Philadelphia, Charlotte, New Orleans, and Fifth Street in Meridian, Mississippi; while others reflected on qualities of discrimination, such as Yolande Daniels's trunk, entitled *de Facto/de Jure* (by rule of custom/by rule of law).

*The Dresser Trunk Project* amplified the history of de facto and de jure spatial segregation that was a central fact of life in the Jim Crow era, a time when all public spaces, services, and buildings in southern states were zoned into white-only and colored-only areas. Similar practices were also a fact of life in northern states, but they were established by custom, not law. This condition led to the publication of books like *The Negro Motorist Green Book* travel guide, whose stated aim was "to give the Negro Motorist traveler information that will keep him from running into difficulties, embarrassments and to make his trip more enjoyable."[25] Within this context of institutionalized, legally sanctioned, as well as de facto discrimination, African Americans craved spaces of respite, comfort, and cultural validation. At the start of the project, the curator shared a copy of the historic travel guide with the participants.

The open trunks allowed glimpses into the world of segregation-era black travelers by sharing information with viewers. For example, during the time of Jim Crow, black travelers visiting Newark, New Jersey, were made to understand that they were not welcome, no matter how accomplished they were or how well-known to the white community. Consequently, a parallel black district developed in Newark that has subsequently been erased. In 1944 the Coleman Hotel, owned by the four singing Coleman Brothers, was a "vibrant cultural Mecca for blacks."[26] Located in Newark's Central Ward, the hotel contained "a barbershop, a restaurant, a swank cocktail lounge, and the Colemans' own recording and broadcast studio for their record label, along with fifty rooms that filled six stories of the building."[27] Billie Holiday, Ruth Brown, Louis Jordan, Duke Ellington, and Sarah Vaughn, among others, all stayed and performed at the Coleman Hotel. The music remains, but the building does not.

Architect Mabel Wilson brought this building to life by imagining personal items carried by travelers and the sounds created by the comings and goings of people and musical instruments. Her *Dresser Trunk* played recordings of the songs of these illustrious performers and displayed personal items, such as scarves, razors, toothpaste, and notes, cast in resin blocks "like insects trapped in amber."[28] When the trunk was closed, an interior light illuminated the building's image and suggested the life within.

The Whitelaw Hotel, also known as "The Black White House," was located in

Washington, D.C., south of the Mason-Dixon Line, where segregation was the law. Built in 1919 by John Whitelaw Lewis, the hotel was unique in that it was designed, built, and financed entirely by blacks. Many travelers came by train to the Whitelaw to attend the national meetings of black organizations. Often, the unionized Pullman Porters also stayed at the hotel. These porters, African American men who crisscrossed the country on the railroads caring for passengers in the sleeper cars, were well-respected members of the African American community and "played a critical role in the pollination of ideas and culture" since they maintained contact with African American communities across the entire country during segregation.[29]

Fascinated by the Pullman Porters, William Daryl Williams modeled his trunk on the spatial and racial negotiations they engaged in as they worked:

Innocuously made from wood scavenged from shipping pallets, the trunk remains mute when closed, emptying any space with its presence. Once opened, the trunk reveals the story of the Whitelaw by coming apart like a puzzle whose interlocked pieces mirror the complex relationship between race, space, memory, and place.[30]

Articles, texts, and images hidden within testify to three different spheres of life at the Whitelaw: events, such as a conference discussing the anti-lynching bill before Congress; visitors who stayed and lived there, like Ellington, Cab Calloway, and the Pullman Porters; and the U Street corridor, the heart of D.C.'s black culture and the location of Howard University, the preeminent historically black university in the United States. This was where travelers from the north passing through Union Station in Washington, D.C., the nation's capital, crossed a threshold into de jure segregation: it was where southbound black travelers were required to switch into segregated cars.

Like the small door in *Alice in Wonderland* that led to an alternate world, the mementos, testimonies, and images contained within each trunk allowed viewers to enter places they could no longer visit and created the illusion that the trunk's interiors were larger than the spaces they physically occupied. The contents of Scott Ruff's trunk expanded beyond the container's boundaries. Unpacked, the contents formed two stools and a table covered with pictures illustrating the historic African American district of Fifth Street in Meridian—it set up a place for a conversation about the present-day dilapidated state of this once-bustling district. Ruff's project probed the value of remembering places associated with the African American experience and suggested the necessity of dialogue to determine how to best do so. It articulated the challenges and revelations implied in the other projects: Do we care if these sites are lost? Will a culture be lost with them? What role should African American architects today play in preserving this past? What role should the rest of us play in preserving this inheritance?

Jim Crow may be long dead, but he has cast a long shadow over the present and will do so into the future. Williams states, "Beyond preservation…[*The Dresser Trunk*] project aspires to pass on memory as a form of inheritance upon which communities can build and in many cases rebuild. It is striking how the acknowledgment of this history helps people to construct lives and communities in the future."[31]

The introduction to the project notes:
The timeliness of *The Dresser Trunk Project* is evident as numerous communities are awakening to the reality that the preservation of their unique heritage is a critical component of cultural and economic development. Places like the Whitelaw Hotel in Washington D.C. and the Dew Drop Inn in New Orleans have survived, but many others have been lost and/or forgotten. This project strives to stem the tide by linking isolated places together in a chain

that gives each their rightful place in architectural, music, and cultural history. Many of these hotels, clubs, and other sites are being lost to the ravages of time and the pressures of development. Unfortunately, many do not qualify for historic designation as individual structures. This project strives the stem the tide by linking isolated places together in a chain that restores each to its rightful place in architectural, music, and cultural history. However, when they are seen as part of the larger cultural phenomena of segregated travel, whose influence is still felt today, their memory if not their physical existence can be preserved.[32]

Maintaining such memories is important, as Hayden suggests in *The Power of Place*, which lays out the theoretical argument for an urban history that is inclusive of broad social and cultural meaning and presents progressive solutions that reveal suppressed stories of gender, culture, and class. Through memory we can "create public places, in all parts of our cities, to mourn and to celebrate who we really are," and so more people can see themselves as part of the landscape.[33] For black architects who come from communities that have had fewer opportunities to build and, consequently, fewer chances to leave their mark on the built environment, this project brings to mind a double erasure as a result of marginalization; there is little evidence in the built environment of the past of African Americans, and now what was built is now being destroyed.[34]

### John Hejduk and the Architectural Association community, *The Collapse of Time*, London, United Kingdom, 1986
(see pp. 132–33)

———

While the previous two installations raised particular silenced voices, the next project, part of the *VICTIMS* proposal by John Hejduk, works abstractly on the relationship between memory and architecture. With the Postmodern critique of Modernism's disregard for history came a resurgent interest in the theoretical and practical role of memory and meaning in architecture. As questioning of the functionalist basis of Modernism took hold, architects sought to recover the perceived loss of meaning by developing an architecture to tap into history and collective memory. This interest in memory manifested itself in a number of forms: for example, Aldo Rossi's use of typology, described by Raphael Moneo as a "juxtaposition of memory and reason" shaped by personal experience; Peter Eisenman's interest in urban memory as "a sign, a record of past events that are part of a collective"; and Hejduk's contemplation of the ways in which narrative and mythic structures tap into a culture's deep memory.[35]

According to architect and former Hejduk student Dan Hoffman, when confronted with the work of Rossi, Hejduk wondered, "Can architecture be a vehicle to convey memory?"[36] Hejduk explored this question through unbuilt works that united ritualized performances with physical structures through drawings, prose, poetry, and written directives. *VICTIMS*, a memorial for the city of Berlin, and *The Collapse of Time* were developed during this period.

These proposals consist of a set of characters, architectonic structures, and instructions that directed future events. They mark absence and create meaning through ritualized performances, actively engaging people in commemoration and the construction of memory. On one hand, *VICTIMS* appeared to be dedicated to the victims of the Nazis, given that it was planned for a site in Berlin, "which had formerly contained [a] torture chamber during WWII."[37] On this site, Hejduk proposed sixty-seven structures be built over the course of two thirty-year periods by the city and citizens of Berlin if they chose to remember the victims in this way. On the other hand, the title, like an

empty vessel, suggested an open set of victims—a placeholder that could be filled by victims from any time, culture and place—for every human society has produced victims. Hejduk suggested that it is up to each society as well as individuals to decide whether, and how, to acknowledge the victims of the society's past.

Different characteristics of time, an important dimension of memory, were recognized in these proposed installations. Hejduk's proposed memorial was living, marking time and with it the fading from memory of the victims. Time both stopped and continued endlessly. Thirty years later, trees planted at the project's start would be taller than the children who planted them and the structures themselves. A trolley circled endlessly around the site; a "clock" portrayed both fixed and continuous time.

*The Collapse of Time,* a clock tower that "marked time" through its collapse and covered up the "correct time," became Hejduk's first project from *VICTIMS* to be translated into built form, but not in Berlin. Hejduk's vision of a nomadic, memorializing work that travels from town to town, engaging townspeople as performers and onlookers, inspired students and faculty at the Architectural Association to erect this project in his honor on the occasion of his visit to London in 1986.[38] The monument was installed in Bedford Square in conjunction with an exhibition at the Architectural Association that showcased the series of drawings constituting *VICTIMS.*

*The Collapse of Time* paper proposal consisted of three elements: a clock tower mounted on a caisson, a security structure, and a poetry booth. All three items were to be placed on wheels, so they could be moved from place to place as the ritual unfolded. Hejduk wrote,

These elements will be moved from place to place. Each place [community] agrees to erect a high wood pole with a pulley system at the top of the pole, from this pulley system a wood chair can be suspended…. A man chosen by the town climbs the pole and sits on the wood chair facing the vertical clock. The clock then begins its backward descent [to a horizontal position] over a twenty-four-hour period.[39]

In sync with the clock's rotation, the man sitting on the chair would be slowly lowered to the ground. Reaching back in time to a story of beginnings, a townswoman sheltered within the booth would read Hejduk's poem "The Sleep of Adam," until the clock tower fell slowly backward from its upright posture, to sleep or perhaps to die.

As the earth completed its full rotation, the tower would reach its position of rest, the chair would be removed, the book would be nailed to the pole, and the townspeople would tow the structures to the next town. Book, pole, and memory would remain as souvenirs. The clock would be resurrected in the new location, ready for the next commemoration.

To Hoffman, Hejduk's project suggests that it is memory that is the victim of Modernism. The clock's rotation from the vertical position to the horizontal presents the idea that "time, through the modern period, through modernism, [is] collapsing and becoming simultaneous…. The victim of that collapse potentially is memory. Because if everything is simultaneous, everything is happening at the same time, memory is lost."[40] Hoffman's interpretation connects a critique of Modernism with the other projects presented in this section. His interpretation raises the question of whether Modernist ideas such as that of the tabula rasa somehow ruled out the raising of the voices of victims of a society's past.

# Richard Kroeker

## *Eye Level*

top left
Participants wheeled the folded structure from the architecture school down to the park.

top right
Like a medieval siege weapon ready to breach a city wall, the "counter-monument" was wheeled up to the statue.

bottom right
The installation made front-page news in Halifax, bringing the debate to the wider public. Photographer: Mike Dembeck, courtesy of the *Halifax Daily News*

bottom left
The structure in turn made a monument of the person who climbed it. When the challenger looked back, she saw the world from the statue's viewpoint.

*"When we folded up the structure…it felt slightly unfinished. There should have been another version to pull behind a vehicle to confront figures like this in cities all over the world."*

*"The higher you climbed the shakier you felt. When you looked into Cornwallis's little bronze eyes, it felt like you were confronting the person, like he was really in there."*

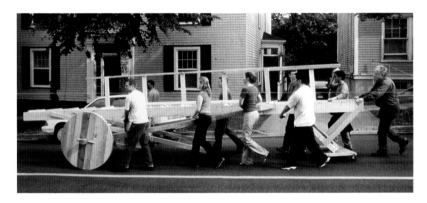

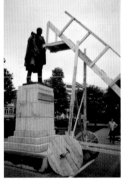

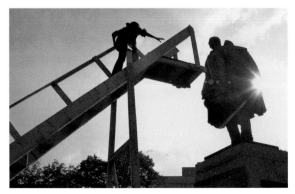

# Craig Barton, Nathaniel Quincy Belcher, Lisa Henry Benham, David Brown, Yolande Daniels, Mario Gooden, Walter Hood, Scott Ruff, William Daryl Williams, and Mabel Wilson

*Places of Refuge: The Dresser Trunk Project*

*"Once opened, the trunk reveals the story of the Whitelaw [Hotel] by coming apart like a puzzle whose interlocked pieces mirror the complex relationship between race, space, memory, and place." —William D. Williams*

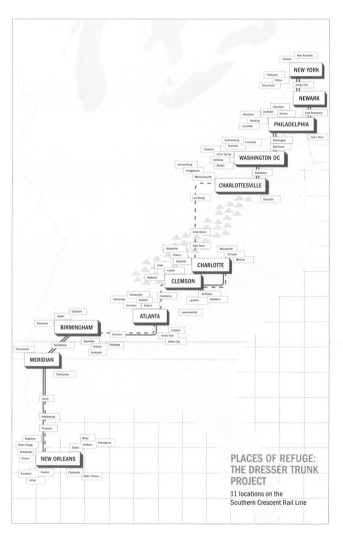

PLACES OF REFUGE:
THE DRESSER TRUNK
PROJECT
11 locations on the
Southern Crescent Rail Line

opposite, left
This map indicates cities along the Southern Crescent Rail Line from New York City to New Orleans. Until 1964, segregation was legal south of the Mason-Dixon Line and customary north of it.

opposite, top right
Unlocked interior. William Daryl Williams, *Whitelaw Hotel, The Black White House, DC*

opposite, bottom right
Images of the now derelict but once bustling African American urban district of Meridian are stored within this trunk. Scott Ruff, *Meridian Mississippi*

top right
This interactive traveler's manual presented the shifting laws and customs that defined segregation. Yolande Daniels, *de Facto/de Jure*

bottom left
The only known image of the Coleman Hotel was incised into the suitcase's exterior. Wilson, *Hotel Coleman*

bottom right
Exhibitied in venues along the Crescent Line, the dresser trunks followed the path of black entertainers. At Elmaleh Gallery, University of Virginia, the blue interior and fossilized sundries of Mabel Wilson's Dresser Trunk honored the Coleman Hotel in Newark, New Jersey. Wilson, *Hotel Coleman*

*"The rich interior is 'electric' with the remnants and remains of the 'sounds and smells of happenings' calculated to suggest the Hotel Coleman at its heyday in 1944." —Mabel Wilson*

# John Hejduk and the Architectural Association community

*The Collapse of Time*

top
Hejduk's drawing is one in a series that depicts the stages of a commemorative performance for unnamed victims, which would be repeated in towns throughout Europe. Volunteers tow *The Collapse of Time* structure to the next site.

bottom
Hejduk's structures await the townspeople—from left to right, *Security*, *The Collapse of Time Clock*, the *Poetry Booth for Eve*, and pole equipped with a chair for "Adam," who descends with the clock's collapse.

*"I am obsessed with time and have recently created time pieces…clock towers. One of my recurrent persistences is that present time cannot be seen…present time has an opacity…present time erases…blanks out time."*
—*John Hejduk*, The Collapse of Time

*"It was a clock that slowly descended… even the elements had a temporal relationship."*
—*photographer Hélène Binet*

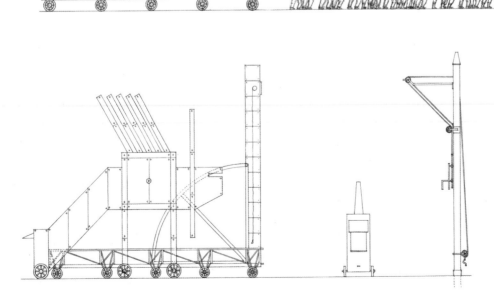

top
Installed in Bedford Square, London

bottom left
*The Collapse of Time* was built with
unfinished timber, large steel train
wheels, and a thick rope that was
used to guide the tower's descent.

bottom right
Detail of twenty-foot-high (seven
meters) clock

*"While Eve waited*
*inside of Adam*
*she was his*
*structure*
*her volume*
*filled him*
*his skin hung*
*on Eve's form*
*when God*
*released her*
*from Adam*
*Death rushed in*
*preventing collapse"*
*—John Hejduk,*
*"The Sleep of Adam"*

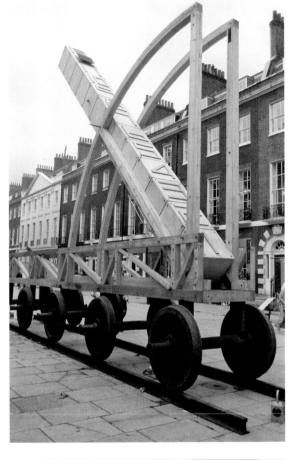

## 4.3 THE ONCE AND FUTURE CITY: COLLAGE STRATEGIES

The final two projects in this chapter reflect on the role of memories associated with place in shaping the future of the built environment, as cities continue to evolve and change. *Berlin: A Renovation of Postcards*, by the architect Lois Weinthal, considered the memories associated with public spaces in the former East Berlin in light of the city's past division and its future under reunification. In Old Montréal, *Projections*, by Atelier in situ, superimposed photographs recalling the former function and projecting potential futures onto the surfaces of an abandoned grain silo, creating memorable images of past, present, and possible futures combined.

Both projects operated by creating photomontages and inserting them into or onto architectural and urban settings. These particular installations brought architects' particular perspectives and readings of the city, and their attendant meanings, to the public eye by addressing significant landmarks and plazas that were central to the identity of each city. In focusing on these urban landmarks, these projects demonstrated the truth of Aldo Rossi's idea of "urban permanences": that there are particular, unique locations in which there is a continuity of experience, where we are conscious of the past as a part of our experience of the present.[41]

**Lois Weinthal, *Berlin: A Renovation of Postcards*, Berlin, Germany, 2004–5**
(see pp. 139–41)

This installation was a series of photographic montages installed as advertising billboards on the passenger platform of the Friedrichstrasse underground station between December 2004 and February 2005. Friedrichstrasse served as the threshold between East and West Berlin before the reunification in 1990; only people with

appropriate documents could pass from one side to the other.

Weinthal inserted tourist postcards of East Berlin (taken mostly between 1961, when the wall was erected, and 1989, when it was demolished) into large panoramas of present-day Berlin she photographed. During the development of the work, Weinthal visited the sites shown on the East German postcards and asked people what they saw in the cards. They shared stories they associated with each place, calling attention to details that she would never have noticed. For example, one person pointed out the empty pedestal in front of the German Historical Museum and explained the mystery behind that absence.[42] These details added a dimension of memory and knowledge to the images. The postcards served as a vehicle to examine the ways in which the physical environment contains evidence of history, politics, and memory— through both presence and absence.

Weinthal noticed that as a result of their different experiences, culture, and political background the observations of the interviewees from the East differed from those from the West.[43] The panoramas provided evidence of one aspect of this difference: they documented the advance of consumer culture into East Germany, capturing details such as advertisements, clothing styles, and cars. Together, the superimposition of the postcards onto the panoramas addresses the meeting of East and West after the fall of the Berlin Wall, and the subsequent diffusion of West German culture and capital into the East.

Weinthal's montaged image of the Lustgarten, the "pleasure garden" of the storied Stadtschloss (Berlin City Palace, completed in 1845), and the debate around its redevelopment, illustrate the power of her project. A 1912 postcard portrayed the palace, which was the principal residence of the German emperors until the fall of the monarchy in 1918, at which point it became a museum. Damaged by Allied bombing during

the Second World War, it was later demolished by the East German government—to erase the "reminder of Prussian militarism and bourgeois values"—and replaced with the Palace of the Republic, an important arts-and-cultural center with a cinema, a theater, a bowling alley, and cafes.[44] This concrete-and-orange-colored-glass building is visible in the contemporary panorama.

After the fall of the Wall, debate began among Berliners about the future of many East German buildings and public spaces. The debate raised polarized views about whose memories of the past should be maintained as a part of the identity of the city. Some people argued that history (and the Palace of the Republic) should be retained as a reminder, even if it was "ugly, both in content and aesthetics."[45] Others argued that it was time to beautify the area, and that rebuilding the Stadtschloss would restore the integrity of the historic precinct of central Berlin and create a more profitable tourist destination. After many discussions and demonstrations by opposing factions, the government decided that the Palace of the Republic would be demolished and a replica of the original palace erected in its place. Weinthal's collage juxtaposed a postcard of the original Berlin City Palace and its pleasure garden with the Palace of the Republic. With the impending resurrection of the Stadtschloss's replica, the future for this site may mirror its past, an instance where one memory—albeit idealized—triumphs over another.

Weinthal's collages highlighted the changes Berlin has undergone since reunification. Her postcard/panorama juxtaposition underscored the value of multiple stories, as shown by the *Ossis* and *Wessis* (East Germans and West Germans), who often have differing, and in some cases contradicting, memories of the sites. Weinthal's work revealed that what is present, powerful, and meaningful to one group may be invisible or alien to another. As a result, despite the montages'

meticulous craftsmanship, the viewer struggles to hold the two images together and in focus.

We read the built environment in part based on who we are as individuals and which groups we belong to. In his 1941 book, *On Collective Memory*, sociologist Maurice Halbwachs argues that it is primarily through membership in religious, national, or class groups that people are able to acquire and recall their memories at all. The division of Berlin resulted in a situation that was as close to a laboratory experiment of Halbwachs's ideas in real life as one could imagine. Two populations that once shared a common political milieu and culture were divided and subjected to differing economic circumstances, ideologies, and political structures. Their reunion left the two groups to face the task of rebuilding and reconstructing a common identity.

In his 1993 book, *The Texture of Memory: Holocaust Memorials and Meaning*, James Young, building on Halbwachs's ideas, considers the way that the memories of persons who are part of a single group contribute to the construction of what he calls "collective meanings": the meanings that a group comes to share. Young suggests that collective meanings of past events may be constructed from a collection of individuals' memories and ways of thinking of particular events in places.[46]

The effort of reunification is an attempt to reconcile the separation between "collected memory" and "collective memory," the joining of differing and often quite painful memories and values and history associated with a single location. Weinthal's collages of Berlin landmarks at different times explored this interweaving of personal and communal aspects of memory and place. Her montages of past and present images reminds us of the power of memory to allow one to experience multiple moments simultaneously; of the fact that memories only include one person's experiences; and that different audiences may or may not share the same

associations. The West Berliner may have no personal memory of the East Berlin that is present for the East Berliner; the tourist sees only what is in front of her eyes, not what once was; the elderly can reach far into the past, complicating and enriching their readings of the present, while the young cannot.

## Atelier in situ (Annie Lebel, Geneviève L'Heureux, Stéphane Pratte), *Projections* and *La Machine à Voir*, Montréal, Québec, Canada, 1997 and 2000 (see pp. 142–43)

—

Situated at the harbor's edge of the Faubourg des Récollets neighborhood, Montréal's remaining grain elevators—abandoned since the mid-1980s—are a monument to the Canadian agricultural industry and the city's central role in distributing grain by boat from the heartland to points across the globe. The deindustrialization of the harbor has resulted in new development that includes residences. The arrival of new apartment dwellers has increased pressure to remove the grain elevators to create unobstructed views of the St. Lawrence River.

In an effort to sway public opinion and valorize the industrial structures, the nonprofit arts group Quartier Éphémère (Ephemeral Neighborhood) organized a series of installation projects and festivals.[47] These events contributed to a larger conversation about preserving the unique character of the city. To Quartier Éphémère, the works they supported "explore our common concerns, be they the preservation of our heritage, our collective memory, or the impact of architecture, in order to forge a strong cultural identity and to inspire reflection about the past and the present."[48]

For the Panique au Faubourg (Panic in the neighborhood), one artistic event organized by Quartier Éphémère, the architecture firm Atelier in situ focused on Grain Elevator No. 5 to create their installation *Projections*. The architects imagined that the large white surface of the grain elevator, located at the

end of a major street, was an ideal screen for projecting images. They decided to employ a strategy first developed by the artist Krzysztof Wodiczko, who projected images of former Jewish inhabitants on buildings that they had occupied before the Holocaust to remind the public of the murdered population. "It was this first impression that the building was a readymade screen that gave form to the idea of projecting images on the building's surface as an ephemeral architectural project," offers Annie Lebel, principal of Atelier in situ.[49]

For one night only, they projected four suggestive images—curtains, spiral stairs, caryatids, and a waterfall—on the structure with the aid of two large projectors borrowed from L'Opéra de Montréal. The superimposed images created a luminous spectacle and underscored different aspects of the elevators:

> The images' subject matter and the physical relation they established with the building aimed to metaphorically reveal the architectural potential of this modern industrial edifice. The curtains evoke the undulating morphology of the silo's surface and reinforce the analogy of the screen; the spiral stairs remind the viewer of a fundamental aspect of the city, Montréal's triplex residences with their exterior staircases; the caryatids reinforce the monumentality of the structure; the waterfall emphasizes the silo's function as a container.[50]

The photographs were carefully chosen to resonate with the silos' forms and former functions. The colossal caryatids added a classical reference to the grain silos, the quintessential iconic structures for Modern architects. This choice reinforced the structures' monumentality while underscoring the role of architecture in the continuity of cultural memory. Likewise, Montréal's ubiquitous spiral stairs suggested a residential future for the grain elevator. The image reinforced the stoop culture of the city: people have long spent time on the stairs in front of their houses, and consequently the stairs

have evolved into a semipublic space. The waterfall—evoking the once abundant flow of grain—suggested a link between the holding power and scale of silos and dams. The curtain alluded to the enabling potential of images to help the viewer see beyond, or through, physical and imaginary barriers; it also exposed the irony embedded in the people's wish to destroy the silos in order to open up a view, not to a picture-perfect view of the river, but to the docks and their machinery. These stunning images allowed the architects to create a visual argument that stimulated the public imagination, enabling passersby to renew their appreciation for the significance and power of these structures.

*Projections* projected into the future by literally projecting upon the silos, mixing image and memory together. The architects describe the experience thusly: "Between the projected image and the built surface, the viewer oscillates between image and the reality, suspended for a moment in the seductive promise of the representation."[51] In this project, the architects grappled with the task of stimulating the public imagination to consider alternate futures for an edifice abandoned as a result of changing economic conditions. The structure was treated as an *objet trouvé* (found object) to be reconsidered, operated upon, and reframed.

Although the images were projected for only one night, the legacy of the project was significant. It stimulated a heated discussion about the future of Grain Elevator No. 5 and reinforced arguments for widening the definition of architectural heritage in Montréal to include the industrial structures. The afterimage of *Projections* lingers in the public memory and appeared for years after the event in public debates about the fate of Montréal's grain elevators and, on a larger scale, about the role of iconic structures in forming the identity of a place.

Atelier in situ continued to fight for the preservation of the grain elevators with a second work, *La Machine à Voir* (The machine

for seeing), which again employed the technique of inserting images into public spaces.[52] This effort took the form of a guerrilla publicity campaign in which slogans and leaflets advocating for Grain Elevator No. 5 were plastered on billboards all over Montréal. This project stirred a large public outcry from the architecture and arts community that, together with the high cost of demolition, contributed to the preservation of the silos. Today, the historic and iconic value of the silos is secured, and several design competitions have been held to solicit ideas for their future use.

"If seeing is foreseeing," as Paul Virilio, architecture critic and urbanist, offers, it is also "a perceptual activity which commences in the past in order to enlighten the present, to bring into focus the object of our immediate perception."[53] *Projections* added a dimension of possibility and potential to the grain elevators' public image, a shift that aided in the effort to keep the structures and the world that they are part of—though perhaps altered and reimagined—present. They projected an alternate future that encouraged adaptive reuse as an alternative to demolition and underscored the iconic and symbolic contribution of the silos to Montréal's heritage.

Like other projects in this chapter, these last two projects did not bring the past forward in the nostalgic sense of yearning for a return to a better day. Rather, they brought the past into dialogue with the present through a process of accumulation (and layering) of meanings with the aim of imagining new futures. By inserting images into the public realm, they explored alternative visions for urban icons, visions that went against the desire to create a seamless, unified place. They argued for the creation of places where multiple moments and contradictory understandings could coexist, enriching the experience and significance of these sites.

With this desire to celebrate multiple readings within a single built environment, these projects explore what Roland Barthes

calls "semantization," the process by which objects of use are attributed both primary (denotative) and secondary (connotative) meanings.[54] Barthes' ideas help to explain why the objects and buildings that surround us suggest a range of other images and concerns—wealth, value, power, possibility, fear—that modify our understanding of their utility. In addition, this concept discloses the challenges posed to the meanings we attribute to place by inevitable changes to the built environment. With the passing of time, buildings often maintain meanings that no longer necessarily reflect their current use or value, and in some cases limit people's imagination as to alternative uses. In the works presented here, their respective architects consider the dimensions of memory—the historical meanings, omissions, and personal associations linked to places in the built environment—stimulating dialogue about current meaning, future visions, and the ways in which both reflect upon the stories people tell about themselves.

# Lois Weinthal

## *Berlin: A Renovation of Postcards*

top
The photomontages were installed in the advertising space of the Friedrichstrasse underground station. The *Strausberger Platz 1971/2003* photomontage is visible here between the cars.

bottom
While waiting for their trains, passengers could contemplate the effects of time on Berlin.

*"The construction of two cityscapes over time can be merged into one, but the rate at which these constructed identities of East and West change will long remain a memory in the urban fabric."*

*"The postcard acts as a starting point to tell a visual account of Berlin's changing cityscape. In the 1912 postcard image we see men wearing three-piece suits and women wearing long, heavy dresses as was only proper at the time…the ghosts of these people walk through the site, while the garden paths and the large granite bowl in the foreground are part of the present. Everything in the background has changed as a result of changing political regimes."*

opposite
Photomontage of *Lustgarten*
*1912/2003*

top
Photomontage of *Weltzeituhr*
*1980/2004*

bottom
Both presence and absence tell a story. An empty pedestal on the bridge in front of the German Historical Museum (depicted in the postcard) contrasts with the present-day panorama, which shows statues on the pedestals. During the Second World War the statues were buried in what became West Berlin, but the bridge and museum became part of the East. A trade before reunification resulted in the return of the statues to the East. East and West Berliners recognize the disappearance and reappearance of the statues, but for newcomers and visitors, its history is embedded in the images of past and present. Photomontage of the *Deutsches Historisches Museum 1963/2004*

*"A central location for people to meet, the World Time Clock is an iconic GDR postcard image. While the clock remains, the GDR character of the site is being erased through subtle renovation and more active redevelopment of the low-rise buildings in the surrounding area."*

# Atelier in situ

*Projections* and *La Machine à Voir*

"Machine for Seeing *was a publicity campaign
to promote Grain Elevator No. 5 to help Montréalers
rediscover this building.*"

opposite top
Billboards indicated the importance of the grain elevators as icons and as a critical link between Canada's west, which produces grain, and the east, which exports it. Atelier in situ, *Machine à Voir*

bottom
Viewed from across the canal, the spiral stairs in this projection recall Montréal's triplex residences and suggest the silo's potential for habitation. Atelier in situ, *Projections*

opposite bottom
On the night of June 19, 1997, the abandoned Grain Elevator No. 5 illuminated the terminus of Commune Street. Atelier in situ, *Projections*

*"The projections form an ephemeral architectural project-event: the images spontaneously and momentarily appear then disappear."*

*"Transient and without physical depth, the projected images successively float on the building's surface, just as intangible mental images furtively haunt our thoughts."*

# 5. Public Space

The public art movement of the early 1970s has shaped installations by architects in two key ways. First, the very notion of an installation takes for granted that art can be found outside of museums and galleries, a direct result of the work of public artists. Perhaps more importantly, as art critic Eleanor Heartney reminds us in her essay "Beyond Boundaries," this movement contributed to changing views of public space reflected in larger debates in sociology, architecture, and urban planning. Heartney writes:

> No longer regarded simply as any open place where strangers intermingle, the public sphere is now seen as an environment that, ideally, can create a sense of public life and reshape people's sense of themselves as thoughtful individuals and responsible public citizens. Art is seen as an important instrument in that endeavor.[1]

As this last sentence suggests, with public art, artists became active in shaping culture, not just commenting upon it.

But the work was not without challenges. For example, artist Mary Miss recalls some of the questions that artists asked themselves as they engaged in this work:

> How could you participate in the conversation in the culture?…What kind of engagement were you going to have with the situation?…How do you make things that are physically and emotionally engaging [for] people who just come upon these things, they don't have the walls of the museum?…This [public artwork]…was going to be out on the street, and anybody would be bumping into it, sitting on it, sitting next to it."[2]

Following the path paved by these artists in the 1970s, architects have inserted their work into the public realm to explore the nature of public spaces. The first section of this chapter includes three installations that challenge the boundary between public and private, exposing underlying assumptions about each: *Toilets* by James Cathcart, Frank Fantauzzi, and Terence Van Elslander; *Pink Ghost* by Périphériques Architectes; and *Line of Site* by Arqhé.

The second section includes installations that examine how we look at the city. They portray the urban experience as simultaneous and fragmented but also celebrate the city as a place of the unexpected. By juxtaposing multiple places and times in new representations of public space, these projects draw out the potential for poetry in city life. Three projects are presented in this section: *Drawing on Site* by Kennedy & Violich Architects, *How to Walk a Flat Elephant* by Shin Egashira + Okamura Furniture Advanced Engineering Team, and *NY A/V* by field office.

The final section presents four projects that directly involve the public in transforming and imagining their environments. In these installations, architects question the very idea of controlling the design process and explore ways to involve members of the public in the design of public spaces. The projects included are: *Structures of Light* by Leonardo Mosso, *Touch* by LAb[au], *Sky Ear* by Haque Design + Research, and *Barking Town Square* by muf architecture/art.

# 5.1 BOUNDARIES

Urban planner and theorist Margaret Crawford argues that existing definitions of the terms *public* and *space* "derive from an insistence on unity [of culture and experience], a desire for fixed categories of time and space, and rigidly conceived notions of public and private."[3] Predicated on an assumption of social homogeneity, such definitions exclude entire segments of society. These segments of society constitute "counterpublics" and suggest a public sphere defined by contestation and competing interests rather than unity.

Two installations in the previous chapter, *Eye Level* and *The Dresser Trunk Project*, enlarged our understanding of traditionally underrepresented groups by bringing their stories to a larger public and challenging dominant narratives. Installations in this section also address these issues, but do so by considering implicit and explicit boundaries within public spaces. *Toilets* provided public facilities on the street; *Pink Ghost* created a new gathering space in an urban setting; and *Line of Site* carved a pedestrian shortcut through a private house. Through architectural incursions, overlaps, and other strategies, these projects examined critically the boundary between public and private.

**James Cathcart, Frank Fantauzzi, and Terence Van Elslander, *Toilets*, New York, New York, USA, 1992** (see p. 149)

The sociologist Richard Sennett coined the phrase "fear of exposure" to describe people's fear of contact with strangers in urban contexts. He suggests that, as a protective measure, people have settled into a mode of "city-building," where they both literally and metaphorically "wall off the differences between people, assuming that these differences are more likely to be mutually threatening rather than mutually stimulating."[4] To rectify this situation, he calls for

"an art of exposure [that] will not make us one another's victims, rather more balanced adults, capable of coping with and learning from complexity."[5]

*Toilets* took on Sennett's "art of exposure" directly with five rented portable construction toilets piercing through the street wall of the Storefront for Art and Architecture in New York City. These toilets were made available for public use and serviced for six weeks. Architects Cathcart, Fantauzzi, and Van Elslander used the project as an opportunity to visit the idea of the street front and what it meant to the public.

The act of breaking through the facade created a symbolic and actual connection between the outside of the building and its inner, more private realm. It at once revealed and concealed the interior beyond, eliminating "the barrier between inside and outside and [redefining] the gallery as an extension of public space."[6] The user of the toilets occupied a threshold between private and public at the property line and inadvertently inhabited space inside the gallery. Visitors entering the gallery doors viewed the backs of the toilets presented like art objects on exhibit. To keep the gallery odor-free, the architects drilled holes in the facade to accommodate extensions of the vent pipes, directing spoiled air out to the street.

The bathroom is considered a private space. By making the toilets directly accessible from the street, the project commented on the need for access to public toilets in urban spaces. Like Marcel Duchamp's *Fountain* (1917), which presented a urinal in an art gallery, the meaning of the five port-o-johns was altered by their placement in the facade of the Storefront for Art and Architecture. With their placement and continued functionality, the toilets dethroned the concept of the art gallery as an exclusive space while also presenting a criticism of New York's public spaces and social priorities.

The issue of free access to public toilets is not new. In Paris, *vespasiennes* (public urinals)

installed on the boulevards designed and constructed in the nineteenth century by Baron Georges-Eugène Haussman, have become symbols of democratic urban design. (But the vespasiennes only attended to the needs of male pedestrians—it was only relatively recently that women had modern public toilets accessible to them.) By creating an in-between space that could be inhabited by anyone from the street, not only those people who would normally enter the gallery, the addition of the toilets at Storefront addressed an issue of social inequality. A large number of poor and homeless people populate the Bowery neighborhood where the Storefront is located, a population that is, in the word of Fantauzzi, "disenfranchised and has to reduce themselves everyday in order to find a place to go to the bathroom. This project showed the difficulties that homeless people had to go through."[7] The project highlighted the distinction between visitors to the gallery, who tend to be educated and relatively wealthy, and the neighborhood people. But surprisingly, because both groups used the temporary facilities, the installation also demonstrated their commonality.

The power of this installation lay in its directness and simplicity. Using economical means (the budget for the project was only $500), it made a strong statement about the right to access public toilets. While important, that concern is symptomatic of a larger issue—the underlying values and structures in society that lead to inequity and permit homelessness in the first place. The installation's bold inversion and interpenetration of public and privileged spaces resonated on many levels: viewer and displayed, wealth and poverty, interior and exterior, object and container. None could maintain an unknowing relation to the others.

Since its founding in 1982 by architect Kyong Park and artist Shirin Neshat, the Storefront for Art and Architecture has welcomed radical engagement with the physical space of the gallery and the display of work on the street for public viewing. In the first chapter, Mark West's concrete *Pressure Buildings and Blackouts* (1991) also broke through this same building's facade. The porosity of the boundary between public and private realms explored by these two installations was given a permanent expression in 1993. Architect Steven Holl and artist Vito Acconci designed a new facade for Storefront composed of large panels that pivoted into the adjacent sidewalk. Now pedestrians can weave in and out of the gallery at will; gallery space is mixed with the public space of the street, bridging the gap between thinking about architecture and experiencing it.

**Périphériques Architectes (Emanuelle Marin-Trottin, Anne-Françoise Jumeau, and David Trottin), *Pink Ghost*, Paris, France, 2002** (see p. 150)

———

*Pink Ghost* was part of an annual Parisian event sponsored by local businesses to celebrate modern art in Saint-Germain-des-Prés, an area of Paris densely filled with universities, boutiques, small art galleries, and bookstores. The theme of the event was "transformation," and Périphériques chose Place de Furstenberg, a small quiet plaza shaded by large trees, for its installation. Architect Anne-Françoise Jumeau of Périphériques describes Place Furstenberg as "devoid of life, museified....People go through the plaza but do not stay there because there is nothing for them to do."[8] Périphériques remedied this situation by filling the middle of the plaza with furniture one would normally find in a living room. In this way they created "an art object and a meeting place."[9]

The installation was constructed off site in sections that were easily transportable. Over twenty armchairs and five tables arranged in groups to encourage conversation were fixed to plastic sheets and covered with plaster of Paris, with a further layer of glass-fiber-reinforced plastic applied on top.

Finally, the entire surface was painted pink. On site the thin covering was drawn up around lampposts and tree trunks to a height of 2.5 meters (7.5 feet). This pink "skirt" was designed to allow water to reach the tree roots during the installation. After the sections were assembled on site, matching pink glue rendered seamless the pink surface that covered the over one hundred square meters (1,075 square feet) of the small plaza.

The once-quiet plaza now held a fantastic pink salon with a luscious tree canopy hovering above and a lamppost in its center. The plaza quickly took on a new life, attracting tourists and architecture students from the nearby École des Beaux-Arts and bringing new people into the neighborhood. Taking advantage of this new setting, visitors brought picnics to enjoy during the long spring evenings of Paris. As the unwritten boundaries of use shifted, some residents living in the apartments overlooking the plaza expressed concern about noise and the loss of peacefulness and privacy in this sleepy place.

The soft pink surface that unified this large *objet d'art* redefined the living room, normally associated with the privacy of the home. But unlike a sculpture set in a plaza to be viewed only, *Pink Ghost* invited people from both within and outside the neighborhood to sit and enjoy the plaza. Like a found object transformed by the context of an art gallery, or by the imprimatur of its designer, the idea of the living room took on new meaning in this public context. The fantastic nature of the work triggered the imagination, suggesting new possibilities for social contact in the urban arena.

**Arqhé Collective (Luc Lévesque, James Partaik, and Michel Saint-Onges) with Blair Taylor, *Line of Site*, Québec City, Québec, Canada, 1999–2000** (see pp. 151–52)

———

Like *Toilets* and *Pink Ghost*, *Line of Site* blurred the line between private and public domains and challenged assumptions about each.

Rather than bringing the private domain into public spaces, *Line of Site* invited the public into the private realm. Arqhé (a multidisciplinary trio composed of an architect and two artists) transformed a private residence in Québec City with the creation of a public passage that cleaved the floor plan in two. Simple materials delineated the passage—walls were built with standard lumber and stained particleboard, a glowing fabric illuminated the ceiling, and a path of pebbles marked the ground plane. New exterior doors inserted into the passage walls allowed the apartment's inhabitants to access the two halves of their still-functional dwelling. Like a desire path made manifest, the passage traced the hypotenuse between two perpendicular streets, Scott Street and Boulevard Réné-Lévesque. It created a new shortcut for the numerous pedestrians circulating between the office buildings of Parliament Hill and the commercial street of the residential district.[10]

The title of the installation, *Line of Site*, referred both to the context or "site" of the dwelling and the "sight" created by the new view corridor that directs the gaze through the apartment to the government buildings to the east. As the seat of the National Assembly for the province of Québec, Parliament Hill is charged with symbolic and real power. The passage also pointed to the past. The work alluded to the invisible yet very real historical lines that connect the decision-makers who work in this building to the residential neighborhood. In the 1970s, Parliament Hill expanded, resulting in the decision to demolish a large portion of the adjacent residential neighborhood. Additional dwellings, including the installation site, were at risk. A public outcry finally halted the demolition of the entire neighborhood, and this home was spared. *Line of Site* commemorated this grassroots effort and the ways in which government decisions affect the lives and dwellings of the people, crossing the boundary between public and private domains.

# James Cathcart, Frank Fantauzzi, and Terence Van Elslander

---

*Toilets*

left, top
The architects inserted five port-o-johns into the exterior wall of the gallery. "Bless you, boys," declared a resident of New York City's streets.

left, bottom
Maintenance truck for *Toilets*; the toilets were free, open for public use, and regularly serviced during the duration of the exhibit.

right
Interior view of toilets projecting into the gallery

*"Our work is like a lever: it opens, measures, illuminates, but also creates a connection. It weighs a moment against a place, an event against an object. It finds a crack and widens it." —Terence Van Elslander*

# Périphériques Architectes

## *Pink Ghost*

top
A lone tree was cloaked in pink and
joined by a single armchair awaiting
the visitor who preferred solitude.

bottom
People quickly took advantage of
the new "salon," bringing their picnics
and relaxing with friends.

*"We tried different colors, but pink was the
color that created the greatest contrast
with the environment. We wanted to create a
sense of high artificiality."*

# Arqhé Collective with Blair Taylor

## *Line of Site*

top left
A slice through 955 Scott Street directed vision toward the Parliament building several blocks away. Decisions made by lawmakers in the Parliament building spawned the "urban renewal" of the residential neighborhood that once surrounded the house.

top right
The video footage of the rotating dining room table was projected onto a screen hanging in front of the Scott Street window. It was thus visible to passersby.

bottom
View from Scott Street. A "public passage" cleaved the apartment of James Partaik, a member of the Arqhé Collective, in two.

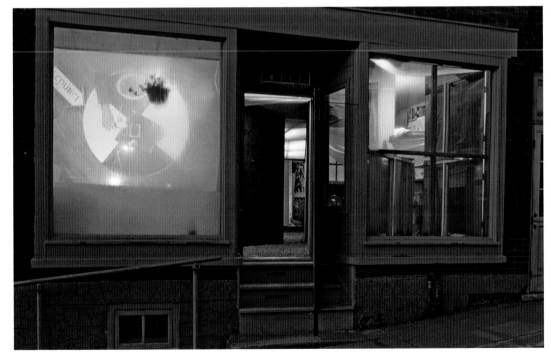

top

The thin constructed boundary separated private (kitchen, office, and dining room on one side of the public passage; bedrooms and bath on the other) and public realms.

bottom

*Line of Site* explored the interface between public and private, virtual and real. Within this temporary public passage, a passerby could peep into the private dwellings or continue through the house toward the Parliament. Cameras and sensors, actuated by visitors in the passage, sent video clips capturing their presence to the website and to monitors located in the apartment.

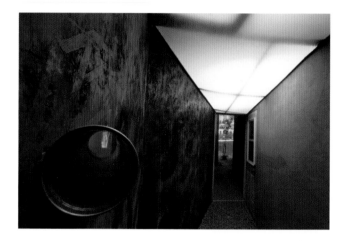

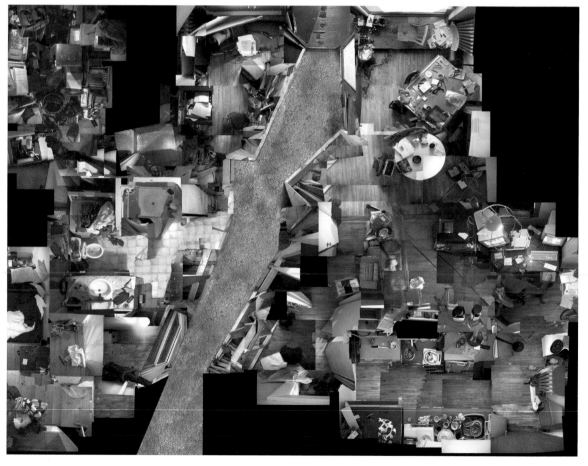

## 5.2 DESCRIBING AND PERCEIVING THE CITY

The projects in the previous section examined the boundary between public and private territories, but none addressed how people perceive and describe public spaces. In the works that follow, architects employ drawing (in the broadest sense of the word) to analyze and describe the city. Through these works they demonstrate that what and how we "draw"—that is, the techniques architects use—can shape and stimulate insight into, understandings of, and dialogue about our environment. The architects of these projects drew out hidden relationships between multiple places, moments, and potentialities, which invited the public to reconsider its experience in and understanding of the city around it.

Architects in the first project used traditional drawing techniques and constructive geometry in an unconventional way to draw the future upon the site. Like author Jorge Luis Borges's imaginary map that depicted reality at "the same scale of the [fictitious] Empire and that coincided with it point for point," the project made the future visible and public through a full-scale drawing on the construction site.[11] Through this work they pointed out hidden infrastructures as well as the evolving nature of the city—two things that are often overlooked. This thread continued with *How to Walk a Flat Elephant* and *NY A/V*. In these works architects employed video to examine and describe the complex and constantly changing whole of the urban environment. Like Italo Calvino's Marco Polo describing a Venice in which ever-changing worlds coexist, both Shin Egashira (*How to Walk a Flat Elephant)* and Martha Skinner and Doug Hecker (*NY A/V)* revel in the simultaneous and conflicting stories that make up a city.[12] However, they take opposing attitudes: while Egashira creates an installation that underscores the fragmentary nature of our understanding of reality, Skinner and Hecker rigorously stitch video clips together to enable the viewer to grasp spatial and temporal continuities that are otherwise invisible.

**Kennedy & Violich Architects (with Linda Pollak and Michael VanderBourgh), *Drawing on Site*, Boston, Massachusetts, USA, 1991** (see p. 157)

The U.S. Federal Highway Act of 1956 resulted in the interstate highway system. These roads were designed to meet the defense needs of the country at national and regional scales, but gave less consideration to the local impact. Along the East Coast, construction of new highways connected areas within the region, but also cut apart many cities. In Boston, for example, an elevated highway cleaved in two the neighborhoods in its path. Fifty years later, the city implemented the Big Dig, which buried this central artery and redesigned the infrastructure to stitch neighborhoods back together.

*Drawing on Site* invited the public to assess what the city planned for a portion of the new infrastructure where a highway interchange would lead into the sunken artery. Over a single weekend the architects mapped out the construction drawings of the engineers at full scale directly onto the site. The architects chose a moment in the site's history when past, present, and future were visible—demolition was underway and construction had begun—reinforcing the constancy of change. Architect Frano Violich explains, "We were interested in finding the dynamic moment when things were beginning to emerge from the ground."[13]

Without proper surveying tools, the architects improvised. Athletic field line markers chalked the transposed construction drawings onto the site. An existing rail line became a scalable reference, enabling them to measure objects found on the drawing but not yet built. Objects in the drawing were located on site using triangulation and a three-hundred-foot (one hundred meters) tape measure. The architects checked the

drawing's accuracy by climbing a one-hundred-foot (thirty-three meters) radio tower on site. The viewing position—at ground level or the top of the tower—affected the drawing's appearance and thus its comprehension: "from the air the line on the debris [looked] straight, but from the ground the chalk broke into fragments."[14] Once the drawing was complete, an aerial photographer documented the site from above. *Drawing on Site* was a hybrid representation, superimposing a drawing upon the material reality of the earth. It was akin to what is now commonly accessible through Google maps, though the technique was unheard of at that time.

When the drawing was complete, the architects invited the public to view the planned interchange and the impact it would have on the neighborhood. For a short time, the construction site became an outdoor gallery. Placards with text and images explained the chalk drawing to the audience, but it was difficult to understand the drawing fully from one position. The visitors walked around the site to assemble the whole scene in their minds and to discover the full extent of the drawing and its implications.

This quick sketch underscored the temporal dimension of the city. "It was important," Violich offers, "for us to see the contrast between what was there, what was planned, and what disappeared over time. Layers of past, present, and future were seen together....The work raised awareness of what was there and convinced people that even a site as derelict and abandoned as this one was could be fascinating."[15]

**Shin Egashira + Okamura Furniture Advanced Engineering Team (with support by Alvaro Cassinelli and Yuji Fukui), *How to Walk a Flat Elephant*, Tokyo, Japan, 2007** (see pp. 158–61)

———

*How to Walk a Flat Elephant* challenged the viewer's ability to understand a city as a whole by emphasizing disjunctions and ruptures in the patterns of an urban landscape. It celebrated the complex nature of the city and questioned whether it was possible or desirable to integrate different understandings of a city into a single construct.

The elephant was the metaphorical focus of Shin Egashira's installation, standing in for the city. In his installation, Egashira combines two representations of an elephant with video footage of Tokyo displayed on a series of devices. The gait of the elephant is the subject of the stop-motion photographic analysis of Eadweard Muybridge (1887); the elephant is at the center of a famous Buddhist parable about seven blind men and the limits of individual perception. In the parable, a king summons seven blind men to examine a discrete part of an elephant through touch. Having never seen an elephant before and only knowing the beast though this interaction, each man describes the animal differently. Rather than consolidating their information, they argue about their conflicting interpretations of the elephant. Their fragmented understandings reflect a truth about human knowledge. The parable ends with the king's declaration that a single viewpoint can never properly reflect the true nature of reality.

The installation juxtaposed a version of this parable written on the wall with a projection of Muybridge's reanimated stop-motion stills. Egashira coupled this reconstituted and flattened elephant in motion with video fragments of yet another giant beast, the city of Tokyo. Egashira suggested that while the photographs appeared to be scientific, the knowledge of the elephant that they produced is as fragmented and illusory as the knowledge of the blind men in the parable and, more importantly, as fragmented as our understandings of the city.

Egashira filmed the video clips of Tokyo from three different vantage points: from a revolving restaurant (a high-angle shot), the window of a commuter train circling the city (a mid-height perspective), and focused

on the feet of pedestrians as they walked across a bridge leading to a zoo (ground-level view). These viewpoints on the city corresponded to three geometric forms: the small circle of the revolving restaurant, the larger circle of a moving train circumscribing the city, and the flow of feet sweeping across the frame.

These simple geometric forms recurred at the site of the installation, where viewers interacted with large glass video screens. As the videos of Tokyo were projected, the screens moved on a system of tracks: two traveled in a circle—one around a large ring, the other around a smaller one—while the third screen traveled along a set of linear tracks. The movement of visitors walking through the space triggered motion sensors that altered the speed and direction of the rolling screens as well as the order of projection of the video clips on each screen. To the viewers' surprise, as they approached the screens the elephants would change direction and walk away from them.

In *How to Walk a Flat Elephant*, Egashira asked the audience to consider the nature of its perceptions and how it interprets them. This relationship is reflected in the ancient Buddhist parable, which is embedded in the Chinese and Japanese languages. Egashira offers a new connection: "The Chinese character of the word *vision*, or *image*, [is] made up [of] a combination of two words—Man on the left and Elephant on the right. Imagination is the contact between the two. Perhaps the body of our city may no longer exist but as an elusive elephant imagined by architects today."[16] Like the Dadaists and the Situationists, Egashira reveled in the city's complex, contradictory, and unpredictable character—what the sociologist and philosopher Henri Lefebvre would call "the place of the unexpected"—and created an environment that responded in unexpected ways to the viewer's presence.[17]

**fieldoffice (Martha Skinner and Doug Hecker), *NY A/V*, New York, New York, USA, 2001 and 2005** (see pp. 162–63)

———

*NY A/V* was "mobile yet site-specific."[18] It was a work composed in two parts: audio/video mapping of the physical conditions and activities found along the length of a major street, and the public presentation of this material four years later. The work began in the summer of 2001. Over seven consecutive days, Martha Skinner and Doug Hecker walked along and documented the entire length of Broadway in Manhattan. Each day they began their work at dawn and ended at dusk. By the end of the seventh day, the team had completed their "cross-sectional audio/video (A/V) map" of the avenue from the southern to the northern tip of the island. Their mapping was accomplished not with pencil, paper, and ruler but with the zoom feature of a video camera and a rigorous plan of action. As the team moved northward, they stopped on each block at four predetermined locations: the southern corner, one-third and two-thirds up the block, and the northern corner. At each location they set up a stationary video camera and focused on a distant point further up the avenue. With the camera they recorded a "zoom" clip that showed the initially distant horizon moving closer to the viewer and filling the screen. Fifteen minutes later, they walked north to the next station point and repeated the action. Over the course of one week, the process was repeated 636 times; in other words, the team collected 636 individual but consecutive zoom clips documenting Broadway's length. Commenting upon the experience of gathering the footage, Skinner remarked, "Each day the investigator, through the viewfinder, is entranced by a different story, by a different place, as the various personalities of the city are experienced."[19]

Four years later, after stitching together the 636 individual clips to create one long, continuous zoom of the entire length of this artery, as well as three versions that played

at different speeds, the team returned to Broadway and retraced their steps. This time they brought a custom-designed "container," a mobile theater on wheels, to present the video map to the public. A ritual ensued. Each day for seven days, the container was driven up Broadway and parked within the section of the street traveled that same day four years earlier. Once parked, the container's ends were opened and a set of stairs was placed at either end to entice the public to enter and look. The shiny skin of the vehicle reflected activities surrounding it, while its darkened interior permitted visitors to view the videos created from the 2001 footage. Inside, projectors played the same footage at three different speeds: slow motion, real time, and accelerated. Like the Baroque clocks that showed the movement of the moon, sun, and the stars, each tempo "allow[ed] different conditions of the city to be read."[20] In slow motion, observers noticed subtleties of human interaction, but, as with a detail drawing, they saw fragments without understanding the whole. Accelerated motion, like a map or an aerial image, offered an overview, which emphasized transformations from one neighborhood to the next, showcased the rhythm of traffic, and revealed topographical changes as one zooms up Broadway, but masked details. Real-time speed, like time travel, allowed the observer to replay four-year-old events and notice changes that would have been forgotten or perhaps have gone unnoticed.

In the words of urban theorist Margaret Crawford: "everyday urban space is the connective tissue that binds daily lives together." The significance of the "utterly ordinary" is that it "reveals a fabric of space and time defined by a complex realm of social practices."[21] These three videos made that realm visible and available to New Yorkers.

According to Crawford's interpretation of Lefebvre: "everyday time is located at the intersection of two contrasting but coexisting modes of repetition, the cyclical and the linear."[22] *NY A/V* inhabited and captured both, natural time—starting at sunrise and ending at sunset—and artificial—marking and measuring the minutes and hours with the video camera. Ironically it was the rigorous structure of the documentary and editing process that made it possible to step back from the flow of lived experience. For the citizens who followed their curiosity to watch the videos, the installation offered a gift: the opportunity to experience a unique, insightful moment and to enter the category of time that was, according to Crawford, "more important to Lefebvre than those predictable oscillations."[23] It is "the discontinuous and spontaneous moments that punctuate daily experience—fleeting sensations of love, play, rest, knowledge."[24] As Crawford points out in her introduction to *Everyday Urbanism*, it is these types of moments that the Situationist Guy Debord relished, for he saw them "as potential revolutions in individual everyday life, springboards for the realization of the possible."[25]

This sense of possibility and passing time is suggested by comments recorded in the guest book: "A great reminder of time and how things seem to never change and yet how quickly what we have seen changes"; "Watching it [was] like traveling through different villages with their own culture and pace"; "This used to be Irish, now it is Dominican. The groups change to let others come in."[26] Rigorous and precise in their planning, the individual video clips evoked the constantly changing, coexisting worlds of Calvino, filled with an infinite number of simultaneous and conflicting stories, while the linked footage of quotidian moments presented at three different speeds provided insights into urban patterns of activity, time, and geography unavailable through lived experience.

# Kennedy & Violich Architects
# with Linda Pollak and Michael VanderBourgh

*Drawing on Site*

top
Lacking a single vantage point to
view the entire project, visitors walked
around the site to discover for
themselves what existed and what
was planned for their neighborhood.

bottom
*Drawing on Site* became intelligible
from the air—a hybrid of drawing
and photograph, before the era of
Google maps.

# Shin Egashira + Okamura Furniture Advanced Engineering Team

*How to Walk a Flat Elephant*

left

Seven blind men examine a very patient elephant! This Buddhist parable attests to the limits of individual perception. Katsushika Hokusai, *Hokusai Manga* [The Hokusai Sketchbooks], vol. 8 (Nagoya, Japan: Eirakuya Tôshirô, 1814–78)

right

Egashira applied the blind men's methods to Muybridge's photographic motion study of an elephant's gait. Photomontage (2007) with photographs by Eadweard Muybridge (1887)

opposite top

The video footage was projected on three viewing apparatuses in Space R, a gallery in Tokyo. As people circulated through the gallery, they triggered actuators that controlled the speed and direction of the viewing assemblies. Sounds of the city, the mechanisms, and the occasional roar of an elephant filled the space.

opposite bottom

Wooden benches incorporated into the mechanized structure traveled with the rest of the design, providing visitors the opportunity to ride with the elephants. Egashira drew an analogy between the elephant's nervous system, the electronics used in the installation, and the city.

following spread

Video footage taken from three vantage points in Tokyo presented a fragmentary view of the city, suggesting an analogy with the Buddhist parable. These clips were superimposed over Muybridge's walking elephant. (Top) Video footage of pedestrians crossing the Ueno Zoo footbridge were superimposed over that of the walking elephant; (middle) the elephant's torso was juxtaposed with people waiting for a commuter train; (bottom) when a visitor touched the glass, like the blind man touched the elephant, a close-up of the animal's skin appeared, or it roared.

*"Communication gadgets deliberately left incomplete are combined with float glass, timber beams, pebbles, and steel angles that give the elephant its weight. Computers, microcontrollers, industrial motors, speakers, and sensors reconstitute its nervous system, creating a new set of relationships in the name of City Elephant." —Shin Egashira*

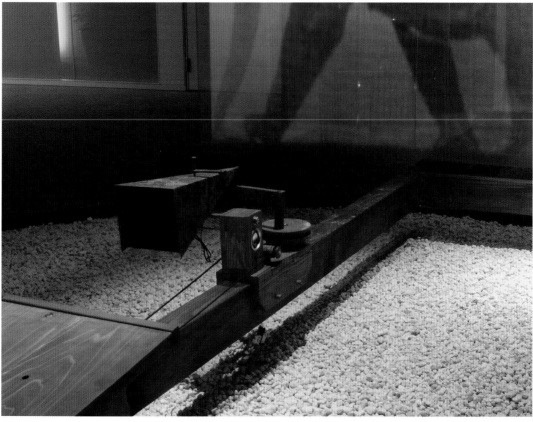

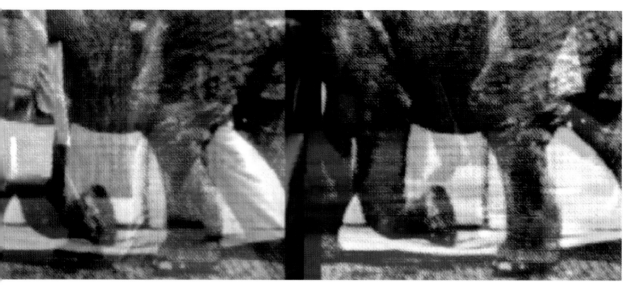

# fieldoffice

*NY A/V*

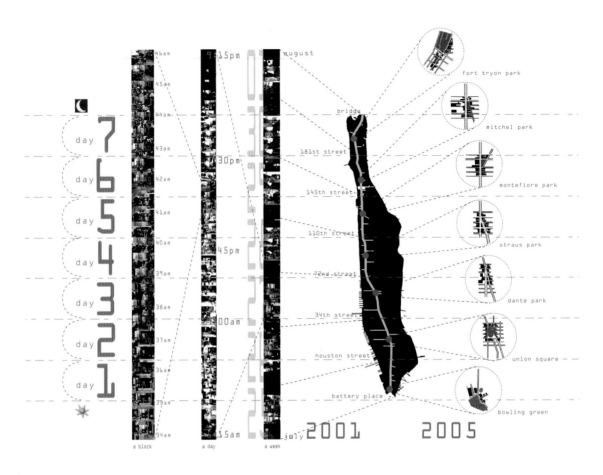

fort tryon park

mitchel park

montefiore park

straus park

dante park

union square

bowling green

bridge

181st street

145th street

110th street

72nd street

34th street

houston street

battery place

day 7

day 6

day 5

day 4

day 3

day 2

day 1

a block    a day    a week

2001    2005

july    august

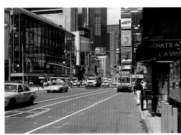

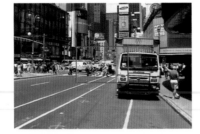

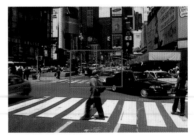

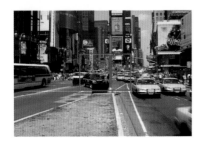

opposite top
This diagram links the filming process in 2001 with its public presentation in 2005. On the left of the map of Manhattan, units of time and distance used to "measure" and "section" the city are outlined; on the right are the seven sites where the container was parked in 2005.

opposite bottom
Video stills: Broadway at Times Square

left
Four years later the architects retraced their steps—this time equipped with a mobile container to display the video. Inside the truck—here stationed at Straus Park (106th Street and Broadway)—New Yorkers were invited to comment on the changes of the past four years in a guest book.

right
The video in the truck was replayed at different speeds on each screen—accelerated, natural, and slow motion—revealing different kinds of information about the city.

*"By walking the city slowly, minute-by-minute, block by-block over a period of seven days, from sunrise to sunset, a series of stationary takes using the zoom feature of the tool were collected in a process that measured the city." —Martha Skinner*

## 5.3 SPECTACLE AND PARTICIPATION

The next four projects directly engaged the public in shaping the social, cultural, and physical form of public spaces. They did so in a playful and often humorous way, with spectacles that triggered the curiosity and imagination of the participants. For example, the first two installations established relationships between the parts of the city and the whole: they linked buildings, neighborhoods, and monuments with light works that were visible from a distance, inspiring people to move around and conceive of the city in new and unfamiliar ways. They underscored existing landmarks and created new ones. Like urban festivals and holiday celebrations, works in this section purposefully set themselves in opposition to everyday life and standard use. They altered understandings associated with familiar places by transforming environments and inventing new ways for the public to participate. Memorable, magical, and in some cases theatrical, they suggested actions that citizens might undertake to alter their environment (or their conceptions of it) permanently.

**Leonardo Mosso, *Structures of Light*, Vlissingen, the Netherlands, 1995–2000**
(see pp. 171–73)

Leonardo Mosso employs his nocturnal *Structures of Light* to bring attention and energy to neglected urban spaces and buildings throughout Europe.[27] Designed and built by the architect, each individual light structure is created from a system of standardized, adaptable components: luminescent neon tubes of colored light held together by flexible joints. This system enables the architect to rework and adjust his structures for each situation; they are experiments in a "directed architecture" that build on his interest in cybernetics and the potential of dismountable elemental structures held together with elastic joints.[28]

Mosso spends weeks deciding where and how to insert each structure, creating "photos…collages and photomontages until he finds the flex point, the magical and precise area where he starts working."[29] Adjusted and reworked in response to the particular context, each light structure is carefully placed in order to enhance the dialogue between these structures, the light they emit, and their surroundings, framing architectural details and bringing light into darkened passages. The luminous neon colors of Mosso's linear lights alter apparent depth, while the shadows they create bring unexpected contours to buildings, drawing the viewer's attention. Mosso's interventions come to life after sunset and create a sense of wonder and celebration: "This is catalytic art in which light installations assist and accelerate the metamorphosis of architecture and environment."[30]

Mosso's Structures of Light installations have been realized throughout Europe. In order to underscore the long-term effort, continuity of his work, and to give a sense of its breadth, we choose to focus on one town, the city of Vlissingen, the Netherlands, where a series of projects have been realized since 1989.[31] These projects are: *Transparent City: Neon Structures on the Towers* (1995), *Urban Plan: light structures for the city of Vlissingen* (1997–2000), and *Lichtwolke Willem 3* (1999), the first permanent work outlined in urban plan to be built.

Vlissingen is a harbor city located near the Belgian border between the Schelde River and the North Sea; it was strategically sited to foster commerce. In 1995 the municipality invited Mosso to create a temporary installation that involved six historic towers. *Transparent City* celebrated the city and was intended to attract travelers who might otherwise pass it by: "This project is about attracting attention to the various monuments of the city of Vlissingen. The buildings included the cathedral that is very old, the city hall, and so on."[32]

The initial installation involved six towers: five were outfitted with linear light structures that clung only to their exteriors, and the sixth had lights inserted into the interior as well. At night, the illuminated towers could be seen from distant highways and the sea—"the boats coming from various countries via the ocean could see the lights on the buildings"—beckoning travelers to take a closer look.[33] Within the city special buses toured the towers and created a festive atmosphere. Like a parade that weaves its way to city landmarks scattered throughout the city, the bus tour told its own story about Vlissingen. With the design of this itinerary and the guide map marking the sites of his interventions, Mosso helped the public to "look at how they are looking, by leading them around the city."[34]

Pleased with the results of the project, city officials then invited Mosso to create *Urban Plan* (1997–2000), which built on the temporary *Transparent City* by envisioning permanent points of light placed on significant buildings of the city. *Lichtwolke Willem 3*, completed in 1999, was the first of eight permanent lights configurations resulting from the plan. An eight-part installation, it consisted of light structures "anchored to the facade and roof, and hung in the lobby of the new Kunstcentrum (art center) in a converted neo-classic army barracks near the sea."[35]

These Structures of Light installations took advantage of the opportunities offered by the blackness of the night. As the sun was setting and the spaces in the urban fabric disappeared, Mosso's brilliant line drawings lit up like large fireflies connecting one place to another in the darkness.

**LAb[au] (Manuel Abendroth, Jerome Decock, Pieter Heremans, Alexandre Plennevaux, and Els Vermang), *Touch*, Brussels, Belgium, 2007** (see pp. 174–75)

———

The Brussels-based architects at LAb[au], or Laboratory for Architecture and Urbanism, specialize in a type of digital architecture they call Meta-Design, which employs existing architecture as a tool for "think[ing about], promot[ing], and establish[ing] public space while using new technologies to enhance the relationship between [the] citizen and the city."[36] *Touch,* for example*,* was an interactive installation held in the winter of 2007 utilizing the facade of the Dexia Tower in central Brussels.[37]

The Dexia company, a bank that specializes in financial services for the local government, wanted its building, Dexia Tower, to be a city landmark. Architects Samyn and Partners together with lighting engineer Barbara Hediger designed a facade on which each window could be independently lit and computer-controlled.[38] The result was a 145-meter (475 feet) tower with 4,200 windows illuminated by red-green-blue light-emitting diode bars (RGB LEDS), which transformed the facade into an immense display surface. Video loops projected on the facade could be designed to change over time: the first such loop flashed advertisements for the Olympic Games.

LAb[au]'s contribution and innovation was the development of a vehicle that allowed the public to alter the facade directly. Their installation *Touch* was the first interactive use of the facade, allowing the public rather than the building's owners to control the lighting in each window themselves (and thus the imagery on the building). To make this possible, LAb[au] designed software that tied into the building's LED window system and an interface that the public could use. A kiosk located in the adjacent plaza sheltered a control panel that enabled people to "touch" the building remotely and change the colors and patterns of the lights on its facade.

When a user touched the control panel and started a sequence by picking a background color from the multi-touch screen, the kiosk would light up, signaling to others in the plaza that someone was at play and a new spectacle was about to begin. Next, by

touching the screen itself participants could create black-and-white graphic shapes that responded to their gestures. Gestural input animated the shapes, giving them momentum and direction. The resulting luminous, kinetic designs were visible on the facade of the building in real time.

The language of the facade's imagery was an abstract one of points, lines, and surfaces whose color, direction, and "motion" changed in response to the choices made by the person at the control panel. The architects of the installation chose this visual language because they felt that it recalled that of Dutch painter Piet Mondrian, whose works—such as *Broadway Boogie Woogie* (1942–43)—suggested "relationships between architecture and urban elements."[39]

A web camera set up on another building made visible a framed view of the Dexia Tower set within the Brussels skyline. By using the Internet to access this camera, participants could photograph their work as it was displayed on the facade and then create a digital postcard to send to friends. Each new image was also posted on the project website.[40] As these postcards reveal, "touching the facade" not only altered the Dexia Tower directly, but also transformed the character and color of the buildings and public spaces surrounding the tower through reflection and light emission.

The people who made their mark on the building felt a sense of pride in the city and a connection to it. Having the opportunity to send the digital postcard further enlarged the power of their creation. The changing colors of the facade engaged evening strollers in that area of the city in a way that was quite appropriate for the holiday season. The building became known for its constantly changing appearance, achieving the owners' original goal of creating a city landmark.

Like Mosso's installations, *Touch* used light as both a communication device and an artistic medium, bringing beauty and a sense of celebration to the city. The transformative

power of light could be enjoyed collectively at an urban scale in these two projects: Structures of Light raised the profile of a city by increasing public awareness of its historical buildings and urban form; and *Touch* strengthened a sense of citizenship by allowing the public to participate directly in crafting the illuminated image of a building and, through their efforts, making this building more prominent in the urban landscape.

## Haque Design + Research (Usman Haque), *Sky Ear*, Fribourg, Switzerland, and Greenwich, London, United Kingdom, 2004
(see pp.176–79)

Like many of the architects whose work appears in the "Tectonics" chapter, Usman Haque and LAb[au] employ installations to experiment with the medium of architecture. However, rather than exploring the poetics of materiality and construction, these architects are part of a growing movement that focuses on the integration of emerging digital interactive technologies into the built environment. These technologies have the potential to "shift the way people interact both with those around them and also with the space around them."[41] Haque sees many possibilities for the use of interactive technologies in participatory design—the involvement of the public in the process of envisioning and creating the built environment—and has developed a series of installations to explore these opportunities. In particular he creates artifacts to examine "how humans, devices and their shared environment might coexist in a mutually constructive relationship."[42] One such experiment was a giant kitelike structure called *Sky Ear* that was launched in 2004 at the Belluard Bollwerk International Festival in Fribourg, Switzerland, and the National Maritime Museum in Greenwich, London.

*Sky Ear* was composed of a thousand interconnected helium balloons enclosed in a carbon-fiber-and-net structure twenty-five meters (eighty feet) in diameter.

Light-emitting diodes (LEDS) and electromagnetic sensors were distributed throughout the structure. The diodes lit up in different patterns based on the various frequencies of electromagnetic waves picked up by the sensors. Tethered by four guidewires held by people on the ground, the entire apparatus hovered a hundred meters (330 feet) off the ground. Participants interacted with the system by means of cell phones attached to the structure.

From a nearby building Haque arranged for the telephone numbers of the flying phones to be projected on the ground. On-site participants used this information to call *Sky Ear* using their personal cell phones. People could also participate remotely by accessing the phone numbers online.

*Sky Ear* both listened and spoke in a number of ways: it was an active participant, translator, and negotiator in the dialogue between its environment and the public. Calling *Sky Ear*'s cell phones altered the electromagnetic waves that triggered the embedded LEDS and resulted in wavelike patterns of colored light that were diffused by the rubbery surfaces of the balloons. Activated by the incoming calls, the flying phones generated additional electromagnetic waves that were in turn picked up by *Sky Ear*'s sensors. Furthermore, calls allowed participants on the ground to hear fluctuating electromagnetic waves converted into sound—much like "whistlers" and "spherics," which are the aural equivalent of the aurora borealis.

The cloud of balloons was both a sensor system, responding to the electromagnetic waves generated by mobile phone calls, and an actuator, producing electromagnetic fields itself through increased activity of the cell phones it carried. Computer chips linked to the sensors and LEDS attached to each balloon were networked and programmed to coordinate with one another in response to the different types of signals. This "balloon-to-balloon" network controlled the concentration of light, thus indicating the epicenter—the place where the mobile phone actually rang in the system. Light patterns emanating from that point were designed so that observers might interpret their cause, similar to how they might understand that a pattern of expanding concentric circles in a pool of water results from a tossed object. By interpreting these signs, participants could grasp the relationship between their actions and *Sky Ear*'s transformations and could alter the pattern seen on the "kite" by increasing their calls to it. When there were many simultaneous calls, the patterns became chaotic. At other times, *Sky Ear* was programmed to respond generally to all of the combined electromagnetic fields it detected in its environment. Then the viewer noticed moving, glowing color that made it appear as if the whole kite was pulsing. In this case the pattern was much smoother, rippling across the object.[43]

Electromagnetic waves are all around us, carrying messages and information, but we cannot see them. *Sky Ear* made these omnipresent waves visible, enabling people to understand their "daily interactions with the invisible topographies of electromagnetic space."[44] In addition, *Sky Ear* shifted the social interactions that depend upon this medium. While cell phones are now multifunctional, their most basic function is to make phone calls: a process that links one or two individuals while at the same time separating them from the larger group around them. In this work these same devices were employed to different effect, linking strangers in a common effort to change the electromagnetic fields around them and thus transform *Sky Ear* hovering above. *Sky Ear* was "groundbreaking," according to architectural critic Lucy Bullivant, "because it [broke] the perceptual boundaries between the physical and virtual by encouraging people to become creative participants in a Hertzian [electromagnetic space defined by Anthony Dunne] performance."[45]

While *Sky Ear* was beautiful and technologically innovative in and of itself, Haque's installations have another dimension. For him they are a part of a larger research agenda building on cybernetic theories that value conversation, interaction, and the democratization of public space. Guided by cybernetician Gordon Pask's arguments in favor of a variable and evolving interaction between people and computers, Haque seeks to enhance the interactive potential of public spaces in order to create places where people feel that they belong and situations in which they have influence.[46] Thus, Haque's installations are conceived as tools for the public to:

> use to construct (in the widest sense) their environments and thus to build their own sense of agency. It is about developing ways to make people themselves more engaged with, and ultimately responsible for, the spaces that they inhabit. It is about investing the production of architecture with the poetics of its inhabitants.[47]

## muf architecture/art, *Barking Town Square*, London, United Kingdom, 2005–ongoing
(see pp. 180–81)

———

The final project in this chapter, like Mosso's work in Vlissingen, is a long-term, multifaceted project, but here we will focus on the combination of installations and permanent architecture that reinvigorated an urban square in Barking, a neighborhood of London.

Barking is an area with a diverse population, some racial tension, and no strong sense of its own history. It is also a key center in the Thames Gateway regeneration area in London and one of the one hundred spaces that the Mayor of London's Architecture and Urbanism office has advocated for in an effort to "deliver an urban renaissance in London."[48] When the developers Allford Hall Monaghan Morris (AHMM) proposed a high-density residential and retail development adjacent to the existing town hall, the local council gave them permission to go beyond existing zoning limitations in exchange for amenities that included a new public library and the revitalization of the public space that would be redefined by this new construction.

The local council hired muf architecture/ art, a cross-disciplinary firm based in London, to work with the developer of *Barking Town Square* based on its reputation for innovative community-involvement techniques. This particular project illustrates its pioneering working method.[49] Building on the strengths and shared ideals of artist Katherine Clarke and architect Liza Fior, muf embeds tactics borrowed from art into the design process in an effort to engender a sense of ownership and ensure affection for its projects once they are built.

The project began with a single public art commission: the design of a hoarding (a printed image covering a construction fence) for one of the sites that fronted the square. A series of permanent and temporary projects intended to make *Barking Town Square* a memorable and vibrant place followed. Muf's work expanded to include the design and construction of a fake "ruin" to add a sense of history, albeit fabricated, to Barking; a ceremonial arcade linking the square to Ripple Road, an important shopping street; the redesign of the central space as "an extra-large outdoor pink room scaled to the dimensions of the civic;" the installation of a second hoarding—a temporary evocation of a future planting and a venue for a community celebration; and the planting of an urban forest and stage, which will be completed in the future.[50] The focus in all of these projects was on using art and architecture together to create not only the physical aspects of a public space but to ensure its ultimate viability by creating a place that the public will care about.

Muf makes installations, plans community events, and initiates workshops to take advantage of the time-lapse between the initiation of a construction project and its completion, recognizing that "during times of change, temporary enhancement offers

an opportunity for citizen involvement and collective imagining."[51] Construction hoardings usually present an idealized rendering of the project, depicting future inhabitants that the developer wishes to attract. Given the opportunity to create a hoarding for the site, muf instead chose to explore "the reality of the people who actually lived in the neighborhood" and how those people conceived of public space.[52]

The firm invited a group of students from the nearby Broadway Performing Arts College as well as members of Barking's Afro-Caribbean Lunch Club to explore the "way artists look at the everyday and see the extraordinariness of it:" they took a field trip to the Tate Gallery and also examined "low" art.[53] Together the firm, students, and lunch club created and performed fantasy scenarios for Barking in front of large projected photographs of public spaces from around the town. Muf used these scenarios as springboards for discussions about what public space meant to the members of the group. Many participants had never thought that people could actually make decisions about public space—they had always assumed it was space left over between buildings. This assumption that the public realm was uncared for and belonged to no one rather than everyone, had greatly shaped residents' attitudes and actions in the public spaces of their neighborhood. This was the sort of assumption that muf hopes to disturb in order to ensure long-term care for its interventions in the public space of Barking.

Photographs of the students and lunch club members performing their scenarios in front of the construction site were incorporated into the first hoarding. Appropriately titled *Your Dream Today, My Dream Tomorrow*, the images projected residents' fantasies into the public realm.

Inserting the extraordinary within the ordinary, creating memories and ambition for the members of the town through the community workshops and hoardings—these were the first steps toward the production of a permanent transformation of the square that welcomed invention and fiction into the design. Explaining the role of the installation in this particular project and in muf's process generally, Fior says that the installation "lifts the bar; this is where you should get to. It creates a fantasy, a theatrical occupation of the site. It then becomes the brief that has to be met by the permanent project."[54] In this project, creating the hoarding began the important process of developing meaning with the community.

Despite Britain's culture of public involvement in decision-making processes that affect the built environment, in Barking there had been little of democracy in the initial negotiations with the developer.[55] As a result, muf's use of the hoarding to involve the public and convey the multicultural nature of the community was well received and helped to reengage the citizenry in the process of shaping the town square. Ultimately, in order to continue the work of developing a relationship with the community and a vision for the place, the town council and the developer awarded muf a series of commissions for the design and construction of both ephemeral installations and permanent elements. These commissions extended muf's ability to integrate a mixture of history, fantasy, and narrative into the plan for the town square.

After the first hoarding, muf contributed to permanent elements to the site. Building on the picturesque tradition of garden follies that took the form of invented ruins, muf designed and built a freestanding wall that appeared to be the remains of a historic structure. In addition to using cast-off bricks, the firm added ancient-looking sculptures in small niches throughout to add to the effect of age. Along the main open space, muf also designed an arcade with a black and white terrazzo floor laid in an Edwardian pattern.

These permanents works were followed by an ephemeral effort. A second installation

and performance called *Gold Chairs, Tapdancing: Celebration and Vision* inaugurated the arcade and the ruin and presented yet another part of muf's design for the square: an urban forest. A new hoarding with photographs of a forest created a backdrop for a festive event with music and tap dancers in geometric formation parading under the arcade and into the public square. A precedent for using the public space was set. Citizens seated in gold chairs faced the image of the forest and contemplated the mix of reality and fantasy, ordinary and extraordinary, placed before them. Later, actual trees were planted, joining the arcade and the ruin in shaping the town square. A small stage located in front of the forest anticipates future performances and the dreams of the Barking residents.

When Clarke and Fior created muf and began working together, they felt quite strongly that "the public realm was completely devalued" and that the communities that used and took care of public spaces were not involved in the visioning process in any meaningful manner. They brought the knowledge and practice of artists to bear on this issue and developed a strategy that they dubbed "action research," which was exemplified in Barking Town Square:

> [Fior] was interested in how conceptual art can influence our thinking when we work in the public realm. [It's an] open-ended piece of research, to understand how people in the community used those spaces, which then informs the design resolution. But it's not like we do the research and then we make a thing…. The research is much more speculative and more open-ended.[56]

*Barking Town Square* exemplifies how installations can play an integral role in the architectural design process and, once built, in the shaping of culture of use. In this project, ephemeral works served as research tools, a generator of meaning, a vehicle to involve the community in the design of their public spaces, and a way to create a culture of long-term civic engagement. If design can be described as the art of anticipating use, muf's work reminds us that shaping the public realm involves shaping the tangible aspects of place, as well as the attitudes of those who will inhabit it.

# Leonardo Mosso

### Structures of Light

A guide map distributed to the
public indicated the locations of the
towers with Mosso's light installations
and the circular itinerary of the bus.
Leonardo Mosso, *Transparent
City: Neon Structures on the Towers,*
Vlissingen, Netherlands, 1995

*"Starting from the landscape where the Watertower CHK (#1)
stands in isolation, all the way to the main buildings of
the city, the city gets woven into a single urban entity through
a visual triangle with luminous spots on the urban towers
[that] date from different time periods."*

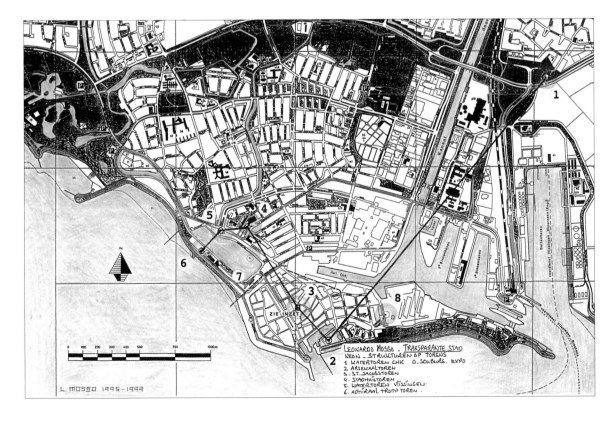

top

Permanent light structures proposed by Mosso were intended to draw attention to historical and contemporary buildings in various parts of the town. Mosso, *The Urban Plan*, Vlissingen, the Netherlands, 1997–2000

bottom left

"For Mosso a joint is a world or, rather, the principal tool—the atomic bonding almost—that makes possible the construction of his world, its molecules and clouds. Through such joints pass the energy that generates sparks and tightrope walks to the sky." Attilio Stocchi. Mosso, *Lichtwolke Willem 3*

bottom right

*Lichtwolke Willem 3*, the first of eight permanent "points of light" to be built, illuminated the details of this neoclassical former navy barracks, now an art center. *Lichtwolke Willem 3*, Vlissingen, the Netherlands, 1999

*"Neon reflections on stainless steel combine with the building materials that the structures rest on to create colors that didn't exist before."*

top

The Arsenal Tower (#2) offers panoramic views of the city. Viewed from below, the delicate pink and blue neon lines suspended outside a single window underscored the scalar interplay between people, building, and city. Mosso, *Transparent City*

bottom left

Through contrast with the medieval cathedral's style, the neon line marked time's passing in another way. Mosso, *Transparent City*

bottom right

Within the Watertower CHK (#1), the light structures illuminated and colored the surfaces to which they clung and articulated new volumes of light that drew the gaze upward. Mosso, *Transparent City*

# LAb[au]

*Touch*

opposite
The Dexia Tower has 4,200 windows that can be individually lit by RGB-LED bars, turning the immense facade into a display surface. Architects of Dexia Building: Samyn & Partners, M & J.M. Jaspers— J. Eyers & Partners; Lighting engineer: Barbara Hediger

top
From a kiosk placed in the plaza, people used the multitouch screen to manipulate the color pattern of the tower. "Playing the screen" altered not only the Dexia Tower but also the light reflected onto the adjacent buildings, thereby transforming the character and color of the architecture and the public spaces.

bottom
A camera placed on a building nearby took photographs of each new color display in the Brussels skyline. The images were integrated into digital postcards for people to share with their friends. The unique qualities of the building quickly grew in people's minds, for it was the only one constantly changing in response to public engagement.

bottom right
On Rue Neuve/Nieuwstraat, the illuminated Dexia building animated the urban night life.

# Haque Design + Research

—

*Sky Ear*

top
Phone numbers corresponding to
cell phones attached to *Sky Ear*
were projected on the ground from
an adjacent building and also made
available online. People on site or
on the web used these numbers to
call *Sky Ear*.

bottom
*Sky Ear* was a social event: volunteers
filled balloons with helium and tied
them to the array. Nine people held
wire tethers when it flew.

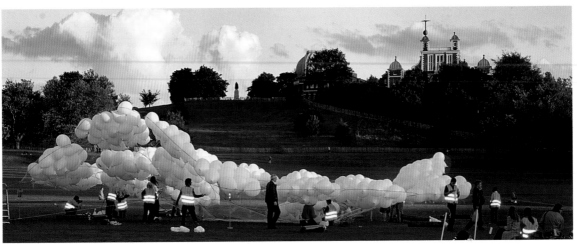

176

*"Electromagnetic waves exist just about everywhere in our atmosphere. The clouds will show both how a natural, invisible electromagnetism pervades our environment and how our mobile phone calls and text messages delicately affect new and existing electromagnetic fields." —Usman Haque*

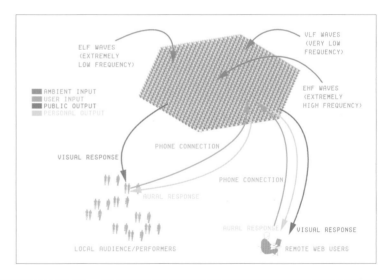

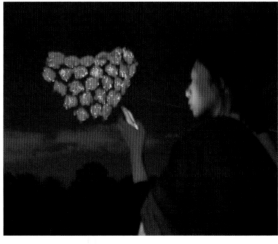

# muf architecture/art

### Barking Town Square

left, top
Muf's work to reshape Barking Town Square in East London extended over a number of years. The duration and scale of these interventions varied. Site plan

right, top
The civic space was conceived as an "empty, unfurnished pink room" that could be programmed by the adjacent institutions or used by the community. The folly wall in the background recovered "the texture of the lost historic fabric of town" and projected a fantasy history, while new temporary uses, such as a fairground and an ice-skating rink, and events, such as a speech day and a tap dancing show, built new histories and narratives.

right, middle
The hoarding around the construction site became the first step in enlisting community members and sparking dialogue among the stakeholders in reimagining Barking Town Square. *Hoarding 1—Your Dream Today, My Dream Tomorrow*, 2005

*"How are thoughts made into things?"*

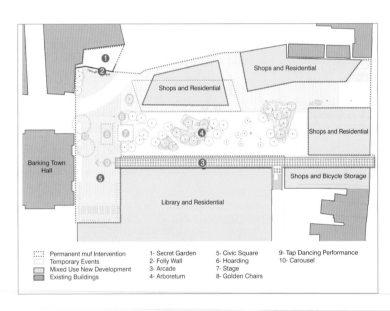

Permanent muf Intervention
Temporary Events
Mixed Use New Development
Existing Buildings

1- Secret Garden
2- Folly Wall
3- Arcade
4- Arboretum

5- Civic Square
6- Hoarding
7- Stage
8- Golden Chairs

9- Tap Dancing Performance
10- Carousel

opposite left, bottom
A new hoarding depicts the future arboretum. The temporary stage and steps (anticipating the permanent one) served as an outdoor classroom for local children. *Hoarding 2 —Arboretum*, 2007, temporary enhancement

opposite right, bottom
"The tableaux were photographed and formed part of the site hoarding. These images stood in contrast to the anodyne and anonymous 'resident' envisaged by the developers." muf architecture/art, *Hoarding 1*

top
At the end of the first phase of construction, muf staged a community celebration that included a new hoarding to launch the vision of an urban arboretum, gold chairs for the community, a temporary stage, and tap dancers, who "played" the terrazzo floor of muf's newly completed arcade. Celebration Phase I, Launching Phase II, 2007

bottom
Night rendering of arboretum looking through arcade

# Conclusion

In creating installations, architects have appropriated ways of working from the art world, such as choosing and controlling the content of the project and building at full-scale (often with their own hands). Emulating artistic practice has given architects license to release themselves from the obligations of function, shelter, and permanence associated with architectural design. But, as architects adopted these practices from the art world, they also added expertise and perspective shaped by their own discipline, bringing architectural concerns to new audiences.

There is a significant difference in the roles artists' and architects' installations play in their respective works. For artists the artwork is ultimately situated in relationship to the ongoing discourse of art history and criticism, whether that product is an object, environment, experience, or an event. For many architects the installation is not the end product. Rather, it is a preliminary step in an ongoing process tethered to the discipline of architecture, whether that process is designing buildings, examining and broadening conversation about the built environment, or expanding ways that architecture can participate in and impact people's lives.

The ways that architects use installations can be grouped in three broad categories: to experiment with both material and social dimensions of architecture, to create conversations both with academics and the general public about the built environment, and to educate future architects.

Architects employ installations as a medium for experimentation with materials, situations, and processes advancing the technological and aesthetic possibilities of the discipline. In some cases these experiments are later incorporated into buildings. Other architects use installations to collaborate with the public in new ways—they serve as a form of social and spatial research for design, as a vehicle to stimulate debate, and a means to develop shared ownership of future projects.

In addition to being a mode of experimentation, installations situate architectural concerns within a larger intellectual context and stimulate discourse both within and outside of the discipline. Some installations broaden the conversation to include a larger public in discussion, for example, about underlying cultural and political assumptions embedded in the built environment or the effects of economic and social change on places considered sites of memory. Others contribute to this effort with new ways to describe and frame our world, altering perceptions and reshaping existing understandings of particular places.

Finally, many educators use installations to train future architects. In educational contexts, installations are employed to teach students about playing and building with materials, the collaborative nature of architectural practice, as well as the importance of social action and public engagement. As a result a new generation of architects have come to see installations as a form of creative expression situated within the discipline.

The projects presented in this book demonstrate that installations have become important professional and pedagogical tools that advance the discipline in ways that conventional buildings cannot. We are eager to see how the practice of installations will evolve and change, as it becomes yet a more common part of the repertoire of architects.

# Notes

### Introduction

**1.** Mark Robbins, in interview with the authors, May 5, 2007.
**2.** Allan Wexler, in interview with the authors, March 6, 2007.
**3.** Julie H. Reiss, *From Margin to Center: The Spaces of Installation Art* (Cambridge, MA: MIT Press, 1999), xiii.
**4.** For a wide range of examples of installations created in an academic context, see Sarah Bonnemaison, Ronit Eisenbach, and Robert Gonzalez, eds., "Installations by Architects: Ephemeral Constructions, Lasting Contributions," *Journal of Architectural Education* 59, no. 4 (May 2006).
**5.** Dan Hoffman, *Architecture Studio: Cranbrook Academy of Art, 1986–93* (New York: Rizzoli, 1994).
**6.** Christine Macy, *Freelab: Design-build Projects from School of Architecture Dalhousie University, Canada 1991–2006* (Halifax, Nova Scotia: Tuns Press, 2008).
**7.** Liza Fior and Katherine Clarke of muf architecture/art, in interview with the authors, March 15, 2007.
**8.** Reiss, *From Margin to Center*, xi.
**9.** Andrew Benjamin and Nicolas de Olivera, eds., *Installation Art* (Chichester, England: Wiley-Academy, 1993); Nicolas de Oliveira, Nicola Oxley, and Michael Petry, *Installation Art* (London: Thames and Hudson, 1994); Ilya Kabakov, *On the "Total" Installation* (Ostfildern, Germany: Cantz, 1995); Patricia C. Phillips, ed., *City Speculations* (New York: Princeton Architectural Press, 1996); Michael Fried, *Art and Objecthood: Essays and Reviews* (Chicago: University of Chicago Press, 1998); Reiss, *From Margin to Center*; Erika Suderburg, ed., *Space, Site, Intervention: Situating Installation Art* (Minneapolis: University of Minnesota Press, 2000); Aaron Betsky, *Scanning the Aberrant Architectures of Diller and Scofidio* (New York: Whitney Museum of American Art, 2003); Claire Bishop, *Installation Art: A Critical History* (London: Tate, 2005); Lucy Bullivant, *Responsive Environments: Architecture, Art and Design* (London: V&A Publications, 2006); and Graham

Coulter-Smith, *Deconstructing Installation Art: Fine Art and Media Art, 1986–2006* (London: CASIAD, 2006).
**10.** Mark Rosenthal, *Understanding Installation Art From Duchamp to Holzer* (Munich: Prestel, 1998), 33.
**11.** Philip Beesley, in interview with Sarah Bonnemaison, July 5, 2008. Also see Philip Beesley, "Oregon Reef," in *Architectural Design*, ed. Bob Sheild (Chichester, England: Wiley-Academy, 2006), 86–89.
**12.** Marc Dessauce, ed., *The Inflatable Moment: Pneumatics and Protest in '68* (New York: Princeton Architectural Press, 1999), 17.
**13.** The architects were Tunney Lee, John Wiebenson, James Goodell, and Kenneth Jadin. Ann Heppermann and Kara Oehler, "The Legacy of Resurrection City," *Weekend America*, May 10, 2008. Available on the web at: http://weekendamerica.publicradio .org/display/web/2008/05/08/1968 _resurrection; Tunney Lee, in correspondence with Ronit Eisenbach, September 24, 2008.
**14.** John Wiebenson, "Planning and Using Resurrection City," *American Institute of Planners Journal* 35, no. 6 (November 1969): 405–11.
**15.** Mary Miss, in interview with Ronit Eisenbach, June 20, 2008.
**16.** Ibid.

### Chapter 1

**1.** Kenneth Frampton, *Studies in Tectonic Culture: The Poetics of Construction in Nineteenth and Twentieth Century Architecture* (Chicago: Graham Foundation for Advanced Studies; Cambridge, MA: MIT Press, 1995), 4.
**2.** Sigfried Giedeon, quoted in Frampton, *Studies in Tectonic Culture*, 13.
**3.** Mark West, quoted in Michael J. Crosbie, "Selected Detail: Fabric Formwork for Concrete," *Progressive Architecture* 75, no. 7 (July 1994): 114.
**4.** Mark West, in interview with Sarah Bonnemaison, November 15, 2007.
**5.** Ibid.
**6.** Crosbie, "Selected Detail: *Fabric Formwork*," 114.

**7.** Kenneth Hayes, quoted in Gary Michael Dault, "Cement, Concrete," *Canadian Architect* 47, no. 6 (June 2002): 32–33.
**8.** West, interview with Bonnemaison.
**9.** The dance was choreographed and performed by Maria Osende on the motion-capture stage at the Nova Scotia Community College in Truro, Nova Scotia.
**10.** Frampton, *Studies in Tectonic Culture*, 148.
**11.** Richard Kroeker, in interview with Sarah Bonnemaison, February 14, 2007
**12.** Mitchell Schwarzer, "Ontology and Representation in Karl Botticher's Theory of Tectonics," *Journal of the Society of Architectural Historians* 52, no. 3 (September 1993): 267.
**13.** Caroline van Eck, *Organicism in Nineteenth-Century Architecture: Inquiry into its Theoretical and Philosophical Background* (Amsterdam: Architectura et Natura Press, 1994), 164.
**14.** Ibid., 165.
**15.** Mette Ramsgard Thomsen, in interview with Sarah Bonnemaison, February 19, 2006. See also Mette Ramsgard Thomsen, "Metabolic Architectures," in *Responsive Textile Environments*, eds. Sarah Bonnemaison and Christine Macy (Halifax, Nova Scotia: TUNS / Riverside Press, 2007), 36–45.
**16.** Thomsen, "Metabolic Architectures," 42.
**17.** Ariel Ben-Amos, "A Conversation with Robert Venturi and Denise Scott Brown," *Philadelphia Independent* 1, no. 15 (April 2004): 1.
**18.** Ibid.
**19.** The exhibition, curated by Robert Rubin and Evan Douglis, focused on furniture and prefabricated building fragments from three of Jean Prouvé's buildings: the Glassmaking School at Croismare (1948), the Tropical House (1949)—now part of the permanent collection of the Centre Pompidou—and the Aluminum Centenary Pavilion at Villepinte (1954).

**20.** Evan Douglis, in interview with Sarah Bonnemaison, November 6, 2007.

**21.** Ibid.

**22.** Ibid.

**23.** Robert Rubin and Evan Douglis, "Jean Prouvé: Three Nomadic Structures," *Newsline,* Columbia University Graduate School of Architecture, Planning, and Preservation (March 2003), http://www.arch.columbia.edu/gsap/25475.

**24.** Le Corbusier, *Towards a New Architecture* (New York: Payson and Clarke, 1927), 29.

**25.** Chris Bardt, in interview with the authors, March 5, 2007.

**26.** Chris Bardt, "Constructing Light," *Journal of Architectural Education* 58, no. 2 (November 2004): 17.

**27.** James Cathcart, Frank Fantauzzi, and Terence van Elslander, *Pamphlet Architecture 25: Gravity* (New York: Princeton Architectural Press, 2003), 30.

**28.** Frank Fantauzzi, in interview with the authors, January 21, 2007.

**29.** Schinkel refers more specifically to Gothic architecture, but for the sake of clarity in this context, we have removed this reference. Caroline van Eck, *Organicism in Nineteenth Century Architecture: Inquiry into its Theoretical and Philosophical Background* (Amsterdam: Architectural et Natura Press, 1994), 161.

**30.** Kourosh Mahvash, "On Electrical Light and Spirituality in Designing Architectural Space" (MArch./ Post-professional thesis, Dalhousie University, 2002), 16.

**31.** Laleh Bakhtiar, *Sufi: Expressions of the Mystic Quest* (New York: Thames and Hudson, 1987), 59.

### Chapter 2

**1.** Joseph Rykwert, *The Dancing Column: On Order in Architecture* (Cambridge, MA: MIT Press, 1996).

**2.** George Dodds and Robert Tavernor, eds., *Body and Building: Essays on the Changing Relation of Body and Architecture* (Cambridge, MA: MIT Press, 2005).

**3.** Kenneth Frampton, "La Maison de verre," *Arquitectura* 70, no. 275–76 (November 1988–February 1989): 26–43.

**4.** Examples of books on phenomenology include Junichiro Tanizaki, *Praise of Shadows* (originally published in 1933, translated into English 1977, with a foreword by Charles Moore); Juhani Pallasmaa, *The Eyes of the Skin: Architecture and the Senses* (London: Academy Editions, 1996). On sexuality and space, see Joel Sanders, ed., *Stud: Architectures of Masculinity* (New York: Princeton Architectural Press, 1996); Duncan McCorquodale, Katerina Rüedi, Sarah Wigglesworth, *Desiring Practice: Architecture, Gender, and the Interdisciplinary* (London: Black Dog, 1996); Diana Agrest, Patricia Conway, and Leslie Weisman, *The Sex of Architecture* (New York: Harry N. Abrams, 1996).

**5.** This was an important technical innovation. Historians of photography do not agree whether or not the Gilbreths were familiar with Étienne-Jules Marey's work with multiple exposures on a single plate.

**6.** Sigfried Giedion, *Mechanization Takes Command: A Contribution to Anonymous History* (New York: Norton, 1948), 130.

**7.** Hoffman, *Architecture Studio,* 168–71.

**8.** Dan Hoffman, in interview with the authors, September 25, 2005.

**9.** "Diller + Scofidio: Bad Press— Traveling Exhibition," *A + U: Architecture and Urbanism* 12, no. 375 (December 2001): 78.

**10.** Aaron Betsky, "Display engineers," in *Scanning: The Aberrant Architectures of Diller + Scofidio,* ed. Aaron Betsky, Elizabeth Diller, and Ricardo Scofidio, (New York: Whitney Museum of American Art, 2003), 32.

**11.** Taeg Nishimoto, in interview with the authors, September 21, 2005.

**12.** Ibid.

**13.** Kenneth Frampton, "Re-f(r)action #4" in Taeg Nashimoto, *Third Line* (Paris: La Gallerie d'Architecture, 2002).

**14.** Laban placed the body of the dancer within a three-dimensional grid of platonic geometry, which he called a kinetogram. Using this spatial geometry, he developed a grammar of gestures in which the limbs would reach the distant points of this grid. The "A" scale moves inward, and the "B" scale, in contrast, moves outward. He used these scales to demonstrate how body movements can be broken down into axes and orientations. All these geometries centered on the navel and treated the body as a perfectly centered object.

**15.** "dECOI: Ether-I, Geneva, Switzerland 1995," *A + U: Architecture and Urbanism* 10, no. 313 (1996): 84.

**16.** Body Building was one of three concurrent exhibitions about architectural installations that were planned as a set under the umbrella title Fabrications (1998). Twelve architectural firms were commissioned by three curators to create installations. Each firm designed an installation, which would be passed on to another firm for further development. It was then returned to the original design firm, which built and installed the work in a gallery setting. The show at SF MOMA was curated by Aaron Betsky; the Museum of Modern Art, New York by Terence Riley; the Wexner Center by Mark Robbins.

**17.** Craig Hodgetts, in interview with the authors, May 28, 2008

**18.** Ibid.

**19.** Byron Kuth, in interview with the authors, September 15, 2005.

**20.** Ibid.

**21.** Phenomenology has clearly had an influence on the work of Arthur Erickson, Louis Kahn, Charles Moore, and Lars Lerup, and the writings of Christian Norberg-Schulz and Yi-Fu Tuan.

**22.** Ruth Keffer, "Thom Faulders: Most of the Conventions of Architecture," in SF MOMA *Experimental Design Award 2001* (San Francisco: SF MOMA, 2001).

**23.** First developed by NASA for seat cushions that maintained even pressure on the body, memory foam was subsequently used to produce earplugs and hospital beds.

**24.** Thom Faulders, in interview with the authors, September 25, 2005.

**25.** Ibid.

**26.** Faulders quoted in the curator's text by Marina McDougall, *Rooms for Listening*, exhibition catalog (San Francisco: California College of the Arts Wattis Institute, 2001).

27. Ibid.

28. Richard Kearney, *Modern Movements in European Philosophy* (Manchester and New York: Manchester University Press, 1986), 14.

29. Maurice Merleau-Ponty, *The Phenomenology of Perception* (London: Routledge, 1962), 93.

30. Paul Klee, quoted in Giedion, *Mechanization,* 109.

31. Frances Bronet and John A. Schumacher, "Design in Movement: The Prospects of Interdisciplinary Design," *Journal of Architectural Education* 53, no. 2 (1999): 97–109.

32. Frances Bronet, *Beating a Path* (Troy, New York: Frances Bronet, 2001), video.

33. Ellen Sinopoli, quoted in Bronet, *Beating a Path*.

34. Ibid.

35. Anna von Gwinner, in interview with the authors, August 21, 2000.

36. Gaston Bachelard, *The Poetics of Space* (New York: Orion Press, 1964), 26–27.

37. Reiss, *From Margin to Center*.

38. One of the best critiques of phenomenology is by Terry Eagleton, *Literary Theory* (Minneapolis: University of Minnesota Press, 1996).

39. Martin Heidegger, quoted in Richard Kearney, *Modern Movements in European Philosophy* (Manchester: Manchester University, 1994), 95.

40. Diana Agrest, Patricia Conway, and Leslie Weisman, eds., *The Sex of Architecture* (New York: Harry N. Abrams, 1996), 11.

41. Yolande Daniels, in interview with the authors, August 16, 2000.

42. Ibid.

43. David Higgs, ed., *Queer Sites: Gay Urban Histories Since 1600* (London: Routledge, 1999), 72.

44. See also Gordon Brent Ingram, Anne-Marie Bouthilette, and Yolanda Retter, eds., *Queers in Space: Communities, Public Places, Sites of Resistance* (Seattle: Bay Press, 1997); and Aaron Betsky, *Queer Space: Architecture and Same-Sex Desire* (New York: William Morrow, 1997).

45. Arturo Torres, in interview with Sarah Bonnemaison, November 21, 2005.

46. Ibid.

47. Ibid.

48. Robert Gonzalez, "For Sale: Life-Size Aquarium," *Architecture* 89, no. 5 (May 2000): 98–99.

49. Torres, interview with Bonnemaison, 2005.

50. Gonzalez, "For Sale," 98.

51. Torres, interview with Bonnemaison, November 2005.

52. Gonzalez, "For Sale," 99.

53. Dr. Edith Farnsworth, interviewed in Elizabeth Gordon, "The Threat to the Next America," *House Beautiful* 95 (April 1953): 127.

54. Torres, interview with Bonnemaison, 2005. Daniela Tobar went on to become a successful actress in Chilean television soap operas.

## Chapter 3

1. Jeffrey Kastner and Brian Wallis, *Land and Environmental Art* (London: Phaidon, 1998), 103.

2. Pierre Thibault, in interview with the authors, February 16, 2007.

3. Ibid.

4. Ibid.

5. Ibid.

6. Examples of this are the balloons of Hans Haacke's *Sky Line*, the large concrete conduits of Nancy Holt's *Sun Tunnels*, or the soft fabric of Christo's *Running Fence*. These objects frame, set in motion, or harness natural elements: the blue sky of Central Park in *Sky Line*, the desert sand in *Sun Tunnels*, and the rolling hills of California in *Running Fence*.

7. The installation at the Nordberg Fort was arranged by the Art Museum of Southern Norway (County of West-Agder) in collaboration with Lista Fyr Gallery of Art.

8. Marianne Lund, in interview with the authors, January 13, 2007.

9. Ibid.

10. Lucy Lippard, *Overlay: Contemporary Art and the Art of Prehistory* (New York: New Press, 1983), 160.

11. Odd Mathis Hætta, *The Sami: An Indigenous People of the Arctic,* trans. Ole Fetter Gurholt (Karasjok, Norway: Davvi Girji, 1993), 34.

12. Marianne Lund, in interview with Sarah Bonnemaison, February 22, 2007.

13. Philip Beesley Architect website, "Erratics Net," http://www.philipbeesleyarchitect.com.

14. Philip Beesley, in interview with the authors, March 4, 2007.

15. Janine M. Benyus, *Biomimicry: Innovation Inspired by Nature* (New York: Perennial, 2002), 11.

16. Beesley, interview with the authors, 2007.

17. Christine Macy, "Disintegrating Matter, Animating Fields," in *Hylozoic Soil: Geotextile Installations 1995–2007*, ed. Philip Beesley (Cambridge, ON: Riverside Architectural Press, 2007), 38.

18. Beesley, interview with the authors, 2007.

19. Robert Vischer cited in Juliet Koss, "On the Limits of Empathy," *Art Bulletin* 88, no. 1 (March 2006): 139–57.

20. Honoré de Balzac, "Théorie de la démarche," in *Oeuvres Complètes de Honoré de Balzac, Oeuvres Diverses*, *(1830–1835)*, ed. Marcel Bouteron and Henri Longnon (Paris: Louis Conard, 1938), 2:621. Translated from the French by Sarah Bonnemaison.

21. Denis Cosgrove, *The Palladian Landscape: Geographical Change and Its Cultural Representations in Sixteenth-Century Italy* (Leicester: Leicester University Press, 1993).

22. For an in-depth discussion of the relationship between the mythologies surrounding wilderness and American architecture, see Christine Macy and Sarah Bonnemaison, *Architecture and Nature: Creating the American Landscape* (London: Routledge, 2005).

23. Jonathan Crary, *Techniques of the Observer: On Vision and Modernity in the Nineteenth Century* (Cambridge, MA: MIT Press, 1990); Hal Foster, *Vision and Visuality* (Seattle: Bay Press, 1988); and Rosalind Krauss, *The Optical Unconscious* (Cambridge, MA: MIT Press, 1993).

24. Mark Robbins, *Angles of Incidence* (New York: Princeton Architectural Press, 1992), 38.

25. Mark Robbins, in interview with the authors, May 5, 2007.

26. Ibid.

27. Jeffrey M. Kipnis, "The Work of Mark Robbins," *A+U: Architecture and Urbanism* 8 (September 1992): 45.

**28.** Robbins, in interview with the authors, 2007.

**29.** Ibid.

**30.** Ibid.

**31.** Glen R. Brown, "Studio View," *New Art Examiner*, October 1995, 34.

**32.** Giorgio de Santillana and Hertha von Dechend, *Hamlet's Mill: An Essay Investigating the Origins of Human Knowledge and Its Transmission through Myth* (Jaffrey, NH: David R. Godine, 1977).

**33.** Anderson Anderson Architecture, "Prairie Ladder," http://www.andersonanderson.com.

**34.** Henry David Thoreau, *The Annotated Walden: Walden or, Life in the Woods*, ed. J. Lyndon Shanley (Princeton, NJ: Princeton University Press, 1970), 96.

**35.** Svetlana Alper, *The Art of Describing: Dutch Art in the Seventeenth Century* (Chicago: University of Chicago Press, 1983).

**36.** Ibid., 44.

**37.** Anderson Anderson Architecture, "Prairie Ladder," http://www.andersonanderson.com.

**38.** Ibid.

**39.** See Connie Bruner, *Video Portrait: Ronit Eisenbach*, (Windsor, Ontario: The Art Gallery of Windsor, 2000), video documentary; and Ronit Eisenbach, "filum aquae: the Thread of the Stream," *IN SPITE OF (or because of)*, ACSA Regional Conference Proceedings (Arizona State University, Phoenix: October 2000), 111–16.

**40.** Abbé Laugier, quoted in Joseph Rykwert, *On Adam's House in Paradise: The Idea of the Primitive Hut in Architectural History* (Cambridge, MA: MIT Press, 1981), 43.

**41.** Ibid.

**42.** Matthew Stadler, "Take It to the Limit One More Time*,*" *Nest*, Summer 2000, 17.

**43.** Ibid.

**44.** Ibid.

**45.** Ibid.

**46.** Ibid.

**47.** Allan Wexler, in interview with the authors, March 6, 2007.

**48.** Ibid.

**49.** Allan Wexler, "Gardening Sukkah," http://www.allanwexlerstudio.com.

**50.** Wexler, in interview with the authors, 2007.

**51.** Mari Hvattum, "Essence and Ephemera, Themes in Nineteenth Century Architectural Discourse" (conference paper, Society of Architectural Historians Annual Meeting, Richmond, VA, April 2002), 66.

**52.** Wexler in interview with the authors, 2007.

## Chapter 4

**1.** Edward S. Casey, *Remembering: A Phenomenological Study* (Bloomington and Indianapolis: Indiana University Press, 1987), 183.

**2.** Kevin Lynch, *What Time Is this Place?* (Cambridge, MA: MIT Press, 1993), 1.

**3.** James E. Young, *The Texture of Memory: Holocaust Memorials and Meaning* (New Haven and London: Yale University Press, 1993), 15.

**4.** For more information on the phenomena, see the Shrinking Cities exhibitions directed by Philip Oswalt, "Shrinking Cities," http://www.shrinkingcities.com; and for a planning perspective see the IURD, University of California, Berkeley, "Shrinking Cities Group," http://www-iurd.ced.berkeley.edu/scg/.

**5.** Sami Rintala, in interview with the authors, May 21, 2007.

**6.** Ibid.

**7.** Ibid.

**8.** Ibid.

**9.** Pierre Nora, ed., *Rethinking France: Les lieux de mémoire* [Rethinking France: The places of memory], trans. Mary Trouille (Chicago: University of Chicago Press, 2001).

**10.** Pierre Nora, "Between Memory and History: Les Lieux de Mémoire," in "Memory and Counter-Memory," ed. Natalie Zemon Davis and Randolph Starn, special issue, *Representations* 26 (Spring 1989): 7.

**11.** Ibid., 11.

**12.** Dan Hoffman, "Erasing Detroit," in *Stalking Detroit,* ed. Georgia Daskalakis, Charles Waldheim, and Jason Young (Barcelona: Actar, 2001), 101–2.

**13.** Hoffman, *Architecture Studio*, 30–37; Detroit Institute of Arts, "Artists Take on Detroit: Projects for the Tricentennial." For online catalogue, see http://www.dia.org/exhibitions/

artiststake/index.html; Kyong Park, ed., *Urban Ecology: Detroit and Beyond* (Hong Kong: Map Book Publishers, 2005), 43–54, 63–76.

**14.** Dan Pitera, in interview with the authors, May 21, 2007.

**15.** Dan Pitera, project text from *FireBreak*, Detroit, October 2002.

**16.** Natalie Zemon Davis and Randolph Starn, "Introduction," in "Memory and Counter-Memory," ed. Zemon Davis and Starn, 2.

**17.** Dolores Hayden, *The Power of Place: Urban Landscapes as Public History* (Cambridge, MA: MIT Press, 1995), 8.

**18.** Working Group: Rina Benmayor, Renato Rosaldo (group coordinators) and others,"Concept paper" (paper, Records of the Inter-University Program for Latino Research at the Centro de Estudios Puertorriquenos, Archives of the Puerto Rican Diaspora, Hunter College, CUNY, 1988); and William V. Flores and Rina Benmayor, eds., *Latino Cultural Citizenship: Claiming Identity, Space and Rights* (Boston: Beacon Press, 1997), 1–38.

**19.** For a more nuanced understanding of this relationship, see Indian and Northern Affairs of Canada, Royal Commission on Aboriginal Peoples, "Highlights from the report of the Royal Commission on Aboriginal Peoples," 1996, http://www.ainc-inac.gc.ca/ap/pubs/rpt/rpt-eng.asp.

**20.** Richard Kroeker, in interview with Ronit Eisenbach, January 15, 2008.

**21.** Ibid.

**22.** Ibid.

**23.** Richard Kroeker, quoted in Rachel Boomer, "Thank You for Giving us Halifax Even Though I don't Agree with Your Methods," *Halifax Daily News*, July 10, 2002, 1, 3.

**24.** William Daryl Williams, introduction to *Places of Refuge: The Dresser Trunk Project* gallery guide, 2008. Published in conjunction with the traveling exhibition "The Dresser Trunk Project" shown at the Extension Gallery For Architecture in Chicago; the University of Virginia Art Museum, Charlottesville; Howard University, University of Maryland Kibel Gallery, Washington D.C.; and the University of Pennsylvania, Philadelphia. See also

http://www.williamdarylwilliams.com/
Site/DTP_Gallery.html.

25. Victor H. Green, *The Negro Motorist Green Book: An International Travel Guide* (New York: Victor H. Green & Co, 1949), 1. This guide was published annually starting in 1936. For further reading on the subject of African American mobility see Cotten Seiler, "So that We as a Race Might have Something Authentic to Travel By: African American Automobility and Cold War Liberalism, *American Quarterly* 58, no. 4 (December 2006): 1091–117.

26. Mabel Wilson, text applied to interior surface of the *Hotel Coleman Dresser Trunk* lid. Also as project text in Williams, ed., *Places of Refuge.*

27. Ibid.

28. Mabel Wilson, in interview with Ronit Eisenbach, July 16, 2008.

29. Williams, "Whitelaw Hotel Dresser Trunk," project text, *Places of Refuge.*

30. Ibid.

31. William Daryl Williams, in interview with Ronit Eisenbach, February 7, 2008.

32. Williams, introduction to *Places of Refuge.*

33. Hayden, *The Power of Place,* 238

34. Thanks to Mabel Wilson for sharing this insight with us.

35. Raphael Moneo, "On Typology,*" Oppositions* 13 (Summer 1978): 23–45; Peter Eisenman, "The Houses of Memory: The Text of Analogy," introduction to *The Architecture of the City,* by Aldo Rossi (Cambridge, MA: MIT Press, 1982), 7.

36. Dan Hoffman, in interview with Ronit Eisenbach, July 13, 2008.

37. John Hejduk, *VICTIMS* (London: Architectural Association Publications, 1986), site plan, inside flap.

38. The authors thank Dennis Crompton, Valerie Bennett, Dirk Lellau, and Renata Hejduk for their help in procuring images of *The Collapse of Time.* Also thanks to Hélène Binet, Raoul Bunschoten, and Nicholas Boyarsky for sharing their insights and anecdotes about its construction.

39. John Hejduk, "Diary Constructions," in *The Collapse of Time and Other Diary Constructions* (London: Architectural Association, 1986).

40. Hoffman, in interview with Eisenbach, 2008.

41. Aldo Rossi, *The Architecture of the City* (Cambridge, MA: MIT Press, 1982), 57–58.

42. Weinthal's explanation of the empty pedestal in front of the German Historical Museum was based on an interview with Dr. Rosemarie Beier-de Haan, head of collections, German Historical Museum, Berlin, July 21, 2004. Lois Weinthal, in interview with Ronit Eisenbach, January 15, 2008.

43. Ibid.

44. Ibid.

45. Ibid.

46. Young, *The Texture of Memory,* xi–xii.

47. Quartier Éphémère is a nonprofit arts organization in Montréal that invests in and supports in situ art projects within vacant or abandoned industrial buildings; Grain Elevator No. 5 is the site of a long-term ephemeral project supported by Quartier Éphémère, *The Silophone.* Over the Internet or by telephone the public can insert voices, music, and sounds into the grain elevators, transforming them into instruments. *The Silophone* was conceived and created by [The User], a team comprised of an architect, Thomas McIntosh, and a composer, Emmanuel Madan. For more information, see http://www.silophone.net/.

48. Quartier Éphémère, mission statement excerpt, http://www.fonderiedarling.org/quartier_e/index.html.

49. Annie Lebel, Geneviève L'Heureux, and Stéphane Pratte, "Projections," *Inter Actuel* 69 (1998).

50. Atelier in situ website, "Projects," http://www.atelierinsitu.com/2006/projets.php?id=31.

51. Ibid.

52. Two organizations, DOCOMOMO and Quartier Éphémère, ran a competition that included this installation. The goal was to "transform the way people looked at Modern architecture," said Annie Lebel, in interview with Ronit Eisenbach, May 14, 2007.

53. Paul Virilio, *La Machine de Vision* [The Vision Machine] (Paris: Éditions Galilée, 1988), 130.

54. Roland Barthes, *Elements of Semiology* (New York: Hill and Wang, 1968), 15.

**Chapter 5**

1. Eleanor Heartney, "Beyond Boundaries" in *Mary Miss* (New York: Princeton Architectural Press, 2004), 10.

2. Ibid.

3. Margaret Crawford, "Blurring the Boundaries: Public Space and Private Life," in *Everyday Urbanism,* ed. John Chase, Margaret Crawford, and John Kaliski (New York: Monacelli Press, 1999), 23.

4. Richard Sennett, introduction to *The Conscience of the Eye: The Design and Social Life of Cities* (New York: Alfred A. Knopf, 1990), xii.

5. Ibid., xiv.

6. Frank Fantauzzi, in interview with the authors, January 21, 2007.

7. Ibid.

8. Anne-Françoise Jumeau, in interview with Sarah Bonnemaison, January 29, 2007.

9. "Installation in a Public Square in Paris," *Detail* 42, no. 12 (December 2002): 1563.

10. Arqhé, *Line of Site V,* Québec City, Canada, project text, 2000.

11. Jorge Luis Borges, "Of Exactitude in Science" in *A Universal History of Infamy,* trans. Norman Thomas Giovanni (New York: Dutton 1972), 141.

12. Italo Calvino, *Invisible Cities,* trans. William Weaver (San Diego, New York, London: Harcourt Brace Jovanovich, 1997).

13. Frano Violich, in interview with Ronit Eisenbach, February 6, 2007.

14. Ibid.

15. Ibid.

16. Shin Egashira, project text from *How To Walk a Flat Elephant,* Tokyo, 2007.

17. David Harvey, *The Urban Experience* (Baltimore: Johns Hopkins University Press, 1985), 57.

18. Speranza Octavia, introduction to "NY AV: A Section through the City and through Time," by Martha Skinner and Doug Hecker, *Arch'it,* September 5, 2005, http://architettura.supereva.com/files/20050905/index.htm.

**19.** Martha Skinner, "Zoom/Section—From South to North," *SOUTH* 1 (2005): 30–39.

**20.** Skinner and Hecker, "NY AV: A Section through the City."

**21.** Margaret Crawford, introduction to *Everyday Urbanism*, 8-9.

**22.** Ibid., 12.

**23.** Ibid.

**24.** Ibid.

**25.** Guy Debord, "Preliminary Problems in Constructing a Situation," in *Situationist International Anthology*, ed. Ken Knabb (Berkeley: Bureau of Public Secrets, 1981), 43–45.

**26.** Entries by Lorisia Clevenger, Susan Rubin, and Alexandra Nicasio in the *NY A/V* guest book, 2005.

**27.** The authors would like to thank Guido Francescato, Thomas Schumacher, Raffaella Zannutini, and Robert Frank for translations from the Italian and German and for their assistance in corresponding with Leonardo Mosso.

**28.** For insight into the theoretical underpinnings of this work, Mosso's "theory of semiotic structural design," and his concept of "directed architecture," see Leonardo Mosso and Laura Mosso Castagno, "Self Generation of Form and the New Ecology," *Architect Association Quarterly* 3, no. 1 (Winter 1971): 8–24.

**29.** Attilio Stocchi, "Structures of Light," *Abitare* 405 (April 2001): 230.

**30.** Ibid.

**31.** This is but one among many urban interventions proposed or realized by Mosso over his long career. In Berlin, for example, Mosso proposed a series of light portals to better connect cultural institutions. In Brandenberg a carpet of red light and a symphonic performance brought a much-needed sensation of pleasure and lightness to an area of the city that people associated with Second World War bombings and therefore found fearful.

**32.** Leonardo Mosso, in interview with Sarah Bonnemaison, January 18, 2007.

**33.** Ibid.

**34.** Leonardo Mosso, letter to authors, June 15, 2008.

**35.** Stocchi, "Structures of Light," 233.

**36.** Alexandre Plennevaux, in interview with the authors, January 17, 2007.

**37.** To learn about additional projects using the Dexia building's interactive infrastructure see http://www.dexia-towers.com.

**38.** Other partners included architect M & J-M. Jaspers – J. Eyers & Partners.

**39.** Plennevaux, interview with the authors, 2007.

**40.** *Touch* is archived at http://www.lab-au.com/v1/dexia/2006/touch/home.php.

**41.** Helen Castle, "Editorial," in "4Dsocial: Interactive Design Environments," ed. Lucy Bullivant, special issue, *Architectural Design* 77, no. 4 (August 2007): 5.

**42.** Usman Haque, "The Architectural Relevance of Gordon Pask," in "4Dsocial: Interactive Design Environments," ed. Bullivant, *Architectural Design*, 55.

**43.** Usman Haque, "Architecture, Interaction, Systems," in *Responsive Textile Environments*, ed. Sarah Bonnemaison and Christine Macy (Halifax: TUNS Press, 2007), 62.

**44.** Lucy Bullivant, *Responsive Environments: Architecture, Art and Design* (London: V & A Publications, 2006), 64.

**45.** Ibid.

**46.** See Jasia Reichardt, *Cybernetic Serendipity: The Computer and the Arts* (London: Studio International, 1968); and Usman Haque, "The Architectural Relevance of Gordon Pask," in "4Dsocial," ed. Bullivant, *Architectural Design*, 54-61.

**47.** Haque,"Architecture, Interaction, Systems," 62.

**48.** For more information see also http://www.london.gov.uk/mayor/auu/publications.jsp.

**49.** While muf architecture/art is unusual in its establishment of a formal partnership between artists and architects, this kind of collaboration is becoming more common. See Jes Fernie, *Two Minds: Artists and Architects in Collaboration* (London: Black Dog, 2006).

**50.** Muf architecture/art, project text from *Barking Town Square*, London, July 2008.

**51.** Ibid.

**52.** Katherine Clarke, in interview with the authors, March 15, 2007.

**53.** Ibid.

**54.** Liza Fior, in interview with the authors, March 15, 2007.

**55.** Ibid.

**56.** Clarke, in interview with the authors, 2007.

# Selected Bibliography

Ancel, Pascale. *Une représentation sociale du temps: étude pour une sociologie de l'art*. Paris: Harmattan, 1996.

Aycock, Alice. *Alice Aycock: Projects 1979–1981*. College of Fine Arts, University of Florida, 1981.

Azara, Pedro. *Arquitectos a Escena, Architects on Stage: Stage and Exhibition Design in the '90s*. Barcelona: Editorial Gustavo Gilli, 1990.

Bach, Penny Balkin. *New Land Marks: Public Art, Community, and the Meaning of Place*. Washington, D.C.: Editions Ariel, 2001. An exhibition catalog.

Beardsley, John. *Earthworks and Beyond: Contemporary Art in the Landscape*. New York: Abbeville Press, 1984.

Beer, Evelyn, and Riet De Leuw, eds. *L'exposition imaginaire: The Art of Exhibiting in the Eighties = de kunst van het tentoonstellen in de jaren tachtig*. Netherlands: Rijksdienst Beeldende Kunst, 1989.

Benjamin, Andrew, and Nicolas de Oliveira, eds. *Installation Art*. Chichester, England: Wiley-Academy, 1993.

Betsky, Aaron. *Scanning: the Aberrant Architectures of Diller + Scofidio*. New York: Whitney Museum of American Art, 2003.

Bonnemaison, Sarah, Ronit Eisenbach, and Robert Gonzalez, eds. "Installations by Architects: Ephemeral Constructions, Lasting Contributions," *Journal of Architecture Education* 59, no.4 (May 2006).

Bullivant, Lucy. *4dsocial: Interactive Design Environments*. London, Chichester: Wiley, 2007.

———. *4dspace: Interactive Architecture*. London, Chichester: Wiley, 2005.

———. *Responsive Environments: Architecture, Art and Design*. London: V&A Publications, 2006.

Cathcart, James, Frank Fantauzzi, and Terence Van Elslander. *Gravity*. New York: Princeton Architectural Press, 2003.

Charney, Melvin. *Parables and Other Allegories, 1975–1990*. Cambridge, MA: MIT Press, 1991.

Davidson, Kate, and Michael Desmond. *Islands: Contemporary Installations from Australia, Asia, Europe and America*. Port Melbourne: National Library of Australia, 1996.

De Oliveira, Nicolas. *Installation Art*. Washington, D.C.: Smithsonian Institution Press, 1994. First published 1994 by Thames and Hudson, London.

Dessauce, Marc, ed. *The Inflatable Moment: Pneumatics and Protest in '68*. New York: Princeton Architectural Press, 1999.

Diller, Elizabeth, and Ricardo Scofidio. *Flesh: Architectural Probes*. New York: Princeton Architectural Press, 1994.

Domino, Christophe. *A ciel ouvert*. Paris: Editions de la Revue Moderne, 1971.

Dompierre, Louise. *Press/enter: Between Seduction and Disbelief*. Toronto: Power Plant, 1995.

*Fabrications*. Edited by Xavier Costa, Terence Riley, Mark Robbins, and Aaron Betsky, catalog of exhibitions held at Museu d'art Contemporani de Barcelona, SF MOMA, Wexner Center for the Arts, and MOMA in New York, 1998.

Fernie, Jes. *Two Minds: Artists and Architects in Collaboration*. London: Black Dog, 2006.

Finkelpearl, Tom. *Dialogues in Public Art*. Cambridge, MA: MIT Press, 2001.

Forster, Kurt W. *Hodgetts + Fung: Scenarios and Spaces*. New York: Rizzoli International, 1997.

Frohne, Ursula, and Christian Katti. *Espace-space: Raumkozepte mit fotografien, Seichnungen, modellen und video,* Kraichtal, Germany: Ursula Blickle Stiftung, 2000.

Gastil, Raymond W., and Zoë Ryan, eds. *Open: New Designs for Public Space*. New York: Van Alen Institute: Distributed by Princeton Architectural Press, 2004.

Graham, Dan. "Art in Relation to Architecture, Architecture in Relation to Art." *Art Forum* 17, no. 6 (February 1979): 22–29.

Grenier, Catherine. *Annette Messager*. Paris: Flammarion, 2000.

Haskell, Barbara. *Donald Judd*. New York: Whitney Museum of Art, 1988

Hayden, Dolores. *The Power of Place: Urban Landscapes as Public History*. Cambridge, MA: MIT Press, 1995.

Hejduk, John. *The Collapse of Time and Other Diary Constructions*. London: Architectural Association, 1987.

Hejduk, John, and Architectural Association. *Victims: A Work*. London: Architectural Association, 1986.

Hill, Jonathan, ed. *Occupying Architecture: Between the Architect and the User*. London: Routledge, 1998.

Hoffman, Dan. *Architecture Studio: Cranbrook Academy of Art, 1986–93*. New York: Rizzoli, 1994.

Hodges, Nicola, ed. *Art and the Natural Environment*. London: Academic Editions, 1994.

Kabakov, Ilya. *On The "Total" Installation*. Ostfildern, Germany: Cantz, 1995.

Kastner, Jeffrey, and Brian Willis, eds. *Land and Environmental Art*. London: Phaidon, 1998.

Kaye, Nick. *Site-Specific Art: Performance, Place, and Documentation*. London: Routledge, 2000.

Kearny, Andrew. *Temporal Change: Installations by Andrew Kearny*. Dublin: Douglas Hyde Gallery, 1994.

Kottik, Charlotta. *Installation Art at the Brooklyn Museum: A Decade of Grand Lobby Projects*. New York: Brooklyn Museum, 1995.

Krauss, Rosalind. *The Originality of the Avant-Garde and Other Modernist Myths*. Cambridge, MA: MIT Press, 1986.

———. *Passages in Modern Sculpture*. Cambridge, MA: MIT Press, 1981.

Lasky, Julie, Bill Horrigan, and Mark Robbins. *Households*. New York: Monacelli Press, 2006.

Lippard, Lucy R. *The Lure of the Local: Senses of Place in a Multicentered Society*. New York: New Press, 1997.

Macy, Christine. *Freelab: Design-build Projects from School of Architecture Dalhousie University, Canada 1991–2006*. Halifax, Nova Scotia: TUNS Press, 2008.

Matta-Clark, Gordon, Whitney Museum of American Art, and Museum of Contemporary Art. *Gordon Matta-Clark: You Are the Measure*. New York: Whitney Museum of American Art, 2007.

Morris, Robert. "The Art of Existence, Three Extra-Visual Artists: Work in Process." *Art Forum* 9, no. 5 (January 1971): 28–33.

Museum of Contemporary Art, San Diego. *Blurring the Boundaries: Installation Art 1969–1996*. San Diego: Museum of Contemporary Art, San Diego, 1997. An exhibition catalog.

Park, Kyong. *Urban Ecology: Detroit and Beyond*. Hong Kong: Map Book Publishers, 2005.

Phillips, Patricia C., ed. *City Speculations*. New York: Princeton Architectural Press: 1996.

Reichardt, Jasia, and Institute of Contemporary Arts (London, England). *Cybernetic Serendipity; the Computer and the Arts*. New York: Praeger, 1969.

Reiss, Julie H. *From Margin to Center: The Spaces of Installation Art*. Cambridge, MA: MIT Press, 1999.

Robbins, Mark. *Angles of Incidence*. New York: Princeton Architectural Press, 1992.

Rosenthal, Mark. *Understanding Installation Art: From Duchamp to Holzer*. Munich: Prestel, 1998.

Ruten, J. A., and Joseph Semah. *The Third Exile: Explorations in the Borderland of Architecture, Visual Art, and Philosophy of Science*. Amsterdam: Arti et Amicitiae, 1993.

Schellmann, Jorg, ed. *Wall Works*. Cologne, New York: Edition Schellmann, 1993.

Suderburg, Erika, ed. *Space, Site, Intervention: Situating Installation Art*. Minneapolis: University of Minnesota Press, 2000.

Tiberghien, Gilles A. *Land Art*. New York: Princeton Architectural Press, 1995.

Young, James Edward. *The Texture of Memory: Holocaust Memorials and Meaning*. New Haven: Yale University Press, 1993.

Wexler, Allan. *Custom Built: A Twenty Year Survey of Work by Allan Wexler*. Edited by Chris Scoates and Debra Wilbur. Atlanta, GA: Atlanta College of Art Gallery, 1999. An exhibition catalog.

# Image credits

All images © respective architects unless
otherwise noted.

Shade Abdul, 117bl | Aldrich Museum 111b, 117br |
Artists Rights Society (ARS), New York/vgbild-kunst,
Bonn 18t | Paul Barnett, courtesy of the Architectural
Association, London 133t | Philip Beesley 80–81 |
Katie Beeson 180rt | Nancy Bergeron 142t |
Hélène Binet 133bl, 133br | Ivan Binet 151b |
Sarah Bonnemaison 129tr | Kirsty Bruce 31l |
James Cathcart 48, 49, 149 | Jorge Christie 79 |
Nikki Chung, Thumb 130r | Erik Cornelius 14 |
Dalhousie University 129tl | Joel Dauncey/Filum Ltd.
30rt, 30rc | David Joseph Photography 16br |
Mike Dembeck, courtesy of the *Halifax Daily News*
129bl, 129br | Evan Douglis 22–23 | Mike Fischer
(diagram) and Arqhé Collective plan 151tl |
© 2008 Estate of Gordon Matta-Clark/Artist Rights
Society (ARS), New York 20tl | Courtesy of the Estate of
John Hejduk 132 | Gary Gold 70 | Jane Haley 131br |
Usman Haque 144–45 | Ai Hasegawa 176t, 177br |
Craig Hodgetts 67 | Jane Hoholm 88, 89 |
Anders Ingvartsen 37b, 38 | Jacob JeBailey 16tl |
Victoria Jolly 29b | Tanja Jordan 108c 109t |
LAb[au] 174–75, © LAb[au], Philippe Samyn & Partners,
M & J. M. Jaspers—J. Eyers & Partner, and Barbara
Hediger | Landslides Aerial Photography—
Alex S. MacLean 157b | André Langevin 151tr, 152b |
Tunney Lee, courtesy of Rotch Visual Collection,
MIT 20tr, 20bl | Heikki Leikola 119bl, 119br |
Courtesy of the Library of Congress, Asian Division,
Japanese Section, Washington, D.C. LC-USZC4-8702
& 8703. 158l | John Li 131t | Jean-Francois Lenoir 142b,
143 | Jason Lowe 180br | Christine Macy/Filum Ltd. 30l,
31r, 30–31b | Glen Moon 103r | Michael Moran 41, 78 |
Leonardo Mosso 171–73 | muf architecture/art with
the assistance of Mike Fischer 180tl | Taeg Nishimoto
52–53 | Ortner + Ortner Baukunst, Vienna 18br |
James Partaik 152t | Andreas Pauly 107, 109b |
Dan Pitera 117bl, 120–22 | Mark Robbins 98l, 98rb, 99 |
David Rothschild 178–79 | SF MOMA 68 |
Martha Skinner 163 | Martha Skinner with the assistance
of Mike Fischer 162t | Scott F. Smith 130lt, 130lb, 131bl,
13lbr | Ryan Sullivan, underlay courtesy of National
Oceanic Atmospheric Administration 102t | Grant Taylor
98rt | Jussi Tiainen 119t | Wang Wei 144–45 |
Lois Weinthal 112–13 | Ellen Wexler 110tl, 110b, 111t |
David Williams 181t | Michael Williams 117ml, 117mr

Published by
Princeton Architectural Press
37 East 7th Street, New York, New York 10003

For a free catalog of books, call 1-800-722-6657
Visit our website at www.papress.com

© 2009 Princeton Architectural Press
All rights reserved
Printed and bound in China
12 11 10 09   4 3 2 1   First edition

Every reasonable attempt has been made to identify
owners of copyright. Errors or omissions will be corrected
in subsequent editions.

Frontispiece images
Pages 2–3: Philip Beesley, *Hylozoic Soil*
Pages 4–5: Chris Bardt, *Sun Box*
Pages 6–7: Pierre Thibault, *Constellations*

Editor: Linda Lee
Designer: Paul Wagner

Special thanks to: Nettie Aljian, Bree Anne Apperley,
Sara Bader, Nicola Bednarek, Janet Behning,
Becca Casbon, Carina Cha, Penny (Yuen Pik) Chu,
Carolyn Deuschle, Russell Fernandez, Pete Fitzpatrick,
Wendy Fuller, Jan Haux, Clare Jacobson, Aileen Kwun,
Nancy Eklund Later, Laurie Manfra, John Myers,
Katharine Myers, Lauren Nelson Packard, Dan Simon,
Andrew Stepanian, Jennifer Thompson, Joseph Weston,
and Deb Wood of Princeton Architectural Press
—Kevin C. Lippert, publisher

Library of Congress Cataloging-in-Publication Data
Bonnemaison, Sarah.
Installations by architects : experiments in building and
design / Sarah Bonnemaison and Ronit Eisenbach.
     p.   cm.
Includes bibliographical references and index.
ISBN 978-1-56898-850-4 (alk. paper)
1. Installations (Art) 2. Architects as artists. I. Eisenbach,
Ronit, 1962– II. Title.
N6494.I56B66 2009
720.92'2—dc22
                                              2008055160